100
Great Artists

100 Great Artists

A visual journey from Fra Angelico to Andy Warhol

Charlotte Gerlings

ARCTURUS

COVER ILLUSTRATIONS
Artists' portraits, left to right:

Top row: Paul Cézanne, Edvard Munch, Vincent van Gogh,
Peter Paul Rubens, Angelica Kauffmann,
Jean-Auguste Ingres, Berthe Morisot

Three central images: Detail from *The Garden of Earthly Delights*
by Hieronymus Bosch; *Mona Lisa* by Leonardo da Vinci; detail
from *The Chair and the Pipe* by Vincent van Gogh

Bottom row: Edouard Manet, John-Baptiste Corot, Rembrandt
van Rijn, Francisco Goya, Jacopo Tintoretto, Paul Gauguin,
Hans Holbein the Younger, Raphael Santi, John Sell Cotman,
Eugène Delacroix

ARCTURUS

Arcturus Publishing Limited
26/27 Bickels Yard
151–153 Bermondsey Street
London SE1 3HA

Published in association with
foulsham
W. Foulsham & Co. Ltd,
The Publishing House, Bennetts Close, Cippenham,
Slough, Berkshire SL1 5AP, England

ISBN 0-572-03161-0

This edition printed in 2006
Copyright © 2006 Arcturus Publishing Limited

Art Direction and Cover Design: Peter Ridley, Beatriz Waller
Design: Sylvie Rabbe
Editor: Belinda Jones

British Library Cataloguing-in-Publication Data: a catalogue record for
this book is available from the British Library

Printed in China

CONTENTS

INTRODUCTION

It is a pleasant but far from simple task to pick one hundred 'great' artists from hundreds of others. Everyone has a range of favourites, and a geographical spread is necessary too. With the early settlers, the European art tradition crossed the Atlantic to the New World, and travelled with traders to the Far East. This book helps to show how that tradition was re-interpreted in different locations. Inevitably, my editors and I had to make many reluctant omissions, and the constraints of copyright affected the choice of twentieth-century and contemporary artists. However, the selection that follows is intended to take readers on a wide-ranging journey through the story of western art, with the aid of one hundred examples of its leading exponents. For the most part, they have trained, inspired or influenced one another from the thirteenth century to the present day. It is a fascinating, ever-developing part of our lives that we shall never tire of looking at.

Major exhibitions are a feature of galleries in every principal city nowadays. Curators put years of planning and negotiation into assembling 'blockbuster' shows of both old and modern masters, whose works are borrowed and transported all over the world. Yet we must remember that we can go to the same galleries at other times, simply to view their standing exhibitions; and the youngest of gallery visitors are often given a special welcome. National and provincial galleries not only house famous works but also give us the opportunity to discover the paintings of less well-known artists. These people frequently worked alongside

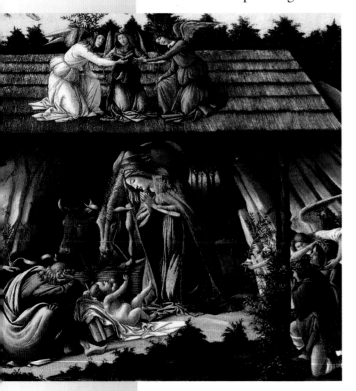

the great names, sharing ideas and techniques, sometimes in the role of teacher or pupil.

Standing in front of a Renaissance picture by the likes of Botticelli or Mantegna, for example, it is hard to imagine that the painters and sculptors we admire were originally classified as 'mere' craftsmen. Most came from humble backgrounds and were accepted into a studio around the age of nine. At first, they earned their keep by cleaning and running errands, gradually working up from apprentice to journeyman and finally master. The fresco painter Cennini has left this daunting account of the Renaissance apprentice's training schedule: 'Start first of all by grinding colours,

Detail from **The Mystic Nativity** *(1500) by Sandro Botticelli*

boiling up glue, mixing plaster, then going on to prepare panels, retouching them, polishing them, applying gold leaf, learning how to grain. Then another six years to study the use of colour, the application of mordants, to find out how to paint draperies and folds and how to work in fresco. And all the time you must practise drawing…work-day and feast-day.'

If an artist graduated to set up his own studio, the process began all over again with swarms of apprentices surrounded by the tools and materials of the business, in pursuit of lucrative commissions. The masters who became Court painters had rather more security – as long as they pleased their patrons – but their status was often that of a servant or palace workman. Some fresco painters, for example, were paid only by the amount of wall they covered. Occasionally, an astute artist like Cranach or Rubens was elevated to the rank of diplomat.

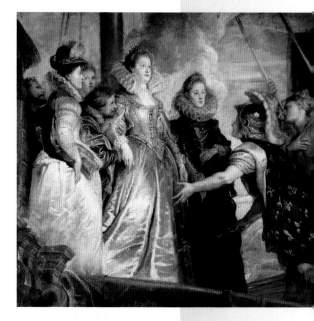

Detail taken from **Marie de Medici Disembarking at Marseilles After Marriage To Henry IV of France** *by Peter Paul Rubens (1622–25)*

The more we examine the great artists of all periods, the more we appreciate that, no matter how sublime their work, they were touched by the events of history as much as the next person. Their lives were disrupted by wars, transformed by scientific discoveries, cut short by the medieval plague or twentieth-century influenza.

To treat our subjects as fully as possible, each one occupies their own double-page spread containing two pictures, a commentary and a timeline that points to the principal events of his or her life. The selection of some less familiar pictures will, I hope, broaden appreciation and encourage a fresh approach. Occasionally, I have combined a pair, where the connection is particularly interesting or useful. Where the commentary mentions an artist with his or her own entry in the book, that name appears in **bold type** for easy reference. For the same reason, the arrangement is alphabetical, incidentally making for some remarkable neighbours.

It is hoped that this book may be enjoyed as a reference by students and practising artists, and a companion to the general reader who loves looking at pictures and is interested in finding out how skills and personal style come through in service of the creative process.

Charlotte Gerlings *2005*

FRA ANGELICO

Deposition of Christ *(detail) (1436–45)*
The frescoes in the convent of San Marco decorated both the communal spaces and the nuns' private cells, where they were designed to encourage meditation. Fra Angelico's experience as an illuminator shows in his thin, precise application of paint. It was an ideal method for detailing wing feathers and embroidery, and well suited to background features, as shown in this detail

Fra Angelico and his brother Benedetto joined the Dominican Order of Preachers together in 1407. At their monastery in Fiesole, the young men were directed to illuminating manuscripts, and it is possible they remained in artistic partnership for most of their lives.

Fra Angelico soon gained a reputation for his technical skills in composition and colour and was promoted to overseeing a busy workshop inside the Order. His religious title was Fra Giovanni but the other friars nicknamed him 'Angelico' for his piety and the beautiful work that he produced. He is reputed never to have altered or retouched any of his paintings, firmly believing that to do so would have been against God's will.

Nothing is known of Fra Angelico's early teachers, other than the influence he shows of the Sienese school. Angelico and Benedetto probably made the leap to full-scale fresco painting during the five years that their order was exiled in the Umbrian hill town of Foligno. **Giotto's** frescoes at Assisi would have been within easy reach and the brothers are certain to have visited them.

Once he had moved to Florence at the invitation of Cosimo de' Medici and started decorating the convent of San Marco, Fra Angelico's handling of form, perspective and colour developed even further. Benedetto is said to have worked alongside his brother on the vast San Marco commission, and one of their apprentices was the young Benozzo Gozzoli.

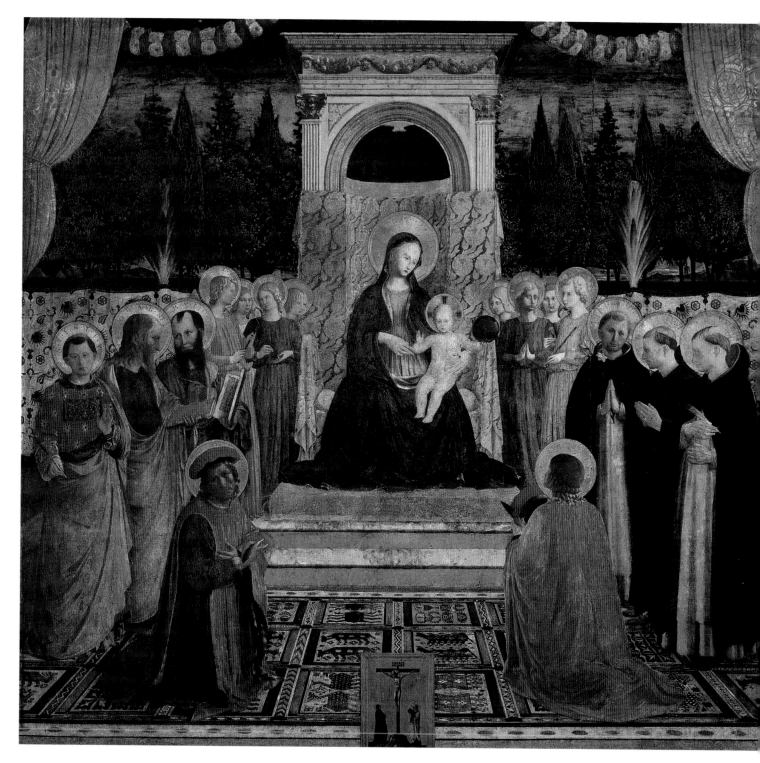

The Altarpiece of San Marco *(1436–45)*
Fra Angelico had an innovative approach to composition and he is credited with the invention of the sacra conversazione, *a device which places all the figures in a painting close to one another, as though in conversation. Although the Renaissance meant a strong move towards humanism, Fra Angelico's work maintained a firm reverence for the Christian ideal*

SOFONISBA ANGUISSOLA

1532(?)	*Born in Cremona, Lombardy, daughter of a leather and silk dealer*
1546(?)	*Studies art under Campi*
1554	*Meets Michelangelo in Rome*
1559	*Appointed Court painter by Philip II of Spain*
1570	*Marries Sicilian nobleman Don Fabrizio de Moncada, widowed*
1571(?)	*Returns to Cremona. Marries ship's captain Orazio Lomellino, settles in Genoa.*
1623	*Visited by Van Dyck in Genoa*
1625	*Dies in Palermo*

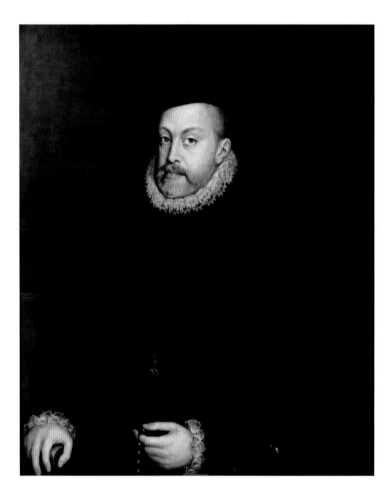

Philip II of Spain with the Order of the Golden Fleece *(1565)*
Anguissola's life at the Spanish Court began in 1559, where she was introduced as an artist already worthy of the highest regard. Anguissola made much use of the half-length portrait throughout her career

Sofonisba Anguissola was one of seven children – six girls and a boy – whose enlightened father had his family educated in accord with Renaissance humanist principles. This resulted in two of his daughters, Sofonisba and Elena, going to study for three years with the reknowned Lombardy artist, Bernardino Campi.

Thanks to the progressive attitudes of Anguissola's father and Campi, the admission of girls to painters' studios became acceptable. However, they were still not allowed to become workshop apprentices and work alongside the men. This very much restricted women in the subjects they could paint – no nude males, for example – and so Anguissola found her niche in portraiture. She gave early notice of her interactive approach with an unusual double portrait entitled *Bernardino Campi Painting Sofonisba Anguissola*.

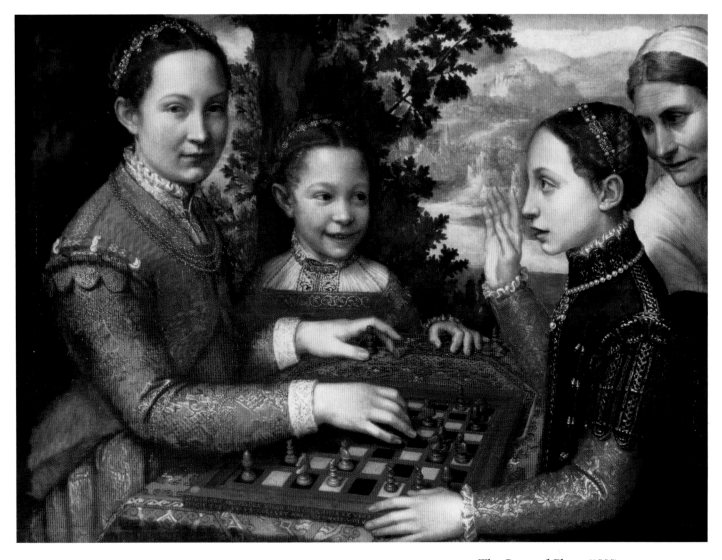

The Game of Chess *(1555)*
Three of the Anguissola sisters, Lucia, Europa and Minerva, play chess, while their governess looks on. Their older sister Sofonisba, one of the first women to gain an international reputation as a painter, had a marvellous ability to capture her sitters' expressions and to register their emotions

Anguissola's unique style was also historically significant. Firstly, she undermined the rigid artificiality of fashionable portraits; and secondly, she demonstrated what female sensibility could bring in the way of emotional candour to the task of capturing a likeness. Through her many self-portraits, she was careful to emphasize her own refined character; in those stirring times, it was still important to convey modesty and virtue.

Anguissola's talent made her famous all over Europe, bringing her into contact with **Michelangelo** at the start of her career and **Van Dyck** near the end. In between, she was appointed not only Court painter to Philip II of Spain but also lady-in-waiting to two successive queens. Interestingly, she received a salary as lady-in-waiting; her aristocratic status prevented her from selling her works and they were always made as gifts to those concerned.

GIUSEPPE ARCIMBOLDO

1527	*Born Giuseppe Arcimboldo in Milan, son of a painter*
1549	*Working as father's assistant at Milan Cathedral*
1558	*Designs tapestry for Como Cathedral*
1562	*Moves to Prague, becomes Court painter to Ferdinand I*
1564	*Remains Court painter when Maximilian II succeeds Ferdinand I*
1566	*Travels to Italy*
1569	*Presents Maximilian II with Seasons and Four Elements*
1570–71	*Organizes two royal weddings*
1576	*Remains Court painter when Rudolf II succeeds Maximilian II*
1580	*Ennobled by Emperor Rudolf II*
1587	*Leaves Prague for Milan*
1591	*Sends Vertumnus to Prague, elevated to Count Palatine*
1593	*Dies of kidney disease in Milan*

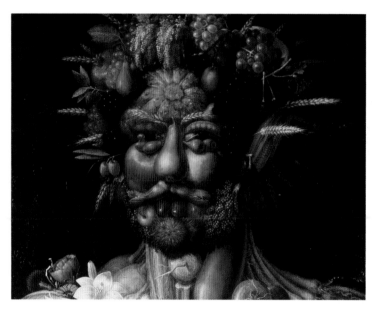

Vertumnus *(detail) (1591)*
A magnificent portrait of Rudolf II as the ancient Roman god of vegetation and the changing seasons. Vertumnus was also the symbol of commerce. The emperor was delighted with the idea of himself as the embodiment of fruitfulness, harmony and a strong economy, and promptly awarded Arcimboldo the title of Count Palatine

Giuseppe Arcimboldo was an artist of great ingenuity. Pre-dating the Surrealists by over 300 years, his compositions of painted flowers, vegetables, and other more bizarre objects took the sixteenth-century Hapsburg Court by storm. Three successive emperors, Ferdinand I, Maximilian II and Rudolf II, became devotees of his extraordinary portrait series.

In 1562, Arcimboldo answered an imperial invitation and left Milan for Prague. There he assumed the post of Court painter and decorator, events organizer, costume designer and all-round art adviser.

Along with royal weddings, festivities at Court consisted of pageants and tournaments.

The Uffizi in Florence has a red leather folder, dedicated to Rudolf II. Inside are 148 of Arcimboldo's pen and wash sketches detailing costumes and 'props' for various events based on classical allegory. These extravaganzas were designed to display the Hapsburgs' dynastic power to hundreds of high-ranking guests.

The Uffizi portfolio is a very rare item, as little of Arcimboldo's signed work survives, nor did he leave any writings, although he is known to have been highly educated. His talents spanned the arts, sciences, engineering and philosophy; he was a true 'Renaissance man'. Yet for no obvious reason, his work sank into obscurity until rediscovered in the nineteenth century.

Water *from 'The Four Elements' (1566)*
As a young man, Arcimboldo painted stained glass for Milan cathedral, but it was through tapestry design that his richly ornamental style emerged, to mature in the painted series of 'Seasons' and 'Elements'. Arcimboldo was to copy Water many times, for gifts to impress their recipients with the glory of the Hapsburgs

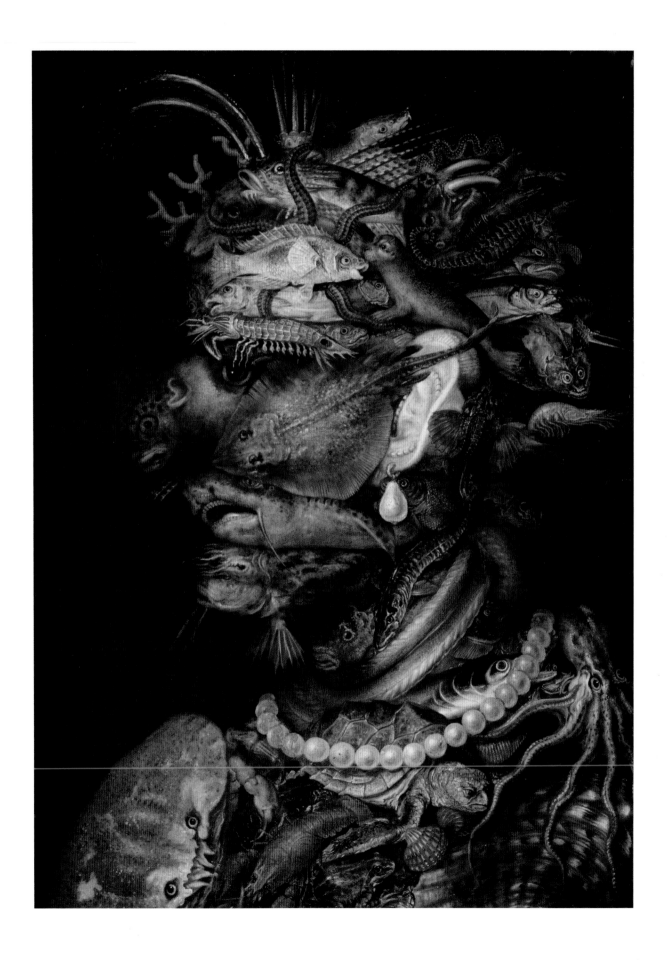

GIOVANNI BELLINI

1430(?)	*Born in Venice, son of painter Jacopo Bellini*
1445(?)	*Giovanni and brother Gentile begin work as Jacopo's assistants*
1453	*Mantegna marries their sister and becomes lasting influence*
1458–60	*In Padua with Mantegna*
1460–68	*Returns to Venice, works on first major commissions*
1470	*Establishes own workshop. Visits Rimini and Pesaro, sees work of Van der Weyden*
1475	*Engages with Flemish technique when Messina introduces oil painting to Venice*
1475–79	*Resurrection, first Venetian painting executed in oil glazes*
1485–?	*Paints portraits and allegories as well as religious subjects*
1490–1507	*Giorgione and Titian among his pupils*
1506	*Visited by Dürer*
1516	*Dies in Venice*

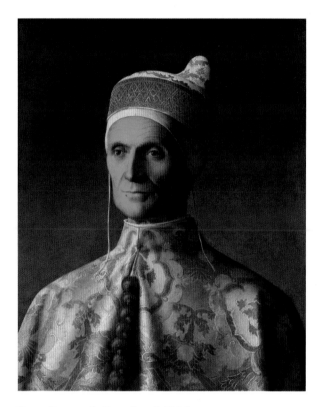

Doge Leonardo Loredan *(c.1501)*
The ruler of Venice wears gold damask robes, an imported fabric that signified the prosperity of Venice as a commercial centre. Bellini reproduced the effect by painting the surface roughly in order to catch the light

Giovanni Bellini is responsible for raising the standard of the Venetian school of painting to the point where the city rivalled Florence as a centre of Renaissance excellence. His father, brother and brother-in-law were artists too, but it is the latter, Andrea **Mantegna**, who initially spurred Bellini on to painting landscapes and defining the mood of a picture.

Like all his Italian contemporaries, Bellini was accustomed to working in water-based tempera, either on wooden panels or plaster walls. However, once he had seen the work of Rogier **van der Weyden**, he was eager to try the Flemish oil glazing technique brought to Venice by Antonella da Messina in 1475.

Bellini was always experimenting. Now, with the rich translucence of oil glazes at his fingertips – revealing new depths to familiar colours and demanding a different type of brushwork – he uncovered a wealth of possibilities. When Bellini learned how to translate the Venetian play of light between sky and water, he had the key to all the subtle harmonies and brilliant colours that would come to signify the school of Venice for the next two centuries.

Bellini influenced the course of European painting through the young painters apprenticed to his workshop. Two of the most famous were Giorgione and **Titian**, whose later rivalry he took in his stride. On a visit to Venice in 1505, Dürer reported, 'he is very old and still he is the best painter of them all'.

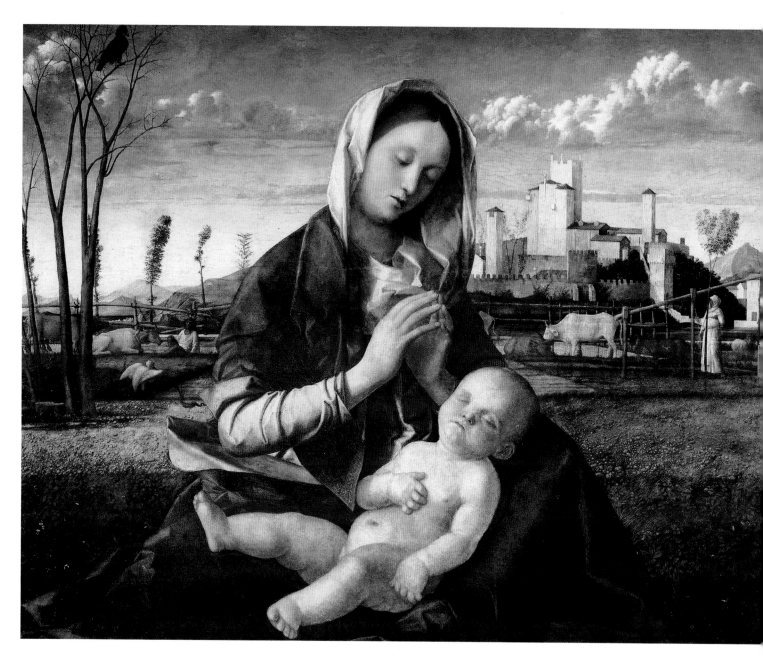

Madonna of the Meadow *(c.1505)*
*Bellini's Madonnas were virtually his trademark, as was the serenity and
tenderness with which he portrayed them. Here the child Jesus sleeps blissfully
under his mother's gaze while daily life goes on behind them in one of the artist's
exquisite landscapes. Only the brooding raven and the solemn pose of the Virgin
hint at the day on Calvary, when this same son will lie dead in her lap*

WILLIAM BLAKE

1757	*Born in London, son of a hosier*
1771	*Apprenticed for seven years to engraver Basire*
1774–87	*Opens and runs a London print shop until death of brother Robert*
1783	*Marries Catherine Boucher, his artist-assistant. Publishes first book of poems,* Poetical Sketches
1789	*Publishes* Songs of Innocence
1790–93	*Engraves key prose work,* The Marriage of Heaven and Hell
1794	*Publishes* Songs of Experience, *including 'The Tyger'*
1800–03	*Taken up by patron William Hayley. Blakes move to Felpham, Sussex*
1803	*Charged with treason at Chichester and acquitted*
1804–08	*Publishes* Milton, *including 'Jersualem'*
1818	*Blake's work gathers young disciples, including Samuel Palmer*
1827	*Dies in London*

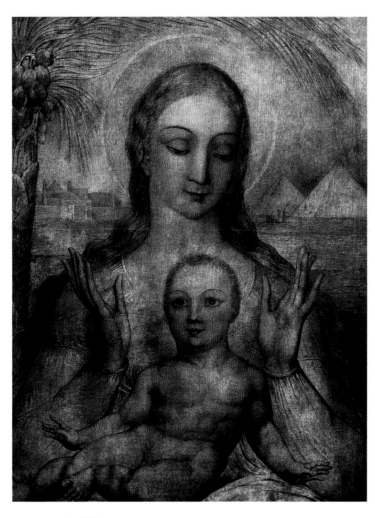

Virgin and Child in Egypt *(1810)*
One of four similar paintings that Blake made in gratitude to a patron, Thomas Butts, who supported him by sending his son for drawing lessons. Blake thought it more ethical to paint in tempera, a water-based medium, than oil, as it was more demanding of the artist's skill

William Blake – engraver, painter, poet and mystic visionary – wrote, illustrated and printed his own books. It was his belief that the imagination was superior to, and more real than, the rationalism and materialism of his day; he found himself firmly outside the cultural mainstream in the Age of Enlightenment. He was also a supporter of the French and American Revolutions.

He counted Royal Academicians John Flaxman and Henry Fuseli among his closest friends, even though he had disliked formal schooling himself. Blake claimed to have seen ghosts and angels since childhood – even that he had spoken to the Virgin Mary – so it is clear that Fuseli's fantasy art was in tune with and influenced his own. The muscular nudes of **Michelangelo** are another clear inspiration,

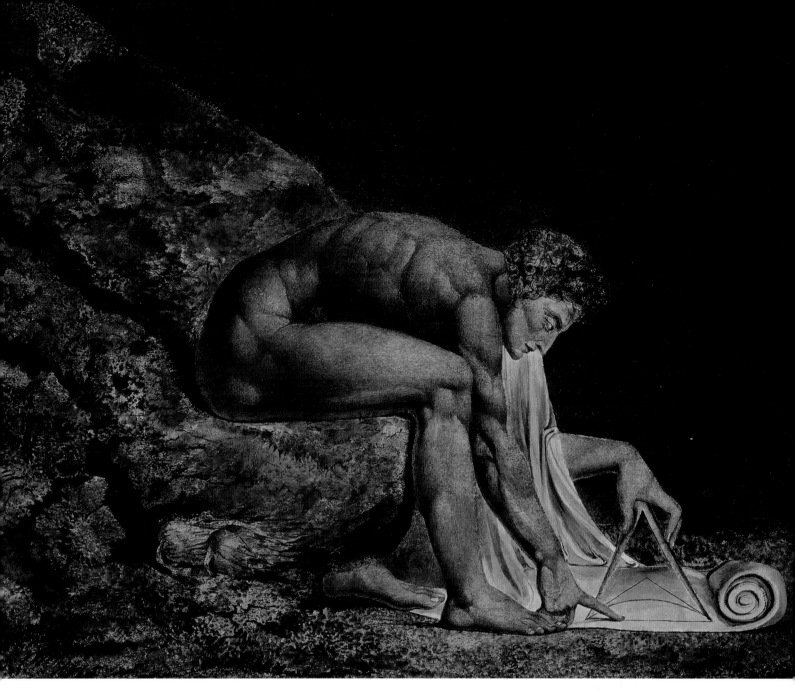

Newton *(1795)*
*In this large, very accomplished colour print, Isaac Newton is shown busily
rationalizing the universe with the aid of a pair of compasses. Blake divided the
background into one bright and one dark section, implying that the great
mathematician and physicist brought not enlightenment but a godless night-time.
Blake believed that artists alone were capable of divine insight and that the soul was
always struggling to free itself from the confines of reason and organized religion*

but these he had known for many years through his collection of engravings.

Blake's special printing process involved transferring reversed images of his words and pictures onto copper plate in an acid-resisting ink. After etching in acid, it produced a relief image, which could yield dozens more copies. Blake and his wife hand-coloured each print individually, using cheap camelhair brushes.

Another of his techniques was more akin to monoprinting. He took impressions direct from the painted surface of stout pasteboard and refined the details in ink and extra paint. Perversely, if Blake had been rich enough to afford letterpress printing and fine painting materials, his work would surely have lost its idiosyncratic edge and the tangible sense of involvement with his message.

ROSA BONHEUR

1822	*Born Marie-Rosalie Bonheur in Bordeaux, daughter of a landscape painter*
1841–53	*Exhibits regularly at the Paris Salon*
1848	*Awarded first Gold Medal by panel that included Corot, Delacroix and Ingres*
1849	*Takes over father's art school on his death*
1853	The Horse Fair *wins acclaim and private view by Queen Victoria*
1855(?)	*Buys chateau near Fontainebleau, shared with Nathalie Micas*
1860–80	*Work sells chiefly in England*
1889	*Death of Nathalie Micas. Relationship established with Anna Elizabeth Klumpke*
1894	*Through Empress Eugenie, becomes first woman awarded Grand Cross of French Legion of Honour*
1899	*Dies in Melun, Fontainebleau*

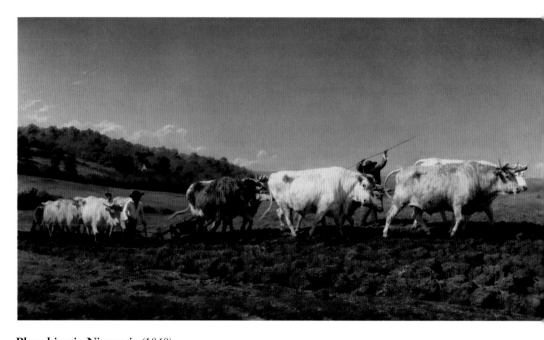

Ploughing in Nivernais *(1848)*
One of Bonheur's most celebrated paintings. It is based on Bonheur's own studies, and also inspired by Potter, a seventeenth-century Dutch animal painter. The nobility of these huge labouring animals appears to surpass the effectiveness of the men driving them

The eldest of four children – all of them artists – Rosa Bonheur decided early to specialize in painting and sculpting animals. Her father encouraged her by allowing a sheep to be kept on the balcony of their sixth-floor Paris apartment.

Bonheur's unconventionality was a keynote to her life: she wore cropped hair, smoked in public and, when visiting slaughterhouses and markets to study animal anatomy, carried authorization by the Paris Prefecture to wear a man's trousers and smock in public. The same outfit worn to the theatre drew loud complaints from a man in the next box, until he was told that she was the famous artist.

Bonheur communicated a directness and honesty with her animal subjects, so refreshingly free from the social conventions that she had to contend with herself as they were. Her work was acclaimed by the Salons and she made a good living from it, while steering clear of the complex sentimentality of the age.

There was no room for sentimentality at her chateau where she housed a menagerie that included a pair of lions, a stag, cattle, numerous dogs and a parrot. The chateau was also home to a free art school; Bonheur was a sympathetic teacher, just as her father had been. She was well-known for her generosity towards artists in difficulty and for making provision for everyone who worked for her.

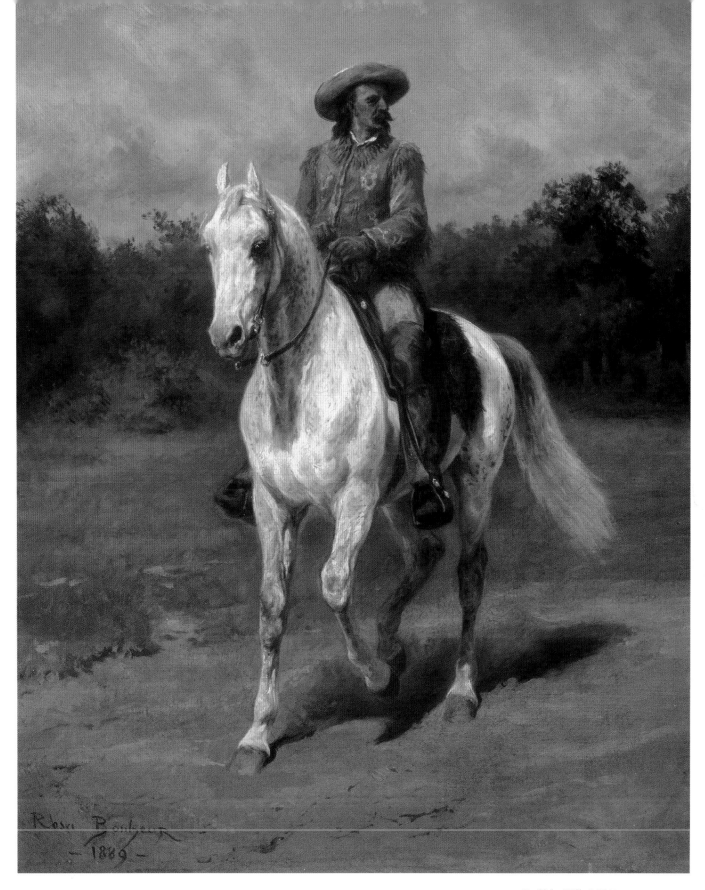

Buffalo Bill *(1889)*
*A portrait of Colonel William F. Cody, otherwise known
as the showman 'Buffalo Bill'. This portrait was made after
Cody's visit to Bonheur's chateau, during the European tour of his Wild
West Exhibition in 1889. After Bonheur's death, it was reproduced as a
poster advertising the show's tour of 1905*

HIERONYMUS BOSCH

King Gaspard, Adoration of the Magi *(detail) (1510)*
Bosch's later works depicted fewer and larger figures playing out a single event. Gaspard is one of the Magi in Bosch's version of the Adoration. Behind him, his page wears a bizarre thorny headdress, symbolic of the only crown that Christ will ever wear

Hieronymus Bosch cannot be categorized. He links back to the miniature narratives seen on illuminated manuscripts at the same time as anticipating the pots and pans of Dutch genre painting. His family were lay members of the Brotherhood of Our Lady in 's-Hertogenbosch. This Catholic group worked for the cultural benefit of the city where Bosch lived and died.

Bosch's unbridled imagination explodes as he depicts life as a continual struggle between man and his inner nature. There are many theories about his astonishing vision; one of the most persistent being that his symbolism encodes the doctrines of a heretical Gnostic sect called the Cathars. Whatever Bosch believed, he had an acute awareness of human psychology. He uses familiar proverbs and folklore to comment on the human condition. His observations – spread across thousands of individual figures in the teeming panels of his triptychs – are continually surfacing, as if to admonish the viewer or proclaim a revelation, and then diving again into the tumult. Bosch painted *alla prima*, that is directly onto a ground with no underpainting or glazes, a method which called for expert brushwork.

The register that records his death describes Bosch as a 'distinguished painter'. He was certainly a strong influence on **Bruegel the Elder** and his allegories of village life. Later, Bosch's paintings were avidly collected by Philip II of Spain, before the Protestant Reformation finally dismissed him to obscurity.

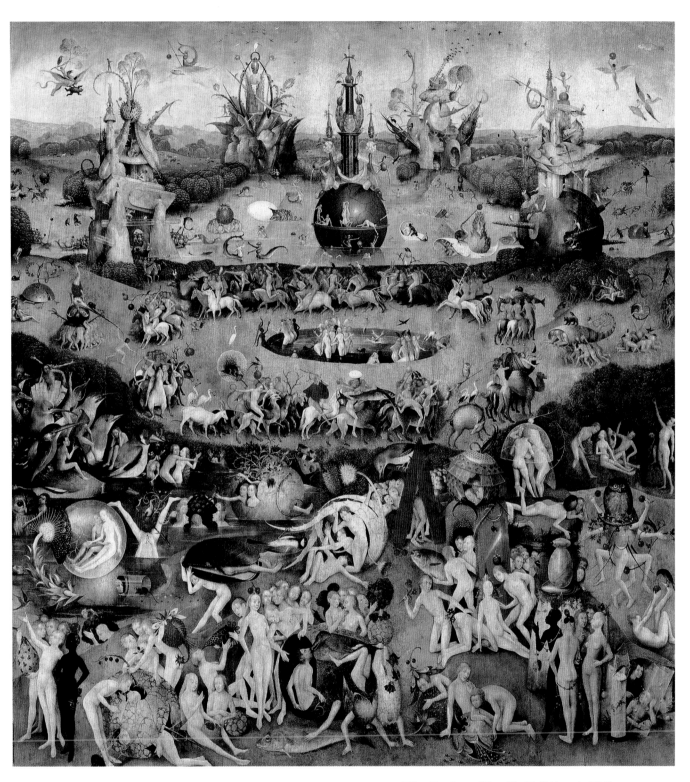

The Garden of Earthly Delights (c.1500)
One of the best known of Bosch's paintings, this is the centre panel of a huge panoramic triptych. The composition is masterful in the way he manipulates the picture-plane between the viewer and different levels of activity in the picture. Arguments continue over Bosch's intentions with this work, between those who believe it shows a world engaged in sinful pleasures and those who think it is how humanity might have lived without the Fall of Adam and Eve

SANDRO BOTTICELLI

1445	Born Alessandro di Mariano Filipepi in Florence, son of a tanner
1461–67(?)	Apprenticed to Fra Filippo Lippi as a painter
1467–70(?)	Associates with Antonio Pollaiuolo and Verrocchio
1470	Sets up workshop in Florence, receives first commission
1472	Becomes member of St Luke's Guild
1474	Paints St Sebastian for Santa Maria Maggiore, Florence
1476–77	Paints portrait of Giuliano de'Medici
1481–82	In Rome, decorates chapel of Pope Sixtus V, later named the Sistine Chapel
1482–85	Paints allegorical works
1484–92	Paints altarpieces for several Florentine churches
1491	Becomes follower of Savonarola
1497	Throws works onto 'Bonfires of the Vanities'
1510	Dies in Florence

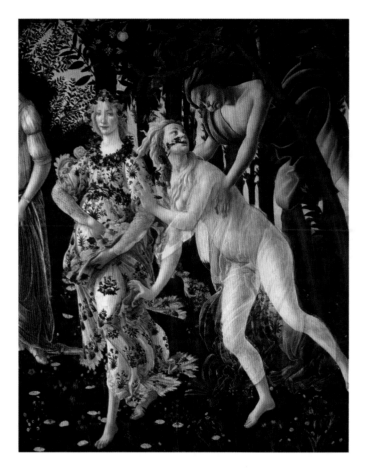

Primavera *(detail) (c.1478)*
The grace, colouring and draperies of the Flora figure were learned from Filippo Lippi. Botticelli's early talent for drawing was probably fostered by the Pollaiuolo brothers, whose work as goldsmiths and engravers required draftsmanship of a high order

During his life Botticelli was connected with three major philosophies. His early pictures are standard Madonnas, made for guilds and private clients. However, Botticelli's relationship with conventional Christianity underwent radical adjustment when he won the patronage of Florentine ruler, Lorenzo de' Medici.

De' Medici advocated humanism through the Neo-Platonists, the scholarly group of men he collected around him. Their aim was to marry classical philosophy with Christianity for an entirely new view of the universe; one where paganism was respected and allegory taught life's lessons. This period yielded Botticelli's celebrated 'pagan' works, *The Birth of Venus* and *Primavera*.

Everything changed again in 1491, following the death of Lorenzo. Girolamo Savonarola, fanatical vicar-general of the Dominicans, arrived to claim Florence back for Christ. Savonarola instituted the infamous 'Bonfires of the Vanities' and Botticelli, now one of his followers, obediently threw several of his own drawings and paintings into the flames. The remaining pictures of his career are noticeably more sober in tone.

Botticelli's most famous pupil was Filippino Lippi, son of Filippo.

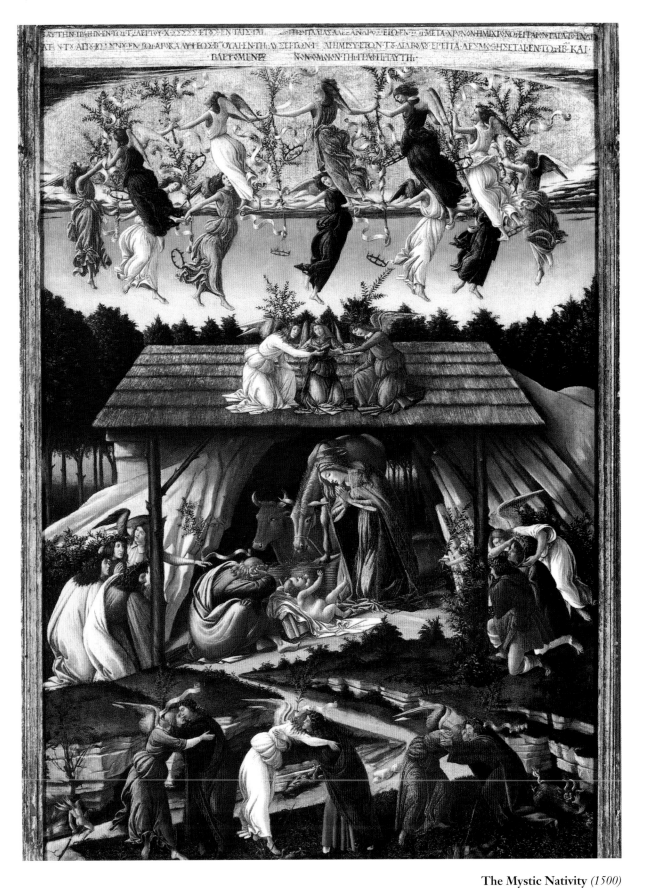

The Mystic Nativity *(1500)*
*The inscription referring to the Apocalypse and 'troubles of Italy' is in both Greek
and Latin. Botticelli has used an archaic device that magnifies the Virgin and
Child; altogether, the picture is calling for a return to medieval morality*

FRANÇOIS BOUCHER

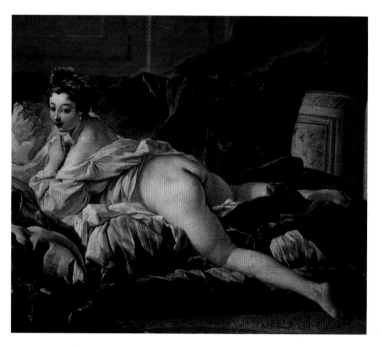

Odalisque *(1745)*
Boucher admired Watteau, whose work he studied and reproduced as engravings in his youth. However, the sensual odalisques that Boucher produced for Louis XV and various other private clients were a far cry from the Academy-approved fête galante, *which harked back to an era of courtly love. His seductive young woman are very much of their own time: 'The pretty thing is the soul of the age – and the genius of Boucher'*

French art of the eighteenth century took its cue from the hedonistic court at Versailles and especially from Louis XV's mistress Madame de Pompadour, whose favourite artist was François Boucher.

Boucher was the supreme exponent of Rococo, a luxurious decorative style, which dominated the wealthiest home interiors. Already an excellent draughtsman, he trained with Lemoyne, the ceiling artist at Versailles; from Lemoyne he learned a versatile technique that he applied to all the decorative arts he was engaged in, from tapestry to porcelain designs.

After three years in Rome, Boucher tried demonstrating his seriousness with a few history paintings. But they were not to the current taste or fashion of the time, so he went for the most lucrative commissions and won fame with his sensuous, light-hearted mythological subjects: goddesses and cupids cavorting happily amongst the clouds mirrored the self-indulgence of the French aristocracy.

Academic objections were raised, both to Boucher's subject matter and use of colour, but these were as much against the self-made Marquise de Pompadour's powerful patronage as against Boucher himself. After all, was it not usually aristocratic *men* who commissioned pictures of enticing, pearly nudes?

Boucher was very hard working; he would often spend twelve hours a day at his easel and ran a busy studio where Fragonard was one of his pupils. He did have a beautiful wife with expensive tastes that he was obliged to please, but declared he would never wish to exchange his career for any other.

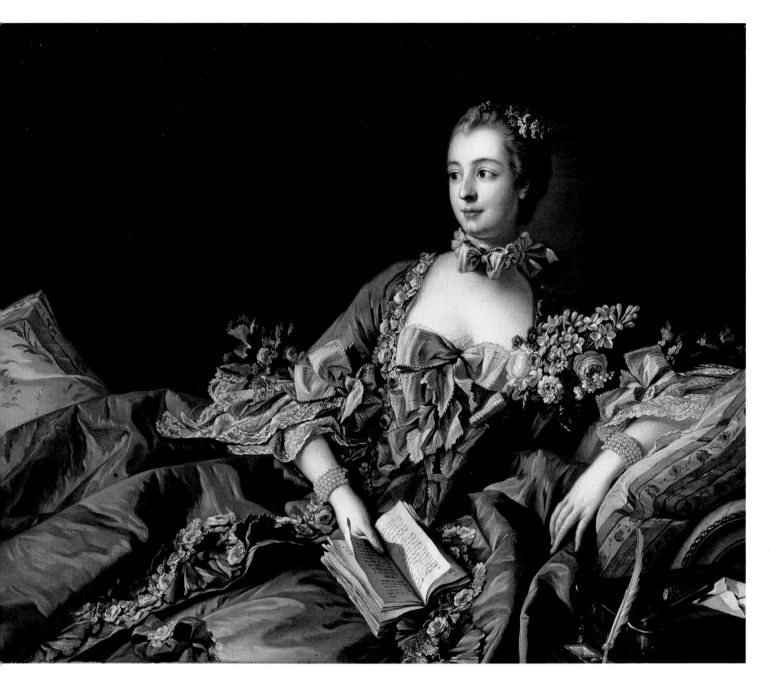

Madame de Pompadour *(detail) (c.1758)*
*Through Boucher, Madame de Pompadour saw a means of portraying herself
as France's ambassador of the arts. He was not keen on painting portraits and
in letters she confided they were not exact likenesses but she didn't mind so long
as they projected the right image. Here she is as a woman of literary
accomplishments. Expert rendering of her gown reminds us that, with his
father an embroidery designer, it is likely that Boucher saw and handled fine
fabrics from an early age*

PIETER BRUEGEL THE ELDER

1525(?)	*Born in Brueghel*
1540(?)	*Apprenticed to leading Antwerp artist Coeck van Aelst*
1551	*Becomes a Master of the Antwerp Guild*
1552	*Tours Italy*
1553–54	*Stays in Rome, travels home via Swiss Alps*
1554-55	*Works in Antwerp with Hieronymus Cock, engraver and publisher*
1558	*First painting,* Proverbs
1563	*Marries Mayken, daughter of Coeck, they settle in Brussels*
1564	*Birth of son Pieter. Acquires wealthy patron, Nicolaes Jonghelinck*
1568	*Birth of son Jan*
1569	*Dies in Brussels*

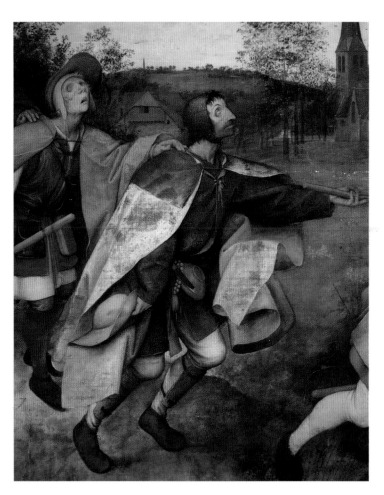

Parable of the Blind (detail) (1568)
A detail from Bruegel's last major work referring to a quotation from Matthew's gospel: 'If the blind lead the blind, both shall fall into the ditch.' In this solemn allegory for the human situation the string of unfortunate people, each by clinging blindly to the next, are jeopardizing their own salvation rather than working it out for themselves

A remarkable fact about Pieter Bruegel is that after travelling extensively in Italy he returned home to then resume work in an unaltered Flemish style. His Italian sketchbooks were full of the grandeur of the Alps rather than copies of Renaissance art.

Bruegel the Elder was nicknamed 'Peasant' because he liked to go in disguise among ordinary working people. He was actually one of a group of distinguished Flemish humanists, which included the geographer Ortelius, also Plantin the printer and Goltzius the engraver, so it would be a mistake to confuse him with one of his peasant figures.

He began painting comparatively late; *Proverbs* dates from 1558. It set a pattern for combining realism and imagination, doubtless inspired by Bosch. Similarly, Bruegel's characters often point to morals and make satirical observations on life, although Bruegel's approach is rather more gentle than Bosch's.

Three robust exceptions are *The Fall of the*

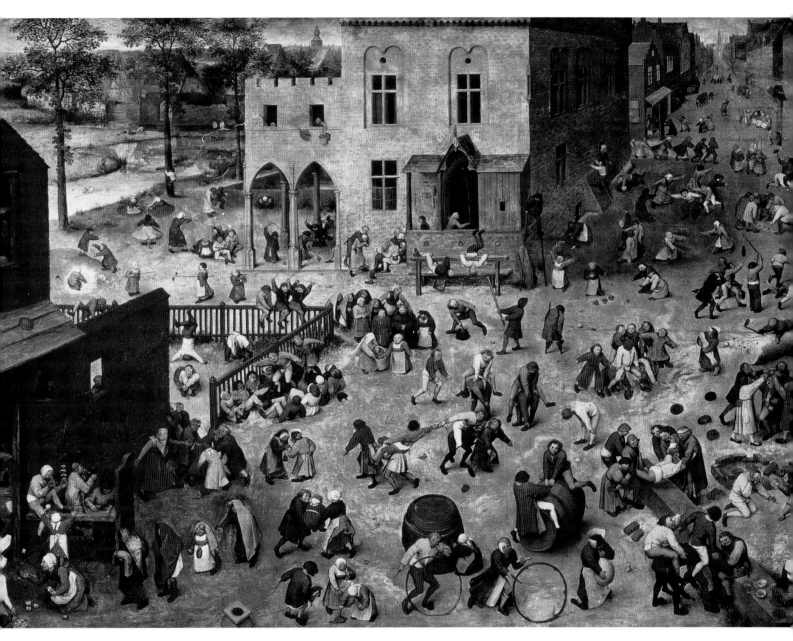

Rebel Angels, The Triumph of Death and Mad Meg
(Dull Griet). In fact, the first nightmarish
image was attributed to Bosch until reframing
revealed Bruegel's signature. His vengeful Mad
Meg may be a reference to the terrors of the
Spanish Inquisition.

Bruegel made social and political protests as
readily as he celebrated the joys of living. In
painting he found a vital means of expressing his
inner and outer vision: 'In all my works there
was more thought than painting.'

Children's Games (1560)
*Bruegel's skill with genre scenes such as this one, depicting hundreds of little
people acting out a catalogue of pastimes, was honed while he was an engraver
with the Antwerp publisher, Hieronymus Cock. His figures are solid with little
modelling but they are wonderfully lively; and beyond the fascination of
identifying all the games and activities, the viewer is treated to a convincing
street perspective on the right, and a delightful glimpse of typical Flemish
landscape on the left*

ANTONIO CANALETTO

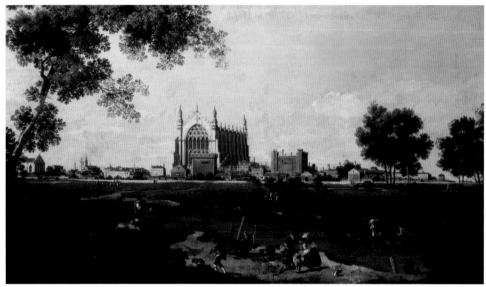

Eton College (*c.1754*)
This view of the famous English public school near Windsor was painted towards the end of Canaletto's stay in England, which had begun in 1746

Antonio Canaletto chose to paint his native city, Venice, knowing it could make him plenty of money. His formula – masses of de......d architecture, shimmering waters and b......- went down well with the English nobility the Grand Tour. So well that, at one sta....rh Smith, the British consul-in-waiting..... a.ng as his agent.

In time, Canal... o refined his output to suit the market even better. His repertoire grew to include popular Venetian festivals and ceremonies and he was willing to paint an entire series of *vedute* (city views) in a uniform size, to furnish any stately home.

Canaletto made no secret of his reliance on the *camera obscura* (see page 198 for a definition of this device), especially at sketchbook stage.

The camera itself was well known, and first recorded in 1550. Canaletto taught others how to use it and thus render perspective convincingly. His nephew, Bernardo Bellotto, proved an excellent pupil and eventually painted for crowned heads all over Europe.

War in Europe in 1740 disrupted foreign travel and it was a time to seek out English clients at home. From 1746, Canaletto lived in London for almost ten years, working for patrons such as the Hanoverian Duke of Richmond.

Always the best customers of Canaletto, the sale of Joseph Smith's entire collection to George III in 1762 brought to England the world's finest selection of his paintings and drawings.

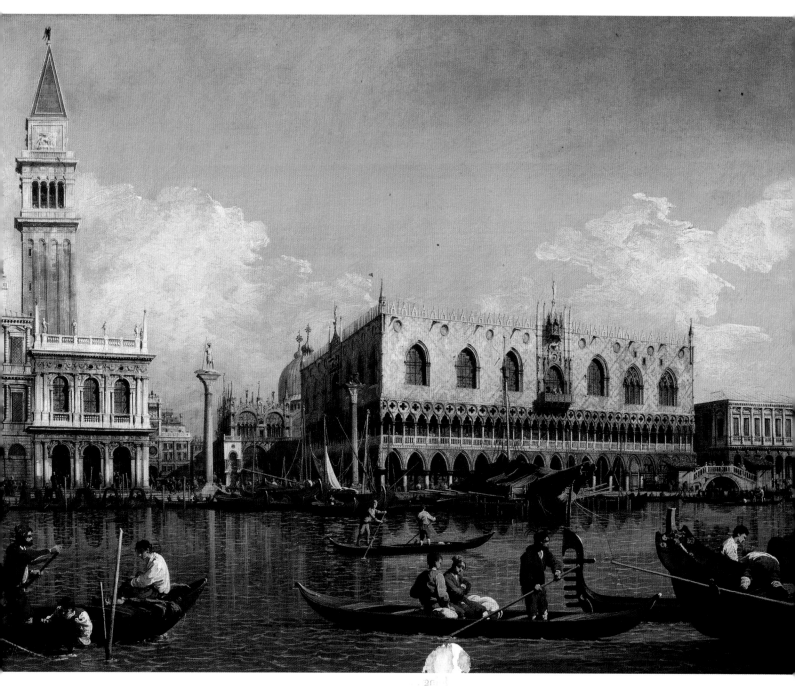

Bas~~ilica of St~~ Mark's Square, Venice *(detail) (c.1745?)*
*The ~~picture~~ ~~tha~~t so many Grand Tourists travelled to see, and
buy – on ~~can~~vas. It was not unknown for enthusiastic clients
to take their Canalettos home before the paint had dried*

MICHELANGELO MERISI DA CARAVAGGIO

1573(?)	*Born in Caravaggio, near Milan, son of an architect*
1584–88	*Orphaned, trained under Peterzano, a pupil of Titian*
1592	*Goes to Rome*
1596	*Meets first patron, Cardinal del Monte*
1599–1600	*First public commission*
1600–06	*Involved in criminal activities, flees Rome for Naples*
1606–09	*Travels to Malta, Syracuse, Messina, Palermo and Naples again*
1610	*Receives papal pardon. Dies of malarial fever in Porto Escole*

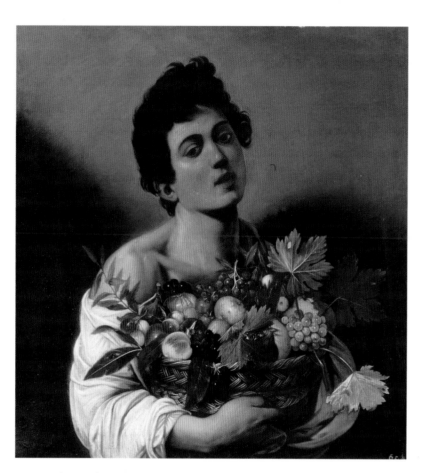

Boy With a Basket of Fruit *(1593–4)*
The boy, who looks as if he could be offering himself to the viewer along with the fruit, is possibly a self-portrait. Caravaggio would have been around 21 years of age but already demonstrated an assurance in handling the extremes of light and shadow known as chiaroscuro

Caravaggio's early education in Lombardy gave him a passion for realism and a dislike of idealization; later, in Rome, he would discover that these were revolutionary concepts. The models chosen for saints and supplicants in his religious pictures were genuine peasants with rags, wrinkles and dirty feet. Not surprisingly, this upset orthodox patrons and members of the public alike, who preferred the contrived elegance of Mannerism to Caravaggio's down-to-earth observation.

Caravaggio himself very much admired **Michelangelo** Buonarroti and paid homage to him several times. The angel's hands in *The Inspiration of St Matthew*, painted for the Contarelli Chapel, recalls *God's Creation of Adam* on the Sistine Chapel ceiling; and in *St John the Baptist* (*Youth with Ram*), the boy poses exactly like one of the *ignudi*, also on the Sistine ceiling.

It appears that Caravaggio's method was to paint directly from his models, with no preparatory drawing. This indicates the use of

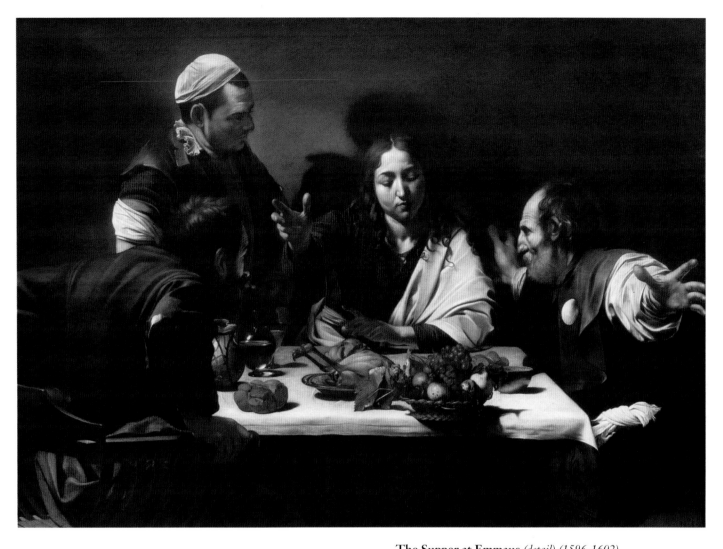

The Supper at Emmaus *(detail) (1596-1602)*
*The gestures in this picture tell us a great deal. The outstretched hands of the
disciple on the right, and those of the other gripping his chair, capture the
immediate moment of recognition, as the beardless youth they met along the
road reveals himself to be the resurrected Christ by blessing the meal. The still-
life of fruit makes biblical references to restored life and expectations fulfilled,
whilst the apples – symbols of temptation – remain noticeably blighted*

lenses as a technical aid. His patron, Cardinal del Monte, is known to have had some expertise with optics and may have provided the artist with equipment that would have projected the images directly onto the canvas, helping to reproduce points of high contrast and foreshortening.

By upholding his own aesthetic values and avoiding any consolatory approach to his subjects, Caravaggio quite literally placed art in a new light. The fresh immediacy of his work suited the aims of the Catholic Counter-Reformation too, as they hoped that dramatic imagery in their churches could be used to tempt people back from dour Protestantism.

Caravaggio combined a short, wild, occasionally criminal life with an iconoclastic attitude. His influence lived on in the studios of the Gentileschi family, particularly that of the remarkably talented Artemisia **Gentileschi**. Caravaggio's works continue to resonate, specifically with film-makers such as Pasolini, Jarman and Bertolucci.

PAUL CÉZANNE

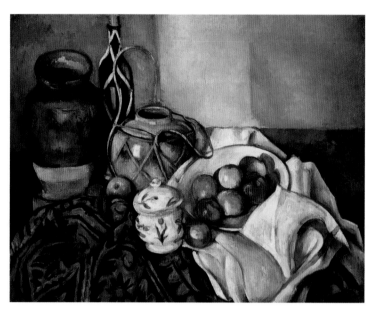

Still Life with Pots and Fruit *(1890-94)*
A study of shape, volume and colour, all minutely arranged, to illustrate perfectly Cézanne's own words: 'Treat nature by means of the cylinder, the sphere, the cone, everything brought into proper perspective…directed towards a central point.'

Paul Cézanne was a shy, irritable man who, after a discouraging start in the early 1860s – a forbidding father, examination failure and Salon refusals – scarcely seemed destined for lasting recognition. Acclaim was hard won, taking over thirty years of disciplined work before his first one-man exhibition in 1895; following which, younger artists like the Nabis formed an enthusiastic clique, alert to Cezanne's pushing of the boundaries beyond airy Impressionism.

Cezanne knew that the theories of Parisian academics and critics, let alone public opinion, were not sympathetic to his ideal of 'the logical development of everything we see and feel through the study of nature'. It was his desire for this essential harmony, expressed by colour as tone, which drew him back to his beloved Provence in 1882. The recluse who wished 'to make of Impressionism something solid and durable' eventually went much further, providing the impetus for Cubism, Abstraction and the gamut of avant-garde experimentation.

Renoir asked: 'How on earth does he do it? He cannot put two touches of colour on to a canvas without its being already an achievement.'

In the Park of Chateau Noir *(c.1895)*
Cézanne's landscapes of this period were solidly built from planes of colour, but 'modulation' was always Cézanne's keyword and he worked patches of subtle earth hues coherently alongside stronger tones of green and blue for a supremely imaginative evocation of his native countryside

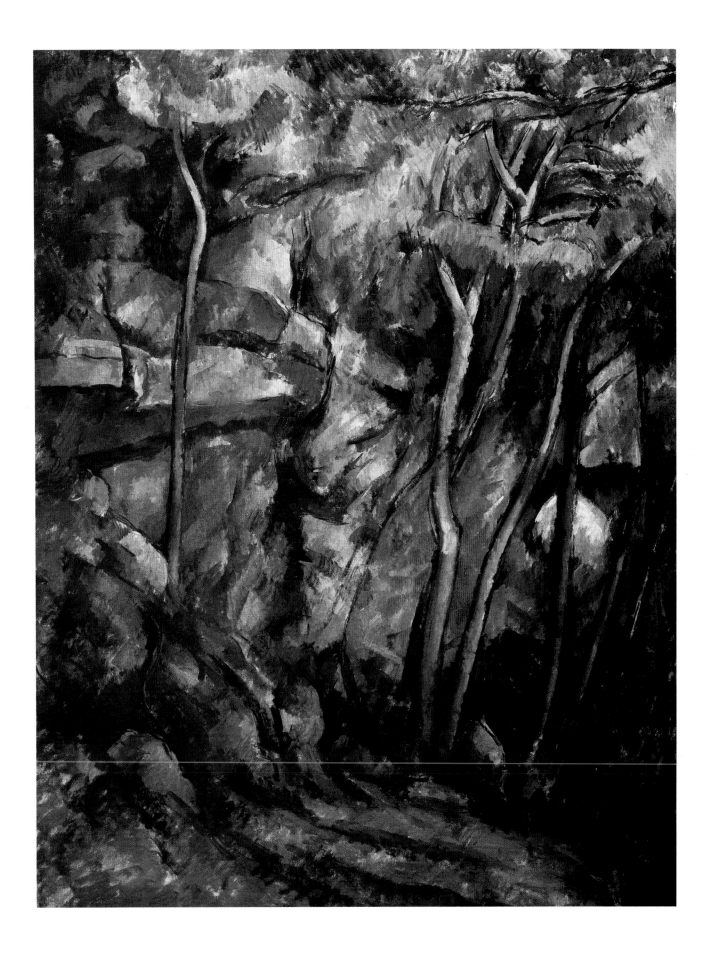

JEAN-BAPTISTE-SIMEON CHARDIN

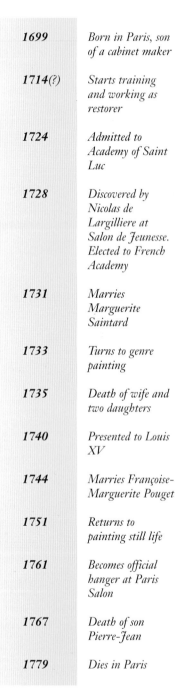

1699	*Born in Paris, son of a cabinet maker*
1714(?)	*Starts training and working as restorer*
1724	*Admitted to Academy of Saint Luc*
1728	*Discovered by Nicolas de Largilliere at Salon de Jeunesse. Elected to French Academy*
1731	*Marries Marguerite Saintard*
1733	*Turns to genre painting*
1735	*Death of wife and two daughters*
1740	*Presented to Louis XV*
1744	*Marries Françoise-Marguerite Pouget*
1751	*Returns to painting still life*
1761	*Becomes official hanger at Paris Salon*
1767	*Death of son Pierre-Jean*
1779	*Dies in Paris*

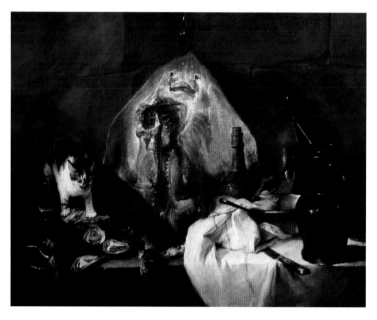

The Ray *(1728)*
One of the pair (the other was Le Buffet*) that Chardin submitted to the French Academy when Nicolas de Largillière first discovered him among other young hopefuls, at the Salon de Jeunesse. People had mistaken the canvases for Flemish still lifes and they were considered good enough to go forward immediately as Chardin's diploma pieces*

Chardin was the least ostentatious of eighteenth-century French painters but is often cited, with **Watteau**, as the greatest. Later admirers of his domestic scenes were **Courbet**, **Van Gogh** and **Cezanne**.

There is no hint of Rococo gaiety in Chardin's pictures, despite the exhuberance shown by other artists of his day such as **Boucher** and Lancret.

To begin with, he produced still-lifes of animals and fruit, similar to the pair that won him his place at the French Academy. Then came his genre period, with a nod to the Dutch school but none of the heavy humour.

For eight years, the activities of Chardin's own petit bourgeois household were his focus, and made their way onto the walls of wealthy art lovers all over Europe. He had an instinct for telling the exact moment when a look or gesture could be crystallized for posterity. Together with that gift, he had evolved a special technique, using thick layers of pigment and thin, luminous glazes to produce just the right textures and play of light.

Chardin's handling of tonal values were impressive enough, but the writer Diderot called him 'the great sorceror' because his pictures offered so much more. Without preaching or false sentiment, he taps into a consciousness beyond outward appearances.

The Young Artist *(1738)*
Chardin's own son, Pierre-Jean, around the age of seven. Dressed in a blue working apron, he is pictured with a stick of white chalk in a holder, studying a drawing in front of him. Pierre-Jean did in fact grow up to be an artist and was living in Venice in 1767 when he died in mysterious circumstances

GIOVANNI CIMABUE

1245(?)	*Born Cenni di Peppo in Florence*
1272	*Active in Rome*
1277–81	*Active in Florence and Assisi*
1301–02	*Active in Pisa*
1302	*Dies in Pisa*

The Santa Croce Crucifix *(c.1272)*
The crucifixion of Christ was a major theme for Cimabue and he is believed to have painted the subject several times. The pathos of this graceful figure is echoed by the grief of the mourners in the panels on either side. Severely damaged by the Arno flood in 1966, the crucifix has since been restored

Giovanni Cimabue, a Florentine painter and mosaicist, was a forerunner of the Renaissance. There are few recorded details of his life, but he did travel to Rome in 1272, where political and religious reform was in the air under the new pope, Gregory X. Gregory was a man of large ideas. He called for a General Council in Lyons, which turned out to be a high-water mark of the Middle Ages.

There in Rome, Cimabue discovered that even the artists were eager for change. Muralists were exploring ways of bringing more realism into their work. There was a strong desire to move away from the traditional flatness of Byzantine art and Cimabue sympathized.

One of his principal works is the set of frescoes that he and his pupils painted for the church of St Francis at Assisi, between 1277 and 1281; another is his apse mosaic in Pisa Cathedral, depicting St John the Evangelist and completed in 1302. While remaining faithful to the Byzantine tradition, Cimabue contrived to give forms a new dimension, acknowledging space and distance.

So the master paved the way for his most famous pupil, **Giotto**. It is said that they met one day on the Bologna road. Giotto was a shepherd boy, scratching the picture of a sheep onto a rock and, recognizing his talent, Cimabue invited him to become his apprentice in Florence.

The Santa Trinita Madonna *(c.1280)*
*Cimabue's pioneering design softened Byzantine monumentality and converted
it to more earthly dimensions. Although the folds of the Virgin's cloak are still
defined with gold lines, the drapery hangs quite naturally; and the faces have
exchanged the formality of icons for a new warmth of expression*

CLAUDE LORRAINE

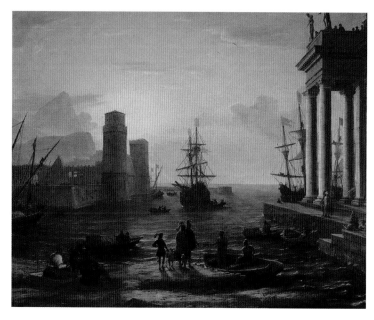

View of Seaport with Mist Effect (*c.1630*)
A typical Claude seaport view, with tall buildings flanking the composition and light flooding the whole scene from a point just above the horizon. This picture also illustrates how depth is achieved by looking towards the hazy horizon through a gradual fading of sharp outline and strong colour

Claude Lorraine's chief contribution to classical landscape painting was his masterly treatment of light. Although not formally educated, Claude knew the stories that provided his themes from mythology and the Bible. He would adapt the settings – pastoral or coastal – for an opportunity to exploit light and atmosphere or perhaps stretch to a broad horizon. But always, the basic inspiration was the Campagna, the stretch of low-lying countryside around Rome, steeped in antiquity.

Tassi, Claude's early teacher, gave him lessons in perspective and composition, figures and animals. Claude then progressed to paint seaports and, from around 1640, to monumental landscapes with rivers winding through tall trees. A decade later, his work became still more epic; rather solemn and mysterious and painted on large canvases with a cooler palette.

Claude's patrons generally came from the French or Italian aristocracy. He painted rapidly from necessity, but never neglected a thorough preparation through drawing, especially from nature. Sometimes he painted outdoors, to observe sunrise and sunset at first hand.

Claude and **Poussin** dominated the seventeenth century in this genre and spawned many imitators. In 1635, to keep track of his output and guard against forgery, Claude began recording his commissions in a sketchbook called the *Libra Veritatis*, the 'book of truth'. Financially secure, he led a quiet life and tutored only two students. His works went on to inspire generations of artists, like **Watteau**, Wilson, **Turner** and **Cole**; nor should we overlook his enduring influence on eighteenth- and nineteenth-century English landscape gardeners.

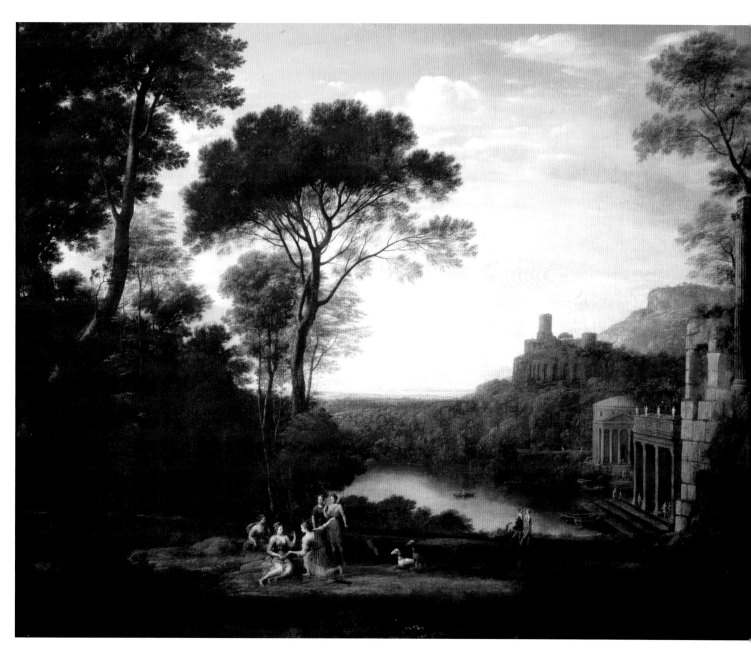

Landscape with the Nymph Egeria *(1669)*
One of Claude's later and largest canvases shows Egeria
in mourning for her dead husband, the king of Rome. Themes of grief and
consolation are echoed throughout a tightly organized colour scheme,
modulating from dark to light. The stock elements of a Claude landscape are
unified by a soft light streaming towards the viewer, whose eyes are gently
guided around a series of small, poetic vignettes

THOMAS COLE

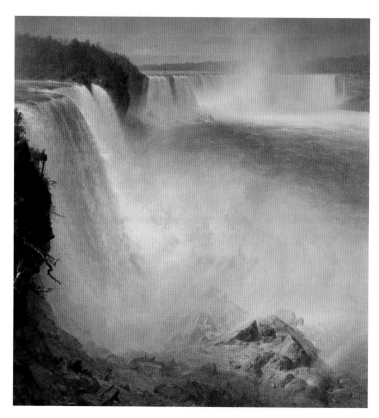

Niagara Falls *(1867) by* Frederick Church
Master of panoramic landscapes, Church was the only pupil of Cole and responsible for some wonderful images of pre-industrial America, in the Romantic tradition. His Niagara Falls *renders this most spectacular phenomenon with a typically inspired and accomplished handling of light, space and water*

With no formal training, the founder of the influential Hudson River School, Thomas Cole, learned the basics of oil painting from an itinerant portraitist in Ohio. He followed that with a self-taught drawing programme that would serve to underpin all his landscape work.

Cole's progress to full recognition was rapid. His paintings resulting from his first trip up the Hudson to the Catskill Mountains earned an enthusiastic reception in New York. By 1829, when Cole visited Europe, he was regarded as America's leading painter of awe-inspiring scenery, single-handedly responsible for introducing the notion of the Romantic landscape. As one who had grown up in a manufacturing environment, Cole was very sensitive to the effects of industrialization and dangers of city sprawl.

Cole returned to America with ambitious plans for a history-style allegorical series, entitled *The Course of Empire*. However, his patrons preferred his views of American nature, which they revered almost as religious images.

After another trip to Europe in 1841–2, Cole adopted the prodigiously talented Frederick Church (1826–1900) as his pupil. Following Cole's startlingly early death in 1848, Church showed himself well able to carry on the Hudson River tradition. Like Cole, he prepared

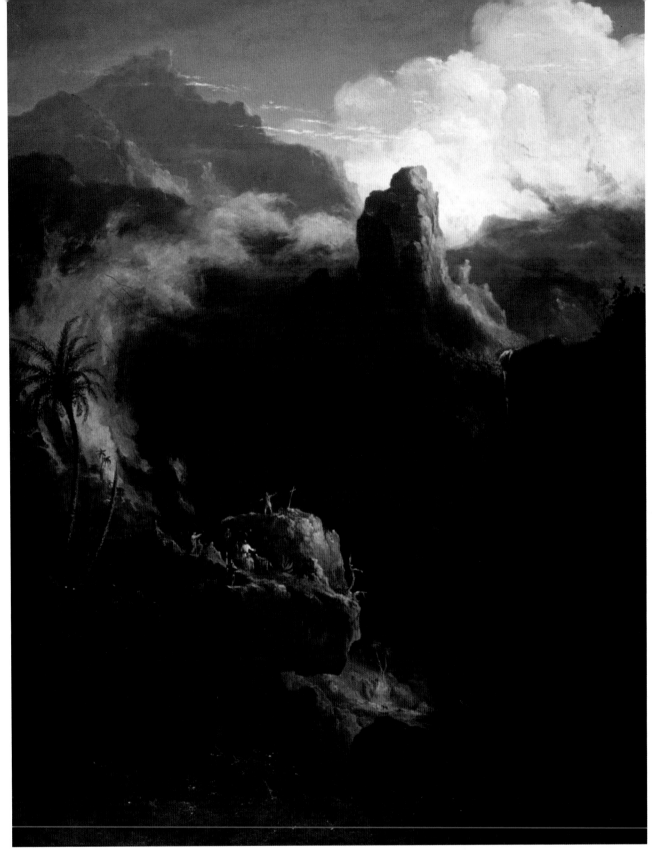

for his studio works with hiking and sketching expeditions. A brilliant draftsman and colourist, he took himself much further than his teacher; to exotic locations in South America where he found a veritable paradise, and once on a long trip right around the shores of the Mediterranean Sea.

St John the Baptist in the Wilderness *(detail) (1827)* by Thomas Cole
Painted in New York, between Cole's historic trip up river and his first visit to Europe, this demonstrates the Hudson River School's treatment of the awesome American wilderness. It not only fed the wonder of travellers, with its soaring mountains and plunging waterfalls, but also stirred their souls in contemplation of 'God in Nature'

JOHN CONSTABLE

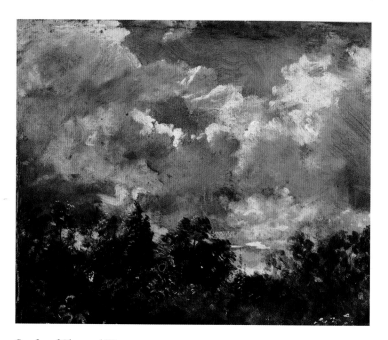

Study of Sky and Trees
For Constable, 'skying' meant making small oil studies of clouds, with full notes written on the back. Typically, he covered red primer in thick strokes and overlapping colours, which gave depth to the cloud formation. They were not necessarily part of any larger composition, but recorded the reality of weather, light and colour in a particular patch of sky

John Constable based his paintings on sketches done outdoors, directly from nature. As a student he had dutifully copied the landscapes of Van Ruisdael and other masters but – although he admired them greatly – he refused to create work in the same style, saying, 'It would be dishonest to wear Claude's coat and call it mine.'

Constable's method depended on using 'divided tones' (pure colours juxtaposed to recreate the vibrancy of external light) laid on with rapid brushstrokes. Such a daringly original approach was criticized by the English Academy but acclaimed by the French. It was Paris that gave Constable due recognition – and a gold medal – when *The Haywain* was exhibited in 1824. **Delacroix** and **Gericault** became instant devotees of his Romantic naturalism.

The Haywain came from Constable's London studio, where he had lived since his marriage in 1816. All the pictures that he painted there relied on skillful preparation from full-size sketches, and many of the canvases were 'six-footers'. Only when Constable had pieced together a sketch in sufficient detail to refresh his memory, was he prepared to begin work.

Sadly, few bought Constable's work in his lifetime, forcing him to rely on the generosity of others. His long-awaited admission to the Royal Academy came in 1829, after years of failure to acknowledge his dedication to interpreting the mutability of landscape; and just when large swathes of it were being swallowed up by the industrial revolution.

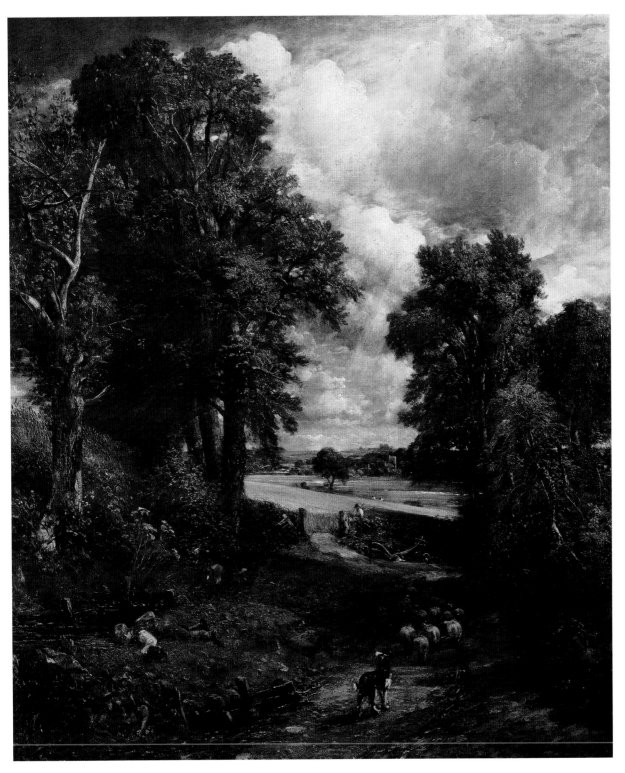

The Cornfield *(1826)*
The inhabited landscape was Constable's constant and most intimate theme.
The lane to the cornfield is the same one the artist followed to school; this is the
Suffolk that he carried in his heart all his life. The Cornfield *traces several*
points in time and space. The vertical format steers the viewer's gaze, from the
boy at the stream, to the man reaping the corn and finally, to the church tower
among the trees. The Romantic poet Wordsworth subscribed to the fund that
purchased this picture for the English National Gallery

JEAN-BAPTISTE-CAMILLE COROT

1796	*Born in Paris, son of a draper and a milliner*
1822	*Quits as draper's apprentice to study art under Bertin*
1825–28	*First visit to Rome, via Switzerland*
1828–34	*Travels round France*
1833	*Wins medal at Salon*
1834 and 1843	*Revisits Italy*
1847	*Awarded Legion of Honour*
1848 and 1849	*Meets Theodore Rousseau. Elected member of Salon jury*
1850	*Meets Millet*
1854	*Visits Belgium and Holland*
1862	*Meets Courbet. Visits England*
1875	*Dies in Paris*

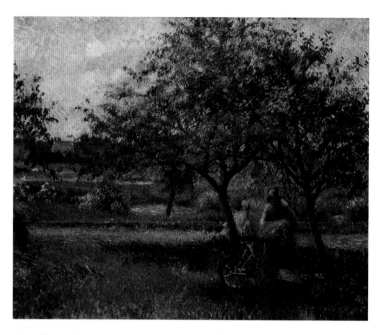

The Wheelbarrow *(1881)* by Camille Pissarro
Like Millet and Daumier, Pissarro shared a profound respect for working people; more than that, he was involved in socialist politics. Although he knew hardship himself, manual work is never portrayed as harsh or demeaning: 'Work is a wonderful regulator of mind and body. I forget all sorrow, grief, bitterness and I even ignore them altogether in the joy of working.' Here a woman pauses with an armful of straw under what suggests a triumphal arch, formed by the apple trees

The works of Camille Corot harmonize with those of his nineteenth-century French contemporaries, rather like the man himself, who was a kind and generous friend to many. Yet his art does not belong to any single category, despite his later acquaintance with the Barbizon School. Originally attracted by watercolourist Bonington's lightness of touch, Corot recognized the possibilities of landscape painting, and that they were too often ignored in favour of a standard classical interpretation.

After his first visit to Italy, which was to prove so crucial to his development, Corot produced rich tonal work that acknowledged the traditions of **Poussin** and **Claude** and borrowed elements of Romanticism. It led to success in the Salons and even influenced **Cézanne** and the post-Impressionists. From the 1850s onwards, Corot began to paint using as many as twenty tones very close to one another, resulting in a delicate silvery look that made trees look particularly attractive. Corot was greatly admired by the Impressionists, and Berthe **Morisot** became one of his pupils during the 1860s.

Camille **Pissarro** (1831–1903) was born in the West Indies and arrived in Paris in 1855. He met Monet at the Academie Suisse, and was influenced, like most young painters, by Corot and **Courbet**. Corot's key advice to him was to 'study light and tonal values: execution and colour simply add charm'. Pissarro showed at all eight Impressionist exhibitions and became a valued mentor to Cezanne and **Gauguin**. As well as teaching, he was always eager to learn new techniques, such as **Seurat's** *pointillism*.

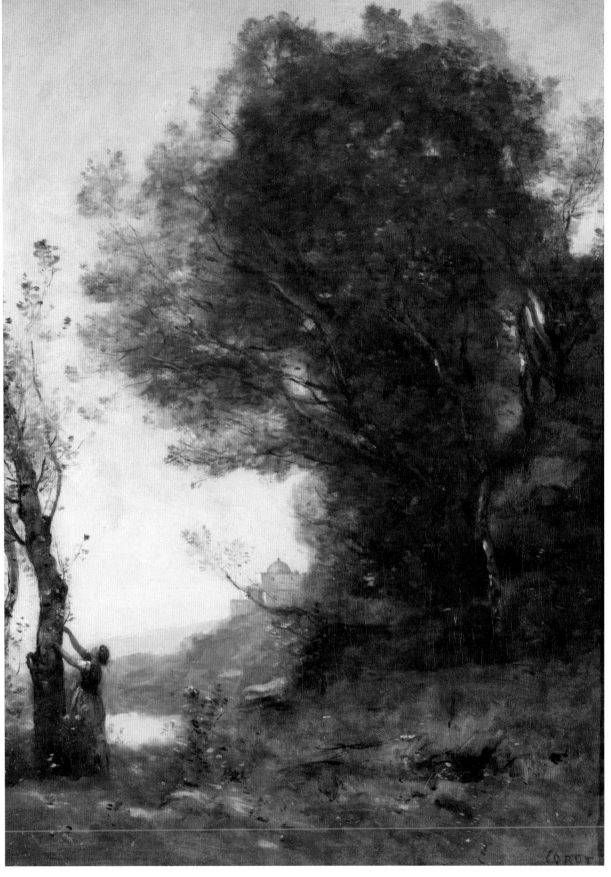

Apple Picking in Ariccia *(c.1867)* by Camille Corot
*One of Corot's silvery landscapes, in which he captures a fleeting moment
of light and movement with such delicacy that his apple picker could
almost be taken for one of the nymphs in a Claude scenario. Her hazy
presence here scarcely hints at Corot's later showing as a compelling
painter of portraits and studies of women*

JOHN SELL COTMAN

The Marl Pit (*c.1809–10*)
Around 1804, Cotman's style evolved to the use of flat zones of translucent colour and dramatic light and shade, and he combined these two elements to create his distinctive visual patterns. This development most probably came about through his association with John Varley, a fellow member of the London Sketching Society

Looking back at the age of sixty, John Sell Cotman said, 'I never knew the time when I was not fond of drawing, and have heard my mother say I drew long before I could speak.' These words confirm what we know of Cotman: the popular teacher set up a circulating library of over 1000 images for students to practise from, and his talent for line illustration extended to fine printmaking, catering to the taste for European culture acquired by those who had made the Grand Tour.

However, Cotman is best known as one of the essentially English, Norwich School of landscape painters, which he and 'Old' John Crome led from 1803. They drew inspiration from Dutch paintings of flat land and big skies, which evoked their own Norfolk countryside.

Cotman's basic technique – including painting outdoors with a limited palette – was learned in his teens at the open studio of **Girtin**, whose brief career profoundly influenced all British watercolourists. Cotman showed a very precise control in the way he 'held out' his white areas, rather than washing colour over all and scraping or sponging back to the white paper at a later stage. His choice of particular viewpoints, high and low, gave scope for his use of abstract patterning in areas of shade and reflection. This, and his characteristic broad washes, were compared at the time to the emerging works of China and Japan and quite startlingly prefigure the modernists.

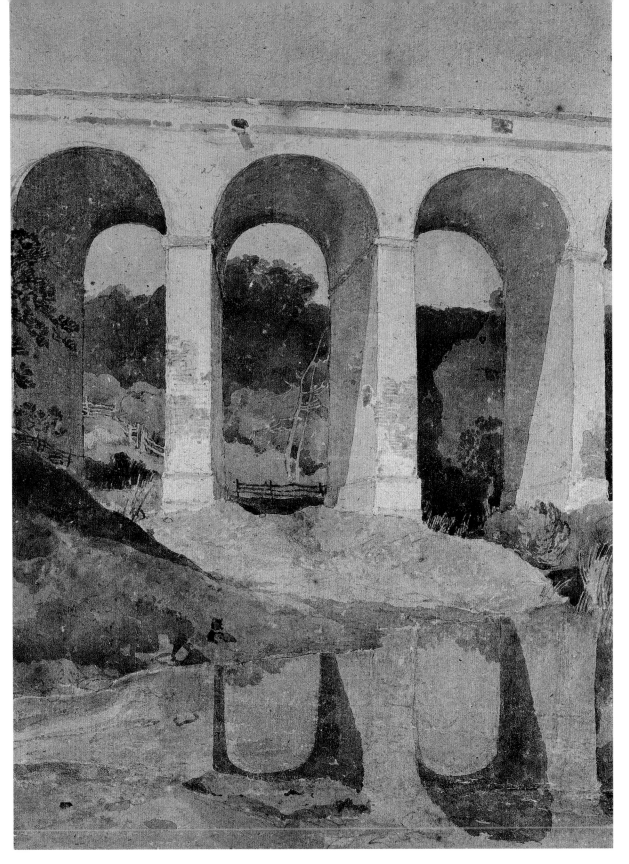

The Chirk Aqueduct *(c.1810)*
The monumentality of this Welsh aqueduct is accentuated in the dramatic cropping; its arches are doubly emphasized by the low viewpoint, mirrored in the water. It is likely that the image was made with the aid of the camera lucida – *a prism that projected an image onto a flat sheet of drawing paper – as the brother of Cotman's friend, John Varley, had recently developed a telescopic version. Both devices require considerable skill to use*

GUSTAVE COURBET

1819	*Born in Ornans, son of a farmer*
1841	*Studies law in Paris but changes to painting*
1844	*Self-portrait accepted by Paris Salon*
1847	*Lover Virginia Binet bears him a son*
1848	*Paris revolution, abdication of Louis Philippe*
1853	*Meets patron Alfred Bruyas*
1855	*Stages exhibition in Pavilion of Realism, Paris*
1856–69	*Travels Europe*
1870	*Active Republican after defeat of Napoléon III*
1871	*Imprisoned for six months, fined for revolutionary activities with Paris Commune*
1872	*Death of son*
1873	*Flees to exile in Switzerland*
1877	*Dies of dropsy in La Tour-de-Peilz*

The Painter's Studio *(detail) (1855)*
These figures appear at the centre of a huge canvas measuring 12 x 20 feet. Although he had studied large-scale pictures in the Louvre (Courbet was mostly self-taught), this composition is very simple; yet certain aspects echo his admiration for Rembrandt and Velazquez. Many other figures crowd in on either side of the full picture, which Courbet described as 'the moral and physical history of my studio'

Gustave Courbet reached his peak as a Realist painter in the 1850s. Realism was regarded as dangerous by the French Academy who disliked anything painted in a spontaneous, uncontrived manner. In those days, Courbet's battle for artistic freedom was totally consistent with his politics, which were socialist and anarchic. He fought any organization, having already grasped the implications of the shift from an agrarian to an industrialized society: 'I must be free even of governments. The people have my sympathies, I must address them directly.'

Courbet took from the Romantic movement a feeling of total emotional involvement, but he discarded the central role of the individual, believing truth and dignity were located in the community and reality of everyday life.

Peasants Returning to Flagey from Market *(1850)*
*One of three Realist pictures that made Courbet's name at the 1850–51
Paris Salon. The other two were* The Stonebreakers, *and his first
monumental canvas* Burial at Ornans. *All three paintings shocked the public
because ordinary villagers were presented in a style that ranked them with
their 'betters'. Opinionated and provocative as ever, Courbet was putting art
at the service of social revolution*

When the jury for the 1855 Paris Universal Exhibition rejected Courbet's *The Painter's Studio*, people ridiculed him for having set up his own show in a 'Pavilion of Realism'. However, one of his few supporters, **Delacroix**, publically declared: 'They have rejected one of the most outstanding paintings of the times.'

By giving 'things as they are' the monumental treatment normally accorded to mythological or historical themes, Courbet set out to demolish the traditional hierarchies of subject matter and increase the emphasis on purely formal values. He felt the actual canvas and paint were as much his subject matter as the scene he depicted. Such ideas were well ahead of their time and Courbet's declaration of creative independence opened a door for **Manet** and the Impressionists.

LUCAS CRANACH THE ELDER

1472	*Born Lucas Sunder in Kronach, son of a painter*
1500– 1503	*Moves to Vienna, in association with new university*
1504– 1550	*To Wittenberg as Court painter to Frederick III, Elector of Saxony. Meets and works for Martin Luther, also becomes city councillor in 1537. His large workshop employs sons Hans and Lucas*
1508	*Visits the Netherlands*
1519	*Elected to Wittenberg town council*
1520	*Acquires apothecary's shop with printer's patent*
1537 and 1540	*Serves as Burgomaster*
1550	*To Augsburg with exiled Elector John Frederick.*
1553	*Dies in Weimar*

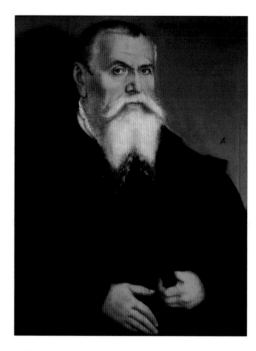

Self-Portrait *(detail) (1550)*
This self-portrait, made towards the end of Cranach's life, shows a typical, prosperous burgomaster but gives no hint of his sensitive work, and adventures, as a diplomat. Cranach also headed a thriving workshop, which he passed on to his son and pupil, Lucas the Younger

Details of Lucas Cranach's youth are obscure but it is possible that he and **Grunewald** studied under the same master. When Cranach moved to Vienna in 1502, he produced two fine portraits, one of the Rector of Vienna University and the other of the wife of the Professor of Law. He also painted his earliest religious subject, *The Rest on the Flight into Egypt*, in the style of the Danube School.

Cranach had clearly established his reputation when in 1505 he was invited to Wittenberg as Court painter and diplomatic agent to Frederick the Wise. His association with the Electors of Saxony would continue for almost 50 years, during which time he created a picture archive of the Elector's entire family and other prominent figures, both Catholic and Protestant.

In Wittenberg, Cranach became a close friend of Martin Luther and designed woodcut illustrations for the first New Testament in the German language. The Reformation signalled a new era in mass communications with the coming of the printing press promoting the rapid circulation of ideas. Artists like Cranach and **Dürer** soon discovered that the mechanical reproduction of their pictures afforded them an extra – and very lucrative – outlet to a wider audience.

Cupid Complaining to Venus *(c.1530)*
Cranach developed the genre of the erotic nude for a select band of private collectors. Generally named after nymphs or goddesses – for an element of respectability – transparent drapery, elaborate hats and jewels only seem to emphasize their nakedness. The slender, Mannerist outline of the body suggests that Cranach worked not from a live model but from stylized engravings

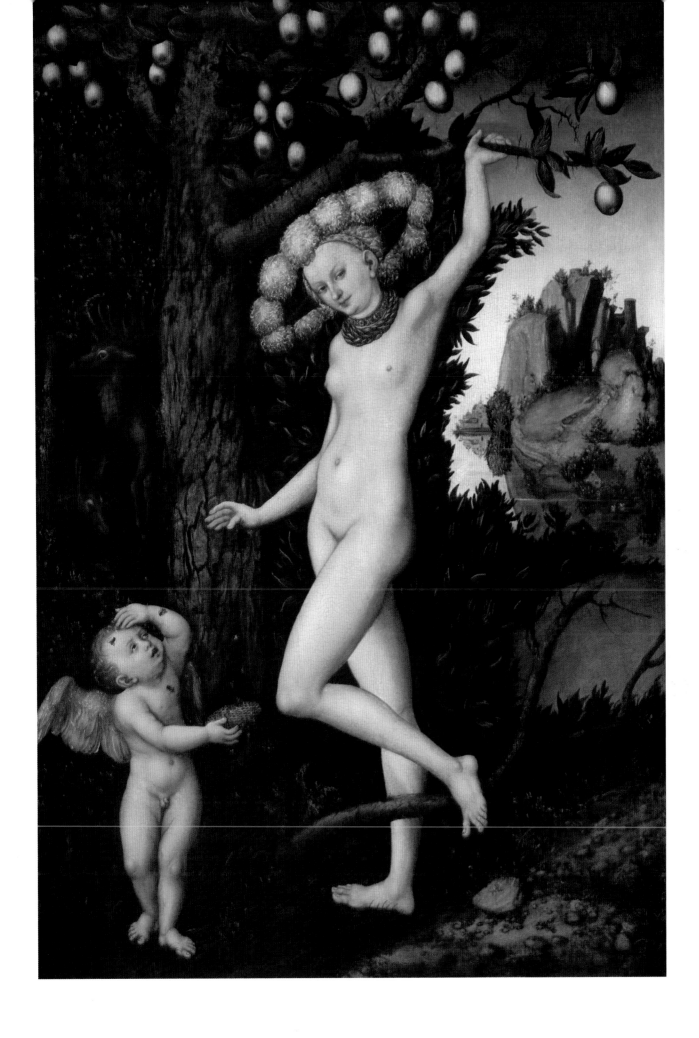

SALVADOR DALI

1904	*Born in Figueras, son of a notary*
1921–23	*Studies painting and drawing at L'École des Beaux Arts, Madrid*
1925	*First one-man show in Barcelona*
1928	*Moves to Paris. Writes screenplay for Buñuel's* Un Chien Andalou *and joins Surrealists*
1934	*Civil marriage to Gala (Helena Deluvina Diakinoff)*
1939	*Declares support for Franco, breaks with Surrealists. Settles in USA, becomes Roman Catholic*
1941	*First retrospective at Museum of Modern Art, New York*
1948	*Returns to Spain*
1974	*Opens Teatro Museo Dali in Figueras*
1982	*Death of Gala*
1989	*Dies of heart failure in Figueras*

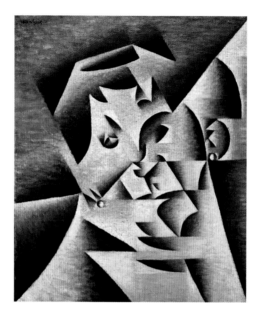

Head (*c.1912*) by Juan Gris
In the early 'analytic' phase of Cubism, Gris' palette was coolly limited. Around 1912, his tones grew richer and he used russet browns and creamy whites. In addition, he would stipple the surface in certain areas, all of which marked his movement towards Cubism's 'synthetic' phase

Salvador Dali was an irrepressible self-publicist and the cultivator of the art world's most famous moustache. The technical brilliance with which he could paint and draw gave him equal facility for reproducing various styles, from Realism, Impressionism and Cubism to the *Metafisica* of the Italians de Chirico and Carra. His versatility and skills also extended to sculpture and film-making.

The screenplay he wrote for Buñuel's *Un Chien Andalou* admitted Dali to the Surrealists' group when he moved to Paris in 1928. This coincided with his discovery of Freud's theory of the unconscious; reading *The Interpretation of Dreams* led to Dali's emphasis on dream imagery and his 'paranoiac-critical' method.

However, the artist's right-wing political views caused an eventual split with the Surrealists. As war loomed in 1939, he and Gala left Europe for America, returning to Spain in 1948. Dali's fame was always controversial, thanks to his provocative exhibitionism as much as to the media. Yet in his own lifetime, his popularity supported two museums dedicated exclusively to his works.

Dali's introduction to Cubism and the art of collage came about through a fellow Spaniard Juan Gris (1887–1927). He was the most able practitioner of Cubism and evolved an individual approach through meticulous grid drawings (he had originally studied engineering). On arriving in Paris in 1906, he settled among **Picasso**'s circle in Montmartre, which included Apollinaire, and was championed by the writer Gertrude Stein. In later years, Diaghilev commissioned him to design for the Ballets Russes. Unfortunately, Gris suffered chronic depression and physical illness, which brought about his early death.

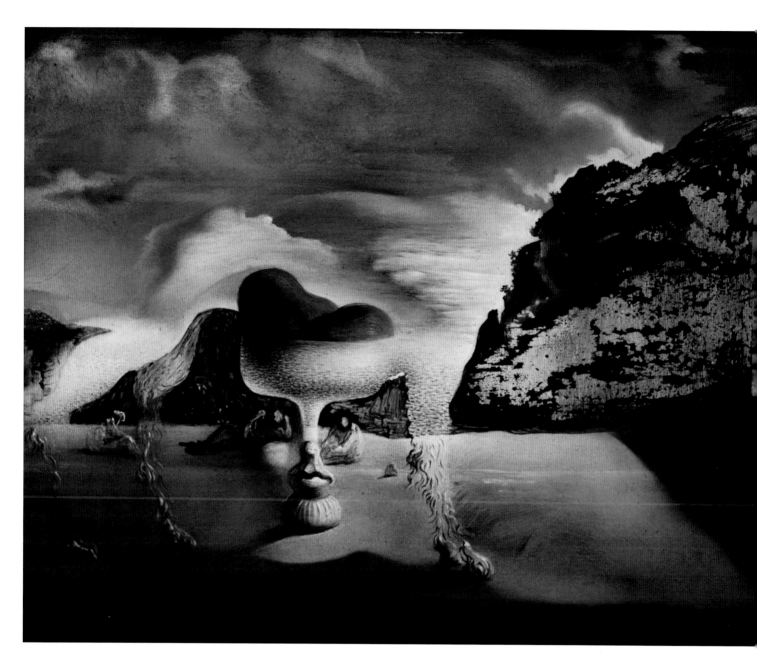

**Invisible Afghan with Apparition on Beach of Face of Garcia in
Form of Fruit Dish with Three Figs** *(1938)* by Salvador Dali
*The 'paranoiac-critical' method used in Dali's 'hand-painted dream
photographs' involved perceiving more than one image in a configuration. The
dominant image here is the face constructed from an urn and two men's heads;
the figs are formed by the rocks beyond; and the outline of the Afghan hound
takes shape through windswept clouds, its head resting on the cliffs and its paws
on the sand. Dali's friend, the poet Lorca, had been killed in the Spanish Civil
War in 1936 and this may explain his 'apparition'*

JACQUES-LOUIS DAVID

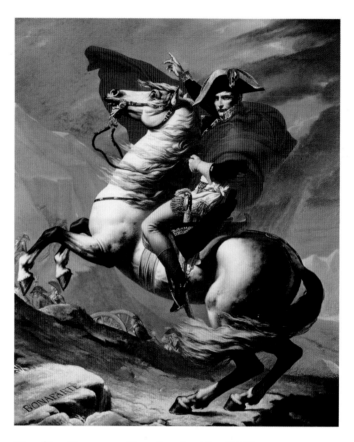

Napoléon Bonaparte Crossing the Alps *(1801)*
This lively propaganda portrait was copied no fewer than four times by David and his studio. The message suggested is that if Napoléon can attack the Alps with such vigour, then he will stop at nothing

When Jacques-Louis David came back to France from Italy in 1780, he returned with strong ideals based on the supposed virtues of ancient Rome. He was committed to Neo-classicism, which demanded that artists should take their subjects and style from antique models, as Poussin had 150 years previously. The French responded by electing David to both the Academy and the Salon. His highly finished line, colour and composition were greatly admired. More than that, his style was perceived as revolutionary, matching the country's mood for an end to aristocratic corruption and a return to the stern, patriotic morals of republican Rome.

Upon joining the revolutionary Convention, David voted for Louis XVI's execution. But on the death of Robespierre and the end of the Reign of Terror, he was gaoled and might have been executed too, had his royalist wife not intervened with the new 'Emperor', Napoléon Bonaparte.

David became a devoted follower of Napoléon. He found himself at the height of his influence and gained a knighthood in the new Legion of Honour.

Exiled to Brussels after Napoléon's fall from power in 1816, David – an outstanding teacher – continued to train young painters, including **Ingres**. He was the virtual art dictator of France for a generation; his influence spread to fashion, furniture design and interiors, and found echoes in the development of moral philosophy.

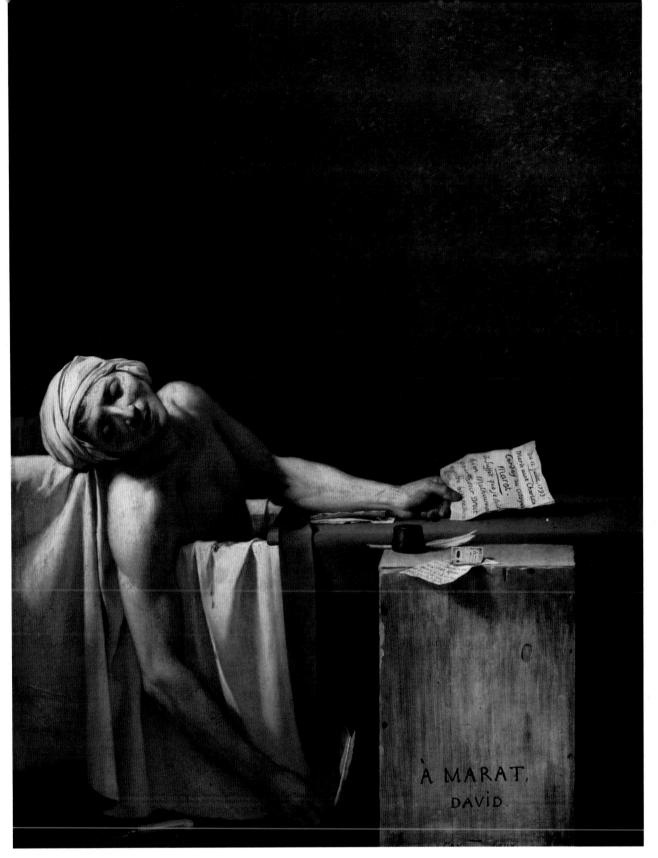

The Death of Marat *(detail) (1793)*
This is David's greatest work and a supreme example of political painting. The radical revolutionary Marat is shown just after Charlotte Corday – a Girondist – has tricked her way in, with the note that he is still holding, and stabbed him in his bath. The immense dark space above Marat's head emphasizes the void that he has left, both in the Jacobin cause and in the life of his friend David. The Death of Marat *has often been compared with Michelangelo's* Pieta; *it is an image of secular martyrdom*

EDGAR DEGAS

1834	*Born in Paris, son of a banker*
1847	*Death of mother*
1853	*Gives up law. Studies drawing with Lamothe, attends studio of Barrias*
1854–59	*Makes several trips to Italy studying and painting*
1865	*Paris Salon debut*
1872–73	*Travels with brother René to New York and New Orleans*
1874	*Helps organize first Impressionist exhibition*
1876–86	*Takes part in subsequent Impressionist exhibitions, bar 1882*
1880	*Visits Spain. Etching with Pissarro and Cassatt*
1881	*Exhibits first sculpture of dancer*
1895	*Takes up photography*
1909–11	*Ceases work due to failing eyesight*
1917	*Dies in Paris*

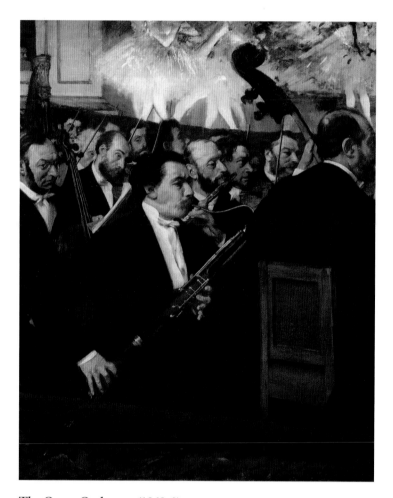

The Opera Orchestra *(1868–9)*
The first of a series of canvases featuring orchestral musicians, this is a portrait of Degas' friend Désiré Dihau, democratically placed among other members of the orchestra just below a bright frieze of dancers in the stage footlights. The work is relatively early and hints at Ingres and Delacroix, both admired by Degas. Degas and Delacroix had a scientific interest in colour theory and pigments

Edgar Degas' personal wealth gave him freedom to devote himself to art. He shunned formal training, preferring to study the Renaissance through frequent trips to Italy and – on his own doorstep – copying in the Louvre. There in 1862, he and **Manet** met in front of a Velazquez. Degas, who never ceased investigating every technical aspect of painting and drawing, had spent three years on the basics of light and colour. Manet may or may not have suggested a new approach to him but, at any rate, he did introduce Degas to the future Impressionists. Degas exhibited with them right from the start in 1874, although he never wholly accepted their doctrines or techniques for himself. He only signed his works when he sold or exhibited them, thus controlling their number and value in the marketplace.

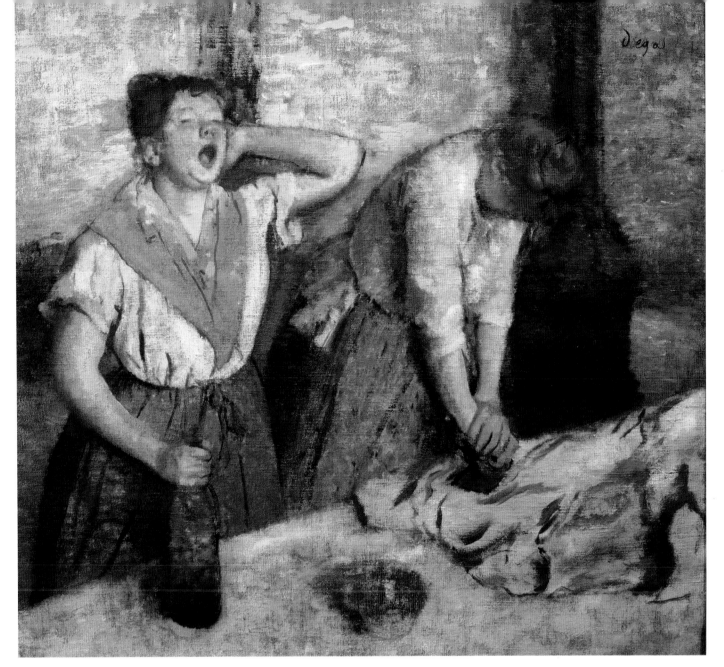

The Laundresses *(c.1884)*
*Nothing could be much further from the glamour of the Opera than the toil
of two weary laundresses, but the strong diagonal of the ironing table is
reminiscent of the edge of the stage. His other inspiration for this picture
was the realism of Daumier's portrayal of working life. Degas counted
almost 2000 Daumier prints among his private art collection*

His subjects come from his own background: the high-born fraternity of the racecourse and opera house; ballet rehearsals attended as a privileged visitor; and the nudes seemingly observed, as he said himself, 'through the keyhole'. Degas was also captivated by Japanese prints, which inspired him to experiment with oblique and unusual perspectives.

Unfortunately, Degas' caustic wit lost him many friends and he came to a solitary old age. Yet his biggest problem was always his failing eyesight. Perhaps that was why he took up photography at the age of 61, the camera being effectively a new pair of eyes. His expert venture into pastels was another attempt to work around the problem. But his last resort was to make small wax sculptures of dancers and horses: '...one sees no longer except in memory.'

EUGENE DELACROIX

Women of Algiers (detail) (1834)
In 1832, Delacroix was among the retinue attending the French Ambassador's visit to the Sultan of Morocco, and he frequently drew upon the experience for inspiration. This detail demonstrates the technique adopted by Delacroix, since observing Constable's use of 'divided colour' and its vibrant effects

Eugene Delacroix prided himself on the speed at which he could work: 'skilful enough to sketch a man falling out of a window during the time it takes him to get…to the ground.' And not only did he paint, he loved music, read widely, and wrote fascinating letters and journals about his life and times.

Delacroix studied with **Géricault** under Guerin and subsequently posed for his friend as the prone figure on the *Raft of the Medusa*. The picture provided impetus to Delacroix's own creativity but he never accepted the Romantic label, obstinately insisting that he was 'a pure classicist'. He greatly admired and copied **Michelangelo**, **Veronese** and **Rubens** in the Louvre, and always made very careful preparatory drawings.

Liberty Leading the People is Delacroix's political masterpiece, an allegory painted in the wake of the 1830 Paris revolution. He included

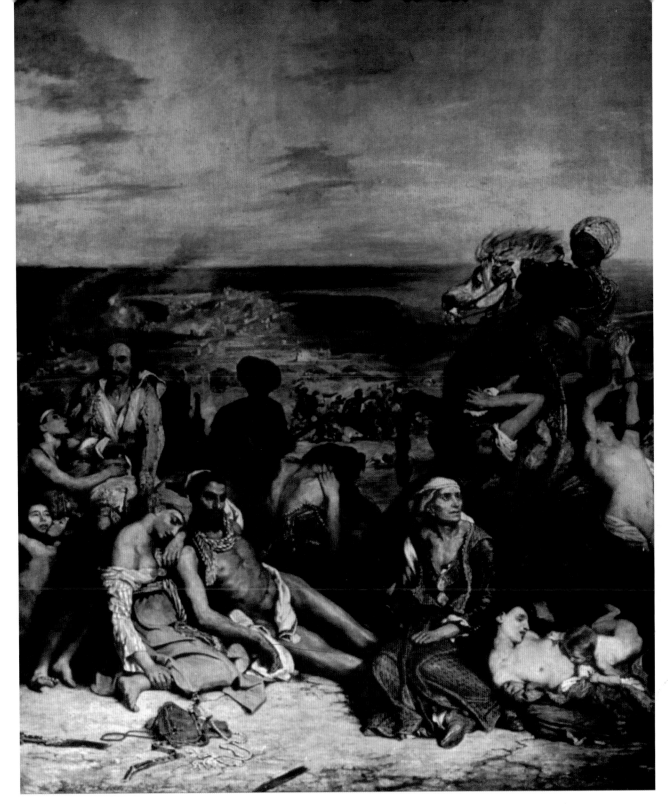

himself beside the iconic Liberty figure as the armed man in the top hat.

Delacroix had completed the journey from startling, innovative colourist to respected older artist by the time he came to influence modern masters, like **Cézanne**, **Degas**, **Van Gogh** and **Picasso**. As long as he lived he was, as the poet Baudelaire wrote, 'passionately in love with passion, and coldly determined to seek the means to express passion in the manner visible'.

Massacre at Chios *(1824)*
Inspired by Gericault's treatment of the theme of suffering, Delacroix presents a harrowing scene from the Greek rebellion against the Turks, which roused many Europeans (including Byron) to their cause. The painting was bought at the Salon of 1824 by the French government, perhaps by Talleyrand in covert support of his son. Significantly, at the same Salon, Delacroix encountered Constable's Haywain

DUCCIO DI BUONINSEGNA

A 'Bishop Saint' *from* **Maestà** *(detail) (1308–11)*
The Sienese painters had a remarkable feeling for colour and also immense decorative skill, both in patterning and the application of gold. The contrast between the painting of the bishop's face and his vestments is in the Byzantine style

Duccio di Buoninsegna was the earliest master of the Sienese school. Like **Cimabue** of Florence, he was a Renaissance forerunner, his art marking a transition from Byzantine to Gothic. **Lorenzetti** and **Martini** would build on his legacy by developing the International Gothic style.

Little is actually known about Duccio, though contemporary records reveal he had seven children, occasionally ran into debt, and committed minor civic offences. He was fined once for refusing to swear allegiance to the local militia, and again for refusing to fight in Maremma. Nevertheless, Duccio seems to have had considerable status as owner of a large house and vineyards.

On one glorious occasion in 1311, the entire city stopped work to accompany the *Maestà* in procession through the streets from Duccio's studio to the cathedral, where the bells rang continuously. Ironically enough for the man who would not exchange a paintbrush for a

'Judas' kiss' *and* 'Prayer on the Mount of Olives'
from **Maestà** *(1308–11)*
Duccio's Maestà *was double-sided. The front was the* Maestà *itself, Madonna and Child enthroned, with crowning panels above and a predella (the base on which the altar stands) below. The reverse contained 26 episodes from the Passion of Christ, originally for the eyes of the clergy alone. The episodes read like a poetic graphic novel, and demonstrate the narrative powers associated with the Sienese school, and Duccio in particular. The* Maestà *was dismantled in 1771, to be rearranged on two separate altars. Damage was inevitable, some panels were sold abroad and others went missing entirely*

sword, the *Maestà* was painted to celebrate a military victory that had saved Siena from invasion. It had been three years in preparation and subject to a strict contract, stating that the entire piece should be Duccio's own unaided work, and that he should accept no other commission until it was finished.

The two Tuscan cities, Siena and Florence were serious artistic rivals at this time. By the turn of the next century, Florence had eclipsed Siena and the eminence of painters like Duccio was past.

ALBRECHT DÜRER

1471	*Born in Nuremberg, son of a goldsmith*
1486	*Apprenticed to painter and wood-cut illustrator Wohlgemut*
1494	*Marries Agnes Frey of Nuremberg*
1494–95	*Visits Italian Alps and studies Mantegna in Venice*
1498	*Publishes* Apocalypse *series, paints Dresden Altarpiece*
1505–07	*Studies in Venice and Bologna, influenced by Bellini*
1512–19	*In service to Emperor Maximilian I*
1515	*Exchanges works with Raphael*
1518	*Meets Martin Luther in Augsberg*
1520–21	*Tours Netherlands with Agnes, meets Grunewald*
1528	*Dies in Nuremberg*

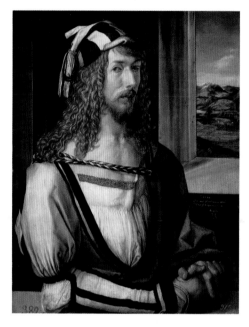

Self-Portrait *(1498)*
The composition of this panel portrait follows the Florentine style. In it, the clothes, hairstyle and distant view of snow-topped mountains all indicate that Dürer considered himself a dignified man of the world, and no mere provincial craftsman

Albrecht Dürer was the foremost artist of the Northern Renaissance. He came from Nuremberg, usefully situated halfway between the Netherlands and Italy, which enabled him to travel with ease in either direction. The notion of 'Renaissance man' appealed to Dürer, whose self-portraits – a new idea in itself – stamped his image on the developing European tradition.

After a visit to Venice in 1494, he remained in Nuremberg for the next ten years, busy producing woodcuts and engravings that marked him as one of the major printmakers of all time. His prints were distributed throughout Europe – bearing his distinctive 'AD' monogram – and his fame was assured wherever he went.

Despite complaining that oil painting took up more time than it was financially worth, Dürer painted numerous altarpieces and portraits. In time, he allied himself to the ideas of the Reformation, and there was a blending of northern realism with the Renaissance vision.

Dürer conserved his works on paper, sometimes dated and even with notes on the subject-matter. His words have survived too, in letters and diaries, and also in the *Course on the Art of Measuring*, one of the first books on the use of mathematics in art, a true Renaissance topic.

Four Horsemen of the Apocalypse *(1498)*
Dürer realized that prints made his art available to the widest possible public and hired an agent to sell them in the fairs and markets of Europe. The Apocalypse *was Dürer's earliest major series, illustrating the* Book of Revelation *with the Scripture on the reverse. His interpretation of the four horsemen – War, Famine, Pestilence and Death – has never been surpassed*

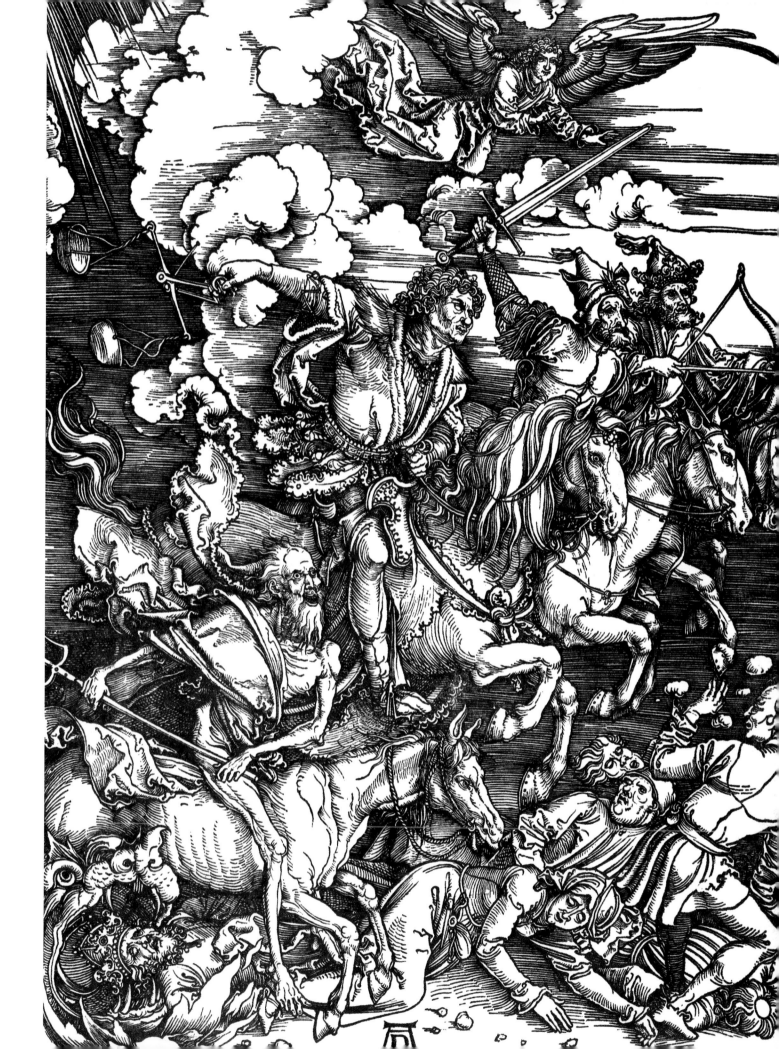

THOMAS EAKINS

The Fairman Rogers Four-in-hand (detail) *(1879)*
The positions of the legs of the four-in-hand are calculated by Eakins from the published set of Muybridge's horse photographs that he owned. Eakins's patron, Fairman Rogers was enthused and invited Muybridge to give some lectures in Philadelphia. Afterwards, the University of Pennsylvania contracted Muybridge to continue his work there

Leading American Realist, Thomas Eakins trained in Europe in the late 1860s but did not venture abroad again. He was intensively occupied for a decade from 1876, teaching at the Pennsylvania Academy of Fine Arts, later becoming overall Director.

Eakins was harshly criticized during his tenure for his innovative teaching methods. He insisted it was best for his students to work from live, nude models; for them to learn anatomy from dissection; and to observe motion by watching athletics. He wanted them to describe reality without the intervention of academic or fashionable formulas. This approach, he believed, led an artist directly to the interior realities of human character. Consequently, a portrait should be penetrating, not flattering, although it should never sacrifice the dignity of the sitter. Eakins paid highly for his revolutionary principles. He was forced to resign from the Academy in 1886 for presenting a completely naked male model to a mixed-gender life class.

From the 1880s, Eakins worked with photography; as inspiration, as an art form, and for tracing projected images onto canvas. Most importantly, he supervised a project for the University of Pennsylvania, devising an improved camera in collaboration with Eadweard Muybridge, who pioneered motion pictures. By means of a revolving disk over the lens, it made several exposures on a single dry plate, thereby recording sequential images of athletes in action.

Eakins's composite plates inspired Duchamp's *Nude Descending a Staircase*.

The Agnew Clinic *(1889)*
This huge picture gave the Pennsylvania University medical students a portrait both of their retiring professor (left) and of themselves as the surgical theatre audience. But the subject of mastectomy was deemed 'not cheerful for ladies to look at' and it was barred from the Pennsylvania Academy show. The work continues to stir debate, chiefly over the sexual implications, which some believe are repressed by its acceptance simply as a document illustrating the (then) modern medical procedures of anaesthesia and antisepsis

CASPAR DAVID FRIEDRICH

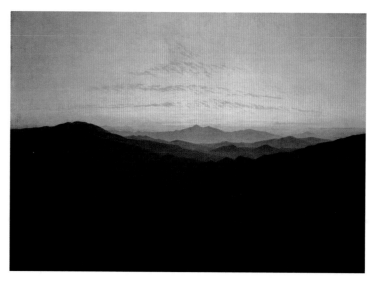

The Riesengebirge *(1830–4)*
Painted during a period of happy stability in his life, Friedrich looks back on a mountain tour he made twenty years earlier and recollects a panorama of tranquillity. Here the sky meets the horizon in a blend of soft yellow and violet, a muted contrast that is echoed in the delicate cloud studies above

Caspar David Friedrich studied painting and natural history in Copenhagen but eventually chose to live in Dresden, whose beautiful surroundings inspired so many of his mystic landscapes. Dresden was also the hub of the Romantic movement in Germany and not only did Friedrich make the acquaintance of painter Philipp Otto Runge, but also met several poets there, including Goethe.

For nine years, he worked only in pencil or sepia, his subjects ranging from seascapes to mountains, often at certain times of day or changes of season. A switch to oil paints boosted his creativity and in 1807 he caused a sensation with *Cross in the Mountains*. Designed for a private chapel, Friedrich's landscape evoked the spirit of the Crucifixion. Shocked by his use of a secular scene to convey a religious message, several critics went as far as accusing him of sacrilege.

Although Friedrich tried both portrait work and architecture, he always returned to landscapes, where he could paint ruined churches and lonely figures in vast spaces, often bathed in a symbolic light. Friedrich suffered a stroke in 1835 and was limited from then onwards to sepia sketches and watercolours. His immediate influence was confined to a few students, but his work was rediscovered at the end of the century.

Wanderer Above the Sea of Fog *(1818)*
The wild-haired, solitary figure is Friedrich himself who, in the character of the Wanderer – booted and stick in hand – has climbed onto a rocky peak above the mountain mists. Only a short time ahead of the American 'sublime' artists, Friedrich has located his God in Nature. The extreme contrast between the dark rock and the swirling white fog makes this quite an awesome prospect for the viewer as well

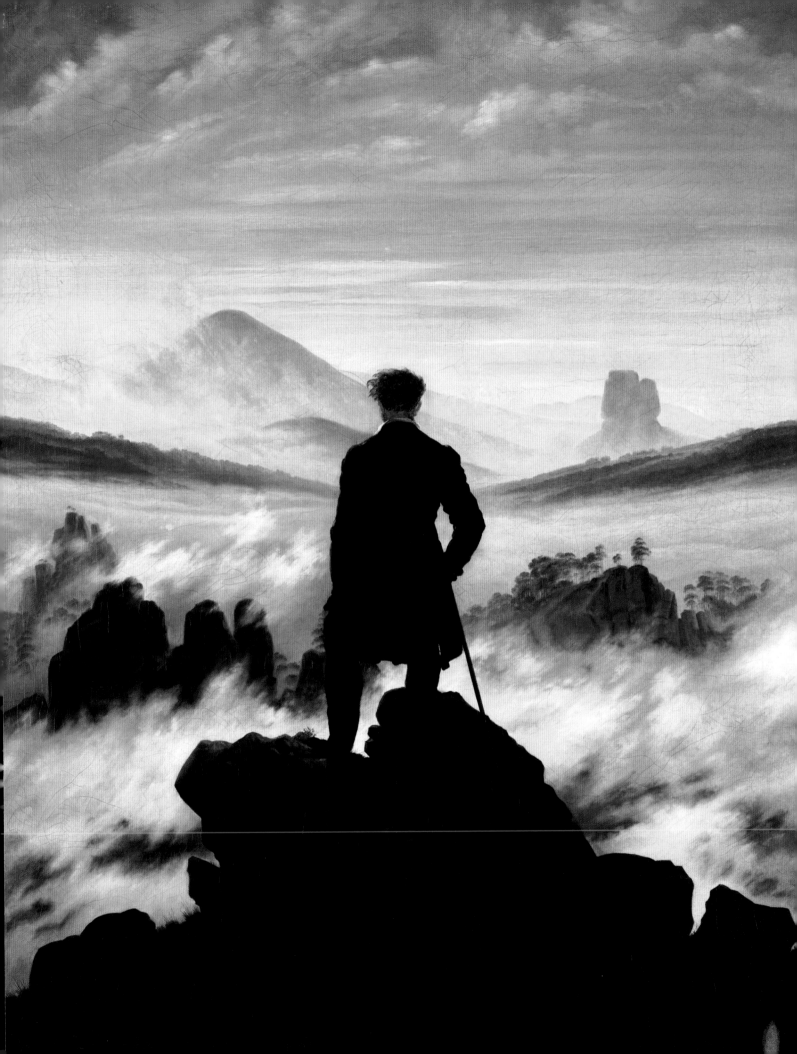

THOMAS GAINSBOROUGH

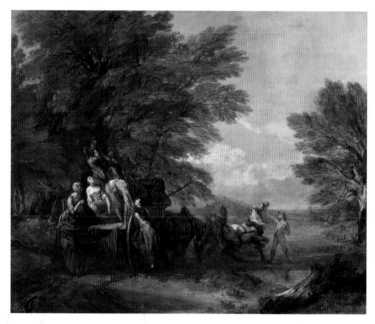

The Harvest Wagon (1767)
Confined to town, Gainsborough often drew candle-lit model landscapes set up in his studio. He came to appreciate Rubens and the Dutch master's influence can be detected here, in the fluency of line and the scale of the beech trees. The group on the cart may be based on Rubens' Descent from the Cross

Thomas Gainsborough was a founding member of London's Royal Academy, together with Joshua Reynolds. Both were accomplished portrait painters but Reynolds modelled himself on **Rembrandt**, whereas Gainsborough, having first studied **Watteau** and Van Ruisdael, became a dedicated admirer of **Van Dyck**.

Like many artists, Gainsborough submitted to the tyranny of society portraiture. He wrote to a friend whose wife's portrait he had already begun: 'I have no oftener promised myself the Pleasure of sitting down to [finish] it but some confounded ugly creature or other have pop'd their Heads in my way and hindred me'.

No wonder he was in demand, his remarkable ability to achieve a likeness with spontaneity and freshness had been legendary since boyhood. Furthermore, Gainsborough could render any texture of fabric, from muslin to satin. However, he still preferred landscape painting to portraits and hit upon the happy combination of posing clients on their country estates, which also allowed him to view their art collections.

Gainsborough's move to London in 1774 attracted the attention of George III. Liking his informality and Tory sympathies in equal measure, the king asked him to paint the royal family, bypassing the official Court painter who happened to be Joshua Reynolds. The old rivals were reconciled at Gainsborough's final illness, when he famously cried from his bed: 'We are all going to Heaven and Van Dyck is of the company.'

The Blue Boy (1770)
The boy is Jonathan Buttall, the son of a friend of the artist. By dressing him in a suit of satin, Gainsborough is paying homage to Van Dyck; and by making it a suit of blue, he is challenging Reynolds who, in one of his discourses, declared that 'the main mass of a picture could not be blue'

PAUL GAUGUIN

1848	*Born in Paris, son of a French journalist*
1865	*Merchant Navy*
1872	*Paris stockbroker*
1873	*Marries Mette Gad*
1874	*Visits first Impressionist exhibition*
1876	*Accepted at Paris Salon*
1885–88	*Separates from wife and children, joins colony in Pont-Aven, meets Emile Bernard*
1887	*Travels to Panama and Martinique*
1888	*In Arles with Van Gogh*
1889	*Visits Universal Exhibition, Paris*
1891	*Sails to Tahiti*
1893	*Returns to France*
1894	*Returns to Tahiti*
1901	*Poor and sick, moves to Hiva-Oa, Marquesas*
1903	*Dies in Marquesas Islands*

Landscape, Pont-Aven *(1886)*
The artists' colony in Pont-Aven was where Gauguin first tried 'going native', wearing a fisherman's smock and clogs. The Breton community was admired by the artists for its folk traditions, which in their view distanced it from urban corruption

In 1889, Paul Gauguin was already rather an exotic figure. Part of his childhood was spent in Lima with his Peruvian mother and he had also travelled widely in the navy and on business. However, his quest for an earthly paradise actually began at the Universal Exhibition in Paris, where the display of a Polynesian village inspired him to reach beyond the artists' colonies he had experienced in France.

Sculpting and carving were Gauguin's earliest artistic outlets. With the encouragement of Pissarro – but absolutely none from his own family – painting enabled him to take stock of himself in relation to a lengthy western tradition and to start presenting his own unique vision. Fortunately, these intense new images found a market and Gauguin was able to finance his first trip to Tahiti in 1891, with another in 1894. He ended his days in the Marquesas, where he had moved to avoid the twin controls of government bureaucracy and the missionaries on Tahiti. 'He was a pagan and he saw nature with the eyes of a pagan' said Le Moine, a fellow expatriate.

Gauguin's final years were a long, drawn-out struggle with alcoholism and the effects of syphilis, relieved only by self-administered morphine. But it was the urge to paint that kept him alive and was all that he lived for: 'My artistic centre is in my brain, nowhere else.' Following his death, Gauguin attained heroic status in the eyes of German Expressionists.

Contes Barbares *(Primitive Tales) 1902*
'Your civilization is your disease; my barbarism is my restoration to health. I am a savage.' Gauguin's bold, non-naturalistic style evolved while working with Van Gogh's friend, Emile Bernard. Strong decorative lines and flat, bright colours were inspired by simple woodcuts and Japanese prints

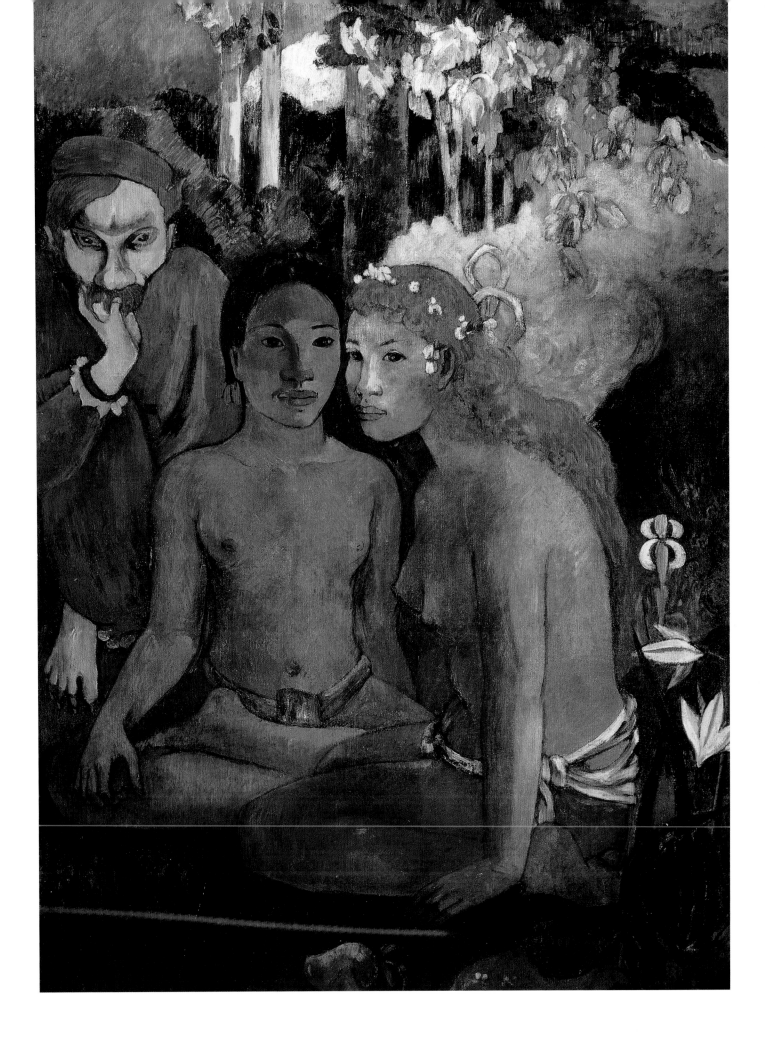

ARTEMISIA GENTILESCHI

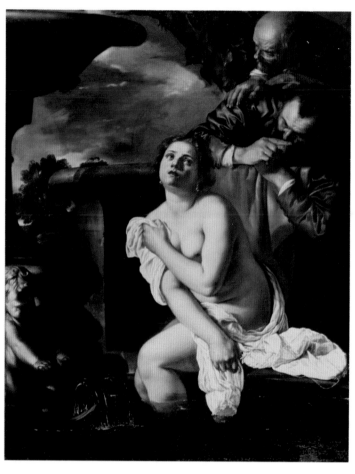

Susannah and the Elders *(1622)*
One of Gentileschi's least violent but most moving images. Susannah is depicted as the victim of unwanted attention rather than from the point of view of a peeping Tom

Artemisia Gentileschi's early education consisted entirely of painting, in fact she couldn't read or write until she was an adult. She studied initially with her painter father and in this way she met **Caravaggio**, whose chiaroscuro style impressed her so much that she was drawn to Baroque drama and expressiveness. She was her own model for her first version of *Susannah and the Elders*, painted when she was only seventeen.

But at nineteen, Gentileschi was raped by her tutor Agostino Tassi. Her father sued and there followed a seven-month trial, during which Gentileschi was accused of being promiscuous, subjected to intimate examination, and then tortured with thumbscrews while giving evidence. Tassi was imprisoned for just one year.

After this humiliation, Gentileschi married another painter, Pietrantonio Stiattesi, and the pair moved to Florence. They both worked at the Academy of Art and Design, where Gentileschi

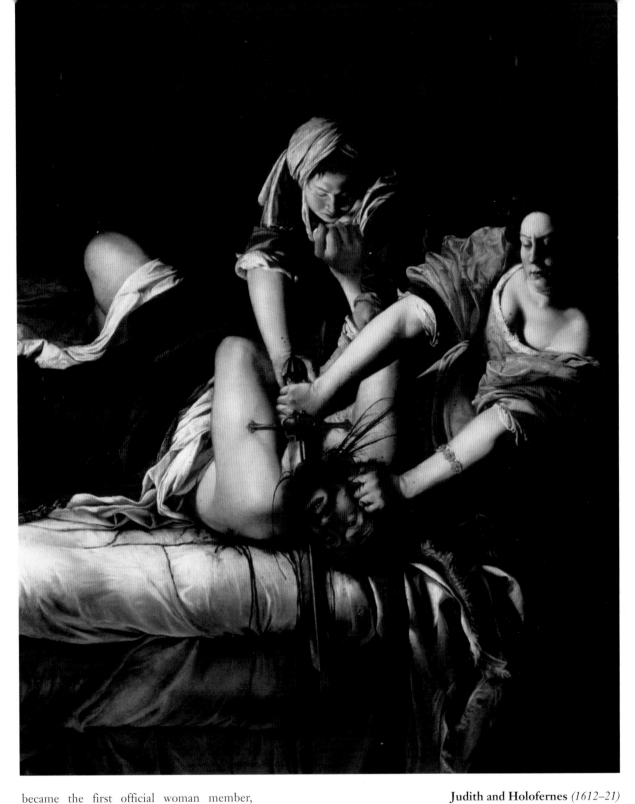

became the first official woman member, supported by her patron, Cosimo II de' Medici.

Gentileschi was hailed as a genius and yet frequently decried, because she possessed a creative talent believed to be exclusively male. Fortunately, this did not stop her producing works of key importance and even gaining patronage from Charles I of England. Recent scholarship has declared that Gentileschi was not merely 'a good woman painter' but one of the major visual thinkers of her era.

Judith and Holofernes *(1612–21)*
Illustrating the decapitation of the Assyrian oppressor Holofernes by the Jewish heroine Judith, this is a powerful expression of the artist's own emotional turmoil. The realism and dramatic chiaroscuro easily match Caravaggio or Rubens. Gentileschi painted five other versions; it was a theme that particularly appealed to the Florentines who were often threatened by more powerful states. For the artist, it was an affirmation of the strength of women in all kinds of adversity

THÉODORE GÉRICAULT

1791	*Born in Rouen*
1812	*Paints* Officer of the Hussars
1814	*Paints* The Wounded Cuirassier
1816–18	*Visits Italy*
1819	*Paints* The Raft of the Medusa, *wins gold medal at Salon*
1820–22	*Visits England*
1822–23	*Paints portraits at La Salpétrière*
1824	*Dies in Rouen following a fall from a horse*

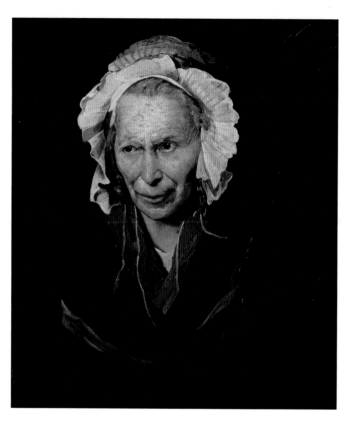

The Madwoman, the 'Hyena of Salpétrière' *(1822–3)*
Whilst in England, Géricault had made studies of the poverty and misery to be found on the streets of London. In the same vein, on his return to Paris, he visited La Salpétrière, *an insane asylum, where he made portraits of the inmates in a compassionate attempt to capture and understand the image of mental illness*

Within a short life, Théodore Géricault strongly influenced his friend **Delacroix**, and left a substantial mark on European painting. Géricault and Delacroix were both pupils of Guérin and collaborated on the famous *Raft of the Medusa*; Delacroix posing as one of the victims.

Géricault studied corpses and interviewed survivors in order to reproduce the horrors of the *Medusa*. The painting was a protest against the French government's attempted cover-up of the wrecked frigate's true fate. The captain had cut 150 people adrift on a makeshift raft, and the fifteen survivors had had to resort to murder and cannibalism to stay alive.

The life-sized *Medusa* is a highly charged work that mixes Realism and Romanticism. It went on show in London, drawing huge crowds for six months. Regrettably, Géricault painted his warm dark tones with bitumen – a common mistake at the time that results in darkening and contraction cracking – and the canvas is now too fragile to leave the Louvre.

Géricault was an ardent admirer of the English school, where 'colour and effect are understood and felt', and spent two years in England where he produced lithographs, watercolours, and studies of race horses, which he loved. Unfortunately, back in France, it was a riding accident that caused his early death.

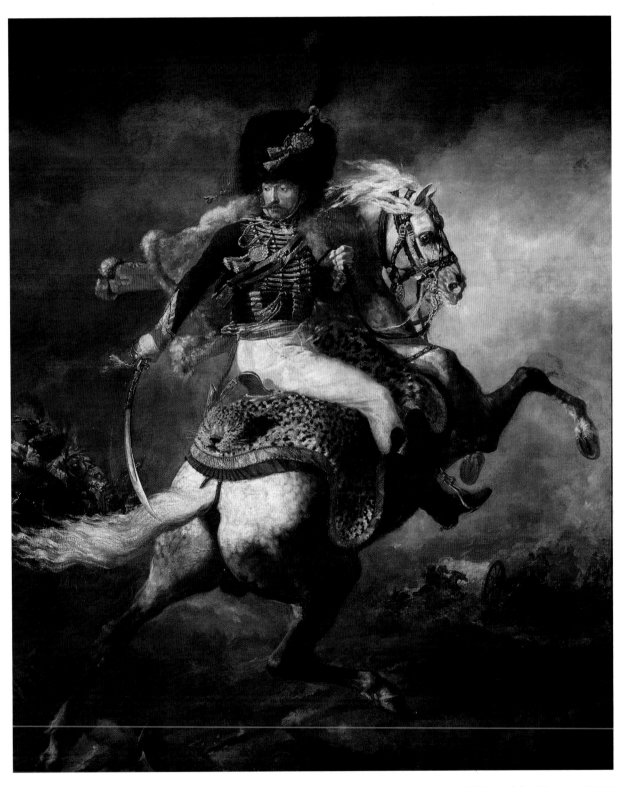

Officer of the Hussars *(1812)*
*Géricault's devotion to horses and racing gave him an unerring eye for the
animal's line and movement, and its power is emphasized even more in this
picture by the leopard-skin strapped beneath the saddle. The rider twists to face
the viewer as his horse rushes towards the smoke and flames of battle. The
composition recalls the vigour of Rubens' battle and hunting scenes*

GIOTTO DI BONDONE

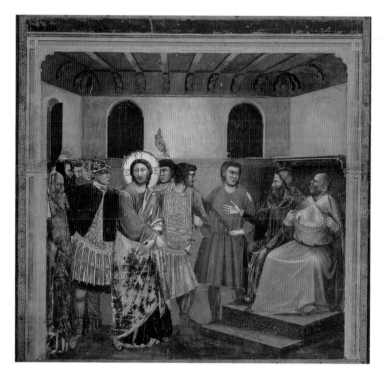

Jesus Before the High Priest Caiphas *(1305–06)*
South Wall, Arena Chapel, Padua
Giotto makes the beamed ceiling of Caiphas' chamber look like the lid of a strongbox, it is obvious there is no escape. So much activity jostles for space that it takes a moment to pick out Jesus' sorrowful glance towards a half-hidden Peter, who has just denied being one of his disciples

Cimabue reputedly discovered Giotto as a shepherd boy scratching the picture of a sheep on a rock. From then on, western art followed a new course. The boy probably worked first on mosaics in the Florentine Baptistery before his interests spread to painting, sculpture and architecture. Giotto became a successful businessman too, running a busy workshop and supporting eight children.

However – prosperous or not – Giotto's contribution would have been immeasurable. His master, Cimabue had worked to represent form in its own space, but it was Giotto who finally discarded Byzantine tradition and, in imitation of nobody, took the portrayal of humanity to new levels. There is an authenticity of expression in the eyes of his figures and every gesture is convincing because real bodies inhabit their clothing.

It seems no expense was spared with costly ultramarine pigment for painting the Arena Chapel in Padua. The glorious blue later inspired Proust to describe the effect as 'radiant day'. There is so much of the outdoors in Giotto's work that it would be surprising if he had not spent his childhood in the countryside. And he makes us feel there is such a thing as inner space too, we are encouraged to respond emotionally to every detail of his dramatic narrative.

Giotto passed on his mastery of fresco painting directly to his pupils. Almost a century later, his work inspired **Masaccio** and later still, **Michelangelo** was busy studying his legacy.

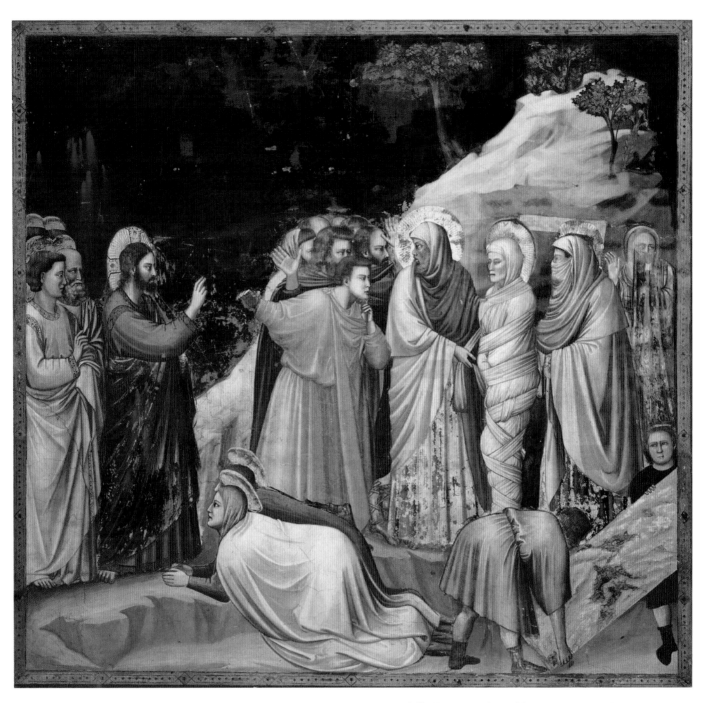

The Resurrection of Lazarus *(1305–06)*
North Wall, Arena Chapel, Padua
Lazarus, the brother of Martha and Mary, has been dead four days. His sisters
have wisely covered their noses and mouths while the tomb is opened and Jesus
miraculously restores him to life. Giotto has placed Jesus and Lazarus in such a
way as to mirror each other, the message being that before long Jesus will die
and undergo a resurrection too

THOMAS GIRTIN

The Tithe Barn, Abbotsbury *(1797)*
Girtin often tinted the sketches that he made in the open air, although he usually limited himself to two or three colours. Many formed the basis of finished watercolours but, as the signature here suggests, his reputation meant that collectors were willing to buy his sketches too

Thomas Girtin marked a high point in the English school of landscape watercolourists. In his day, his work was always compared with that of **Turner**, the consensus being that Turner laboured justifiably to produce a better finish, but that Girtin's 'daring and vigorous execution' were an indication of genius.

Girtin learned to draw and colour topographical and architectural views as an apprentice. Often, this meant 'working up' from another artist's sketch. Nor was it unusual for two artists to engage on the same piece. In the mid-1790s Girtin and Turner were employed together by a patron, Thomas Monro. Girtin drew the outlines from sketches by the landscapist J.R. Cozens, and Turner coloured them. It was a mechanical task but both young men gained much from it. Monro's London house was a meeting place for artists to work, study and socialize. From these gatherings, professional societies were set up and exhibitions organized.

A huge oil-painted panorama of London, called the *Eidometropolis*, provided Girtin with his biggest challenge; he covered 181 square yards of canvas first with a detailed graphite drawing and then colour sketches, to regularize light and weather effects on the overall view.

Girtin conducted an open air studio as he worked up and down Britain (**Cotman** became one of his pupils) ensuring that he passed on his knowledge before his untimely death at the age of twenty-seven.

Durham Cathedral and Bridge *(1799)*
Views of Britain were most popular while the war with France prevented
continental travel. It was also considered patriotic for the wealthy to commission
pictures of their own national monuments.
Girtin would manipulate the light to evoke any mood required,
from stormy to tranquil. He revolutionized the technique of watercolour by
omitting underpainting and applying colours directly to the paper. Specialist
papers were rare and artists would paint on all kinds. Cartridge, for example,
was liked for its rough texture; its original purpose was, of course, for
containing gunpowder

FRANCISCO GOYA

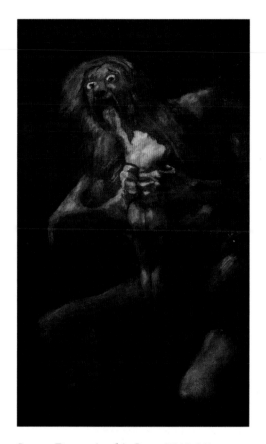

Saturn Devouring his Sons *(1819–23)*
In 1819, Goya retreated to a solitary house outside Madrid where he filled the walls with his Black Paintings, *the last and darkest products of a haunted genius.* Saturn *is one of the most horrifying pictures ever painted, flaunting the unthinkable acts of infanticide and cannibalism. Yet Goya's son Javier said his father achieved peace through expressing his worst fears in paintings that he could confront daily*

Francisco Goya is the first great painter of the nineteenth century, a 'modern' master who has influenced countless artists. He lived in a revolutionary period, in Spain, the least enlightened European country at the time. However, Goya did find a liberal-minded faction in Madrid, who dared to criticize the establishment. It was in Madrid too that he encountered the works of **Velazquez**. He once declared: 'I have had three masters, Nature, Velazquez, and Rembrandt.'

But Goya could never just slot into the European art tradition, his inventiveness and dark obsessions always set him apart. As one scholar wrote: 'The darkness in his works is that of despair…terrifying. No mysterious gleam of light appears as a solace…'

Goya approached the horrors of corruption and injustice, not from an empty-gesturing, political angle but as an intuitive artist, believing his images could bring about a new moral understanding.

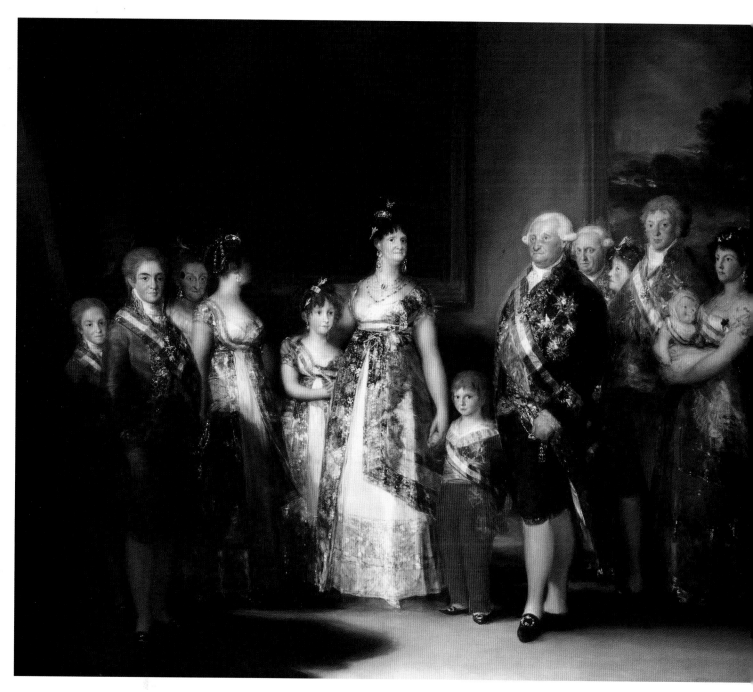

The essential Goya emerged through his own physical suffering; one winter in Andalusia he fell prey to a terrifying illness, which left him deaf and fearing insanity. Without this ordeal, he may never have deepened our vision with great works like *The Third of May, 1808: The execution of the defenders of Madrid*; or with the *Black Paintings* daubed in oil paint directly onto the plaster walls of his lonely house; and whole series of etchings too disturbing to be published in his lifetime.

Charles IV of Spain with Family *(1800)*
This group portrait, clearly inspired by Velazquez, depicts a model – though far from beautiful – family of the Age of Enlightenment. 'The corner baker and his wife after winning the lottery', as the critic Gautier later described them, was definitely not how Goya intended to portray Charles IV and María Luisa. As Court painter, his opinion has to be delivered with far more subtlety, which is why he sites himself 'prudently' in the shadows, signalling that he views the truth from the inside out

EL GRECO (DOMENIKOS THEOTOKOPOULOS)

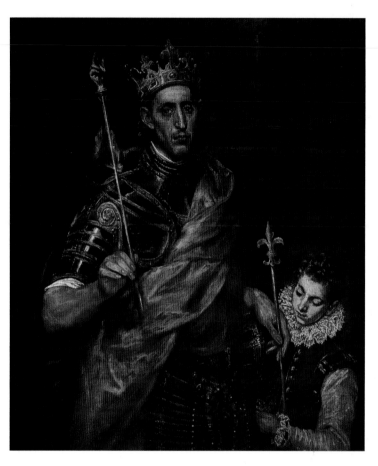

Saint Louis IX of France *(1586-94)*
Louis IX , King of France, was canonized in 1297 as the ideal Christian monarch. El Greco painted him for the Counter-Reformation cause. Although the face is traditionally iconic with high cheekbones and staring dark eyes, El Greco places Louis' body in the fashionable three-quarter pose and gives him beautifully expressive hands

When El Greco the icon painter left Crete for Venice, he was confronted – quite literally – by new perspectives. His first major influence was **Titian**; Bassano was another. However, there are strong indications that El Greco actually worked under **Tintoretto**. Both artists made compositional sketches from clay or wax statuettes, artificially lit. And Tintoretto's influence shines through El Greco's *Christ Driving the Traders From the Temple*.

In Rome, El Greco had little success, perhaps due to his arrogant claim that he could paint better than **Michelangelo**. Proud and self-assertive, he later became embroiled in long-term lawsuits. The nickname 'Greco' irked him too and he always signed his work Domenikos Theotokopoulos in Greek, sometimes adding Kres ('Cretan'). Nevertheless, while in Rome he did consolidate the 'essence of Byzantium' with Italian Mannerism. He compressed space and twisted his forms; he may well have used lenses and mirrors to develop these effects.

Although Toledo demanded a cooler palette, the move to Spain did not diminish El Greco's

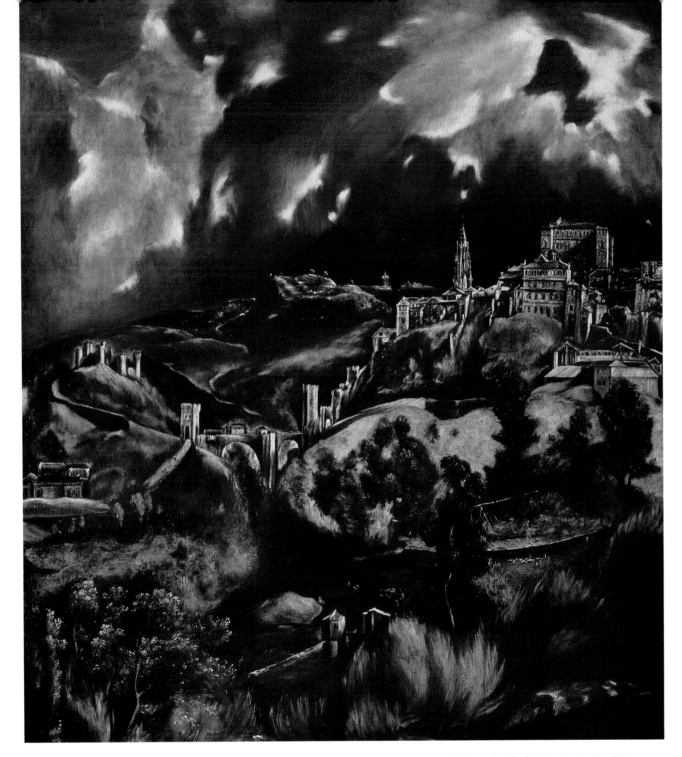

View of Toledo (*detail*) (*1597–99*)
In the ancient city of Toledo, immortalized here in one of the earliest and most dramatic landscapes in western art, El Greco found a sympathetic circle of intellectual friends and patrons and built a profitable career

religious and mystical intensity. He caught the mood of Spain's key Catholic city, which engaged with the Counter-Reformation by investing generously in religious art. How fortunate that the formality of Spanish altarpieces offered tall, narrow panels to complement the artist's elongated figures.

El Greco's unique style had no followers and was disregarded for centuries. A group of art lovers rediscovered him in the nineteenth century, much to the admiration of others like **Delacroix, Degas, Cézanne, Van Gogh** and **Gauguin.**

MATHIAS GRÜNEWALD

1470(?)	*Born Mathis Neithardt Gothart in Wurzburg*
1480(?)	*Apprenticed to a goldsmith in Strasbourg, later works in Schongauer's studio in Colmar*
1490–98	*Works in Basel as woodcut illustrator*
1501–21	*Proprietor of workshop in Seligenstadt*
1503	*Earliest known work, Mocking of Christ*
1511–26	*Works at court of Archbishop of Mainz*
1512–15	*Paints Isenheim Altarpiece for hospital chapel of St Anthony's Monastery in Alsace*
1514	*Meets Dürer*
1525	*Embraces Lutherism. Ceases painting. Flees to Halle, works as hydraulic engineer*
1528	*Dies of the plague in Halle*

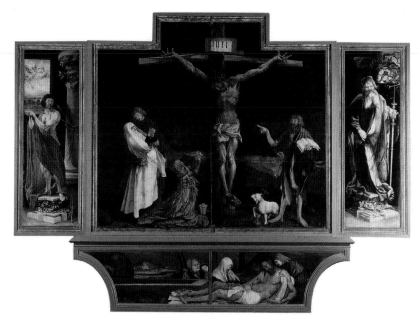

Crucifixion Isenheim Altarpiece (centre panel) *(c.1515)*
The Hospitallers cared for victims of incurable diseases like St Anthony's Fire (ergotism) and syphilis, so this vividly realistic image of unutterable torment and pain would have made a consoling link between Christ and the sick. The words of the inscription: 'He must increase but I must decrease' are emphasized by the disproportionate sizes of Jesus and those gathered around the cross

A contemporary of **Bosch**, **Cranach** and **Dürer**, Grünewald considered his own reputation secondary to the religious and social message of his paintings.

From 1511, Grünewald was employed by the archbishops of Mainz as their Court painter. It was the era of the Reformation and the artist's sympathies really lay with the Protestant cause, but he managed to keep his secret until he disclosed his support for the Peasant's Revolt in 1525. He was dismissed, and from then on embraced Lutherism, exchanging painting for a career as a hydraulic engineer.

Grünewald is seen nowadays as the great precursor of twentieth-century German Expressionism, but this was not realized until Modernism prompted a re-evaluation of his work as an alternative to classical idealism. Grünewald himself did not seek to uncover any great artistic truths or to break new ground with his style. What he did was for the plain understanding of those sufferers and their carers who knelt in front of the altars that he had decorated. His images, whether sorrowful or triumphant, and his extraordinary use of colour surpass the need for words.

Saint Anthony of Egypt's Visit to Saint Paul the Hermit,
Isenheim Altarpiece *(detail) (c.1515)*
This story would have been familiar to everyone who prayed in the chapel of St Anthony's Hospitallers in Isenheim. The old hermit tells their patron saint about the raven who has miraculously fed him with half a loaf of bread every day for sixty years. The bird was doubly obliging that day and brought a ration for St Anthony as well

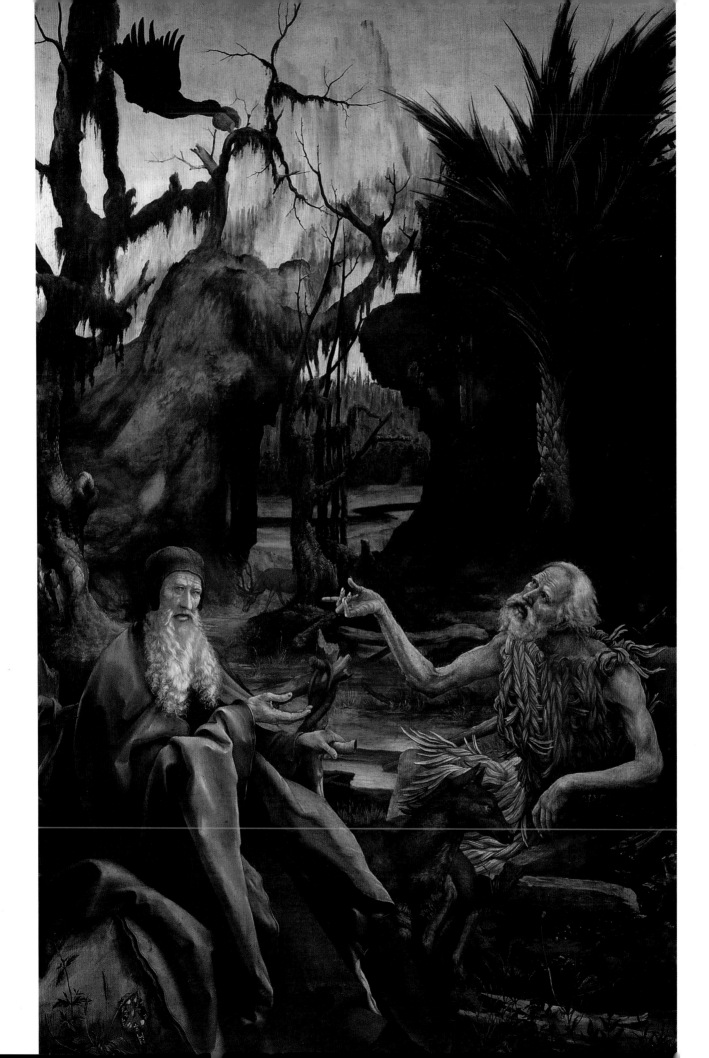

FRANS HALS

Portrait of Sara Andriesch Hessix *(1626)*
The eminently respectable Sara Hessix is portrayed on the occasion of her 40th wedding anniversary. Her husband, the vicar Michael Middelhoven, appears in a companion piece

Frans Hals and **Rembrandt** (van Rijn) were contemporaries, both consummate portraitists, but both were very different in their approach. Where Rembrandt is discreet and introspective, Hals' sitters are frequently bursting with vitality and surface charm.

His portraits have been called 'pleasant' art, although, since he was constantly in debt, Hals himself had little reason to be cheerful. Providing for ten children or poorly paid by his clients, whatever the reason, numerous commissions could not save him from an impoverished old age.

In his day, Hals was unrivalled as a painter of groups. With no demand for decorated interiors or religious paintings at the time, Dutch artists were keen to gain orders for group portraits. From the swagger of the *Banquet of the Officers of the Civic Guard of St George* to the delicate air of the *Regentesses of the Old Men's Almshouse at Haarlem*, Hals was famed for his accurate likenesses of each member.

With neither sketches nor underdrawing, he probably used optics to map the features onto the canvas, while conveying spontaneity through skilful posing of the body.

Hals' influence can be seen in Jan Steen's work, who lived in Haarlem during Hals' final years.

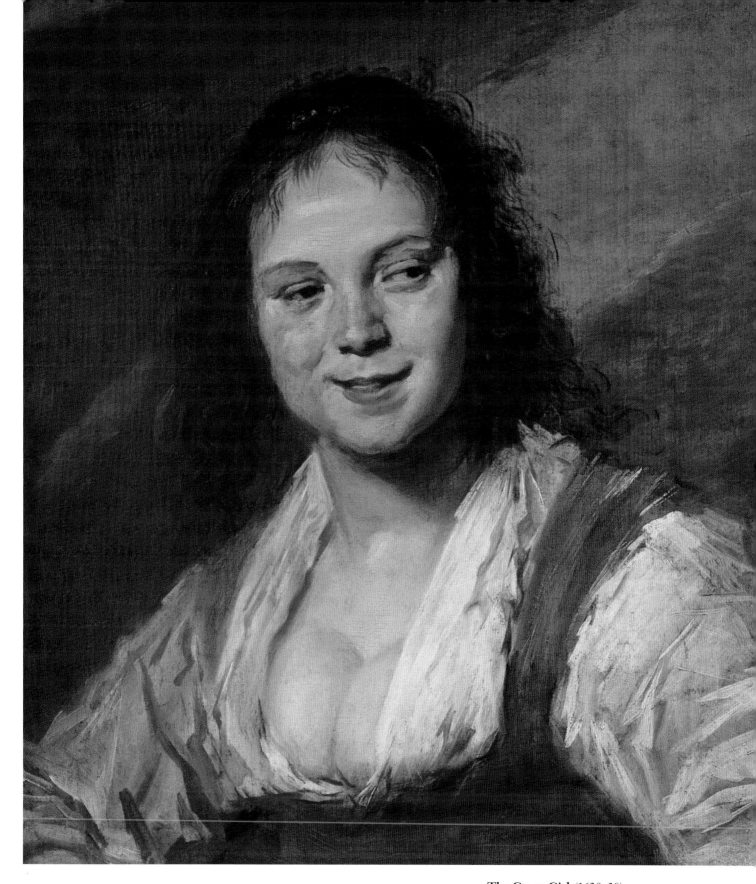

The Gypsy Girl *(1628–30)*
One of Hals' most appealing portraits, the way in which he handles the brushwork suggests that he quickly seized a fleeting impression. The girl's sidelong glance towards another, unseen person is a device that Hals often uses, to give the illusion that we are all part of a real-life gathering. The girl's immodestly deep neckline suggests that she was in fact a prostitute

ANDO HIROSHIGE

1797	*Born in Edo, son of a fire warden*
1811–12	*Pupil of book illustrator Utagawa Toyohiro*
1811–30	*Creates prints of traditional subjects, including views of Edo*
1834	*Publishes complete edition Fifty-Three Stations of the Tokaido Road*
1833–40	*Peak of popularity, publishes various notable series*
1841–43	*Tempo Era austerity affects quality of work*
1855	*Abandons horizontal format for vertical compositions*
1858	*Dies of cholera*

Rice Planting in the Rain at Ono, Hoki Province (*c.1855*)
Hiroshige was not afraid to use western-style perspective, here the rice fields stretch away to the foot of a mist-covered hill. Meanwhile, rain-drenched workers plant up reflective squares of water with shoots of rice, in a beautifully modulated patchwork of greens and greys

Ando Hiroshige was a leading exponent of *ukiyo-e* – 'pictures of the floating world' – during the last half-century of its existence as a Japanese art form. Ukiyo-e originated in the late seventeenth century, dedicated to the pursuit of pleasure in everyday urban life and based on popular idols taken from the ranks of courtesans and actors.

The collectable ukiyo-e woodblock prints developed along relatively sophisticated lines of their own, within a Japanese tradition of harmonious colour and graceful composition, which raised them above plain folk art. They were priced to suit the pockets of middle-class tradesmen, artisans and merchants. Paintings were reserved for the wealthier ranks.

Hiroshige's total output was immense, some 5400 prints. He studied drawing from childhood and was apprenticed to just one master, Utagawa Toyohiro. Yet Hiroshige worked for over twenty years before producing the series that established his reputation, *Fifty-three Stations of the Tokaido Road*; an ambitious travelogue that followed the great highway between Kyoto and Edo.

Night Snow at Kanbara *(1832–34)*
A wood block from the series Fifty-Three Stations of the Tokaido Road
His characteristically shaded sky registers twilight over a mountain village engulfed in snow, through which three people are struggling home. Snow, rain or mist are favoured background conditions against which Hiroshige sets his travellers, often depicted crossing each others' paths, emphasizing the transience of existence

Working in the nineteenth century, Hiroshige and **Hokusai** each preferred to create landscapes rather than portraits of actors, wrestlers, poets and courtesans. The innate love of the Japanese for all aspects of the natural world ensured that both artists had an enthusiastic following. Although he may not have matched Hokusai's draftsmanship, Hiroshige at his best is unsurpassed in his poetic vision. His ability to evoke the mood of a particular place still has unfailing appeal to westerners.

DAVID HOCKNEY

1937	*Born in Bradford, son of a clerk*
1953–57	*Studies at Bradford School of Art*
1959–62	*Studies at Royal College of Art, London, meets Kitaj*
1963	*Publishes* Rake's progress *etchings. First visit to North Africa. Meets Andy Warhol in New York*
1964–68	*Travels, paints, teaches and exhibits across USA*
1970	*Retrospective at Whitechapel Gallery, London and tours Europe*
1973	*Moves to Paris*
1978	*Settles in Los Angeles*
1982	*Takes up photography*
1984	*Resumes painting after three-year break. Begins series of lithographs*
1988	*Major retrospective shown in USA and UK. Sets up studio in Malibu*
1995–96	*Major retrospective of drawings, Royal Academy, London*
2005	*Exhibits water-colours of East Yorkshire landscape*

*Scene from **The Rake's Progress**, San Francisco 1982*
Hockney first engaged with re-interpreting Hogarth's Rake's Progress *when he embarked on a suite of etchings in 1961. In 1975 he designed the set and costumes for Igor Stravinsky's opera version, first performed at the Glyndebourne Festival, England. Hockney's theatre work mixes practicality with exceptional vision. To those who accused him of neglecting painting, he replied: 'I've never treated the theatre as a sideline, nothing I do is a sideline.'*

David Hockney is one of most versatile artists of his generation, many of whom have not developed as interestingly from their common roots in Pop Art. Throughout a long career, Hockney has managed both to court controversy – through his quietly affirmative homo-erotic paintings – and to become a British national treasure, as witnessed by his creation as a Freeman of Bradford, his home town. He has maintained strong ties with Yorkshire and recently returned to make gentle watercolours of the landscape. These exist in total contrast to his monumental treatment of the Grand Canyon, originally exhibited at London's Royal Academy.

Not only is Hockney a skilled draftsman, he has also produced etchings to illustrate *Six Fairy Tales of the Brothers Grimm* and C.P. Cavafy's *Poems*. During the 1970s he ventured into stage design with costumes and sets for Stravinsky's *The Rake's Progress* and Mozart's *The Magic Flute*, both staged at Glyndebourne. Many say that his painting style has benefited from the broadening out that was required for stage design. When Hockney took up photography, he pursued mechanical image-making through various processes, from photographic collage and photocopying to ciglee (inkjet).

The debate continues over his apparent avoidance of subjects such as war, poverty, sickness and injustice, and whether one can be a great artist without confronting 'serious' issues. But Hockney believes it is vital to continue looking and learning, with the dedication of an explorer who suspects there is so much more to discover about art itself.

Mr and Mrs Clark and Percy (detail) (1970–71)
*Ossie Clark's flowing designs combined with Celia Birtwell's printed
textiles produced some of the most desirable garments of the late 1960s
and early 1970s. Hockney plays with allusions as if he were a Renaissance
portraitist. The lilies associated with Mrs Clark stand for purity and
incorruptibility; and the cat Percy (a slang term for penis) sits bolt
upright on Mr Clark's crotch area. The couple occupy two distinct halves
of the canvas, which could be divided easily enough. This may or may not
reflect the fact that the Clarks were divorced within three years*

FERDINAND HODLER

1853	*Born in Bern, son of a carpenter*
1871	*Moves to Geneva. Studies at L'Ecole des Beaux-Arts under Menn*
1887	*Meets Bertha Stucki. Augustine Dupin gives birth to son Hector*
1889	*Marries Bertha Stucki, divorces her 1891*
1891	*Visits and exhibits in Paris*
1894	*Meets Berthe Jacques, marries her 1898*
1897	*Wins gold medal at Munich*
1899	*Admitted to Berlin Secession*
1900	*Wins gold medal at Paris World Exhibition*
1909	*Death of Augustine Dupin*
1913	*Valentine Gode-Darel gives birth to daughter Pauline-Valentine*
1915	*Death from cancer of Valentine Gode-Darel*
1917	*Professor of Drawing, Geneva Art Academy*
1918	*Dies of pneumonia in Geneva*

Poster for 19th Art Exhibition of the Vienna Secession *(1904)*
Hodler was guest of honour at the 19th Exhibition of the Vienna Secession. This showed over thirty of his works and was one of many accolades he received

Both of Ferdinand Hodler's parents had died from tuberculosis by his fifteenth birthday, along with six of his siblings. His experiences of death in the family make it tempting to compare his work with **Munch**, but mystic and melancholy themes were common during the intense period known as the *fin de siècle*.

Hodler studied in Geneva under Barthélemy Menn, a former pupil of Ingres. It was a very traditional education but it taught him to draw well and exposed him to the lasting influences of **Rembrandt**, **Holbein** and **Dürer**. Hodler worked initially as a very competent portraitist.

He eventually visited Paris to explore new ideas and styles and specially admired those of **Gauguin** and **Seurat**. He had devised his own system, which he called 'parallelism'. Hodler's earliest symbolist work, *The Night*, has sleep prefiguring death, but the mayor of Geneva failed to see beyond the naked bodies and banned it from exhibition. The resulting publicity, with awards from France, Germany and Austria, secured Hodler's international reputation. His influence can be traced in the work of others, like **Matisse** and **Klimt**.

Later pictures were on a smaller scale. Hodler made many self-portraits and, with shades of his childhood, he documented the lingering deaths of two lovers, both mothers of his children. His success in so many categories continued; his last years were devoted to dreamy landscapes, which satisfyingly combined the Swiss identity with images of transcendence.

Painting of a Mountain *(1909)*
Landscape painting was a successful area for Hodler during his final years. The colours he used for mountain ranges and lakes grew stronger and clearer as his style evolved. He managed to preserve traces of the grand Swiss image within a highly personal, visionary style and the results were particularly appealing to the many tourists who had journeyed on the mountain railway

WILLIAM HOGARTH

1697	*Born in London, son of a Latin teacher*
1713	*Apprenticed to a silver engraver*
1720	*Sets up as copper engraver, producing book illustrations. Attends Thornhill's free art academy*
1729	*Elopes with Thornhill's daughter, Jane. Becomes a portrait painter*
1731	*Starts painting 'modern morality' subjects*
1735–55	*Runs his own academy in St Martin's Lane, a guild for professionals and school for young artists*
1748	*Is expelled from Calais as a spy*
1753	*Publishes treatise: The Analysis of Beauty*
1757	*Appointed Serjeant Painter to the King*
1764	*Dies in London*

The Shrimp Girl (*c.1743*)
This lively portrait was not done for a commission; Hogarth kept it for himself. It is based on a popular theme known as the Cries of London, *where different street traders were portrayed in a series of prints. It is a rapidly executed oil sketch, an unusual approach to portraiture, but it gives just the right impression of a face glimpsed in passing. Hogarth's widow showed the picture to visitors with the comment: 'They said he could not paint flesh. There's flesh and blood for you!'*

Wickedly witty Londoner, William Hogarth has at least two claims to fame. First, through his own academy in St Martin's Lane, he probably did more than any individual to establish an English school of painting. And secondly, he produced forerunners of the graphic novel with several series on 'modern morals', the two best known being *A Rake's Progress* and *Marriage a la Mode*. Hogarth's great friend, Henry Fielding (author of *Tom Jones*) put it perfectly when he called him 'a comic literary painter'. Through satire, both Fielding and Hogarth exposed the evils of their age, targeting the mean, calculating morality of those who took the poverty and misery of others as stepping stones to their own advantage.

As far as Hogarth was concerned, he was also campaigning against the taste for French Rococo (he was an exact contemporary of **Boucher**) which he reckoned was undermining the livelihood of English artists. His attitude was not improved by his arrest in Calais for spying, after

being caught sketching the port's fortifications.

In 1753, Hogarth published a tract called *The Analysis of Beauty*. This was partly a rebuke aimed at so-called connoisseurs for being insufficiently informed about art; and partly a valuable contribution to the discussion of aesthetics. Hogarth had a theory that a 'line of beauty' in the shape of an 'S' was intrinsic to the structure of a picture. Looking carefully into the *Painter and his Pug* we see he has drawn the famous 'S' on his palette.

Chairing the Member (1754/5)
'An Election' was Hogarth's final modern morals series. Illustrated in four parts, this is the final scene, when everything degenerates into a riot. Hogarth often makes sly references to earlier history paintings within his own; this time it is Charles Le Brun's Victory of Alexander over Darius. *Instead of the imperial eagle signifying victory, Hogarth has a fat goose flying over the head of the new member of parliament. It suggests that his contribution to debate will be no better than that bird's cackling*

KATSUSHIKA HOKUSAI

The Poetess Ono no Komachi (*c.1810*)
The poems accompanying ukiyo-e *prints take various forms. Here is an image of the Japanese poetess Ono no Komachi with one of her poems, quoted word for word. The letters of her name are also in the outlines of her figure and the screen*

Hokusai was responsible for a phenomenal 30,000 works of art. He lived for nothing else and was driven to perfect his style with every new undertaking. Between the ages of sixty-four and seventy-two he had a burst of creativity that resulted in several major series of woodblock prints, including *The Thirty-Six Views of Mount Fuji*.

As a youth, Hokusai was on a constant quest for his artistic niche. After a relatively long period under Katsukawa Shunsho, he left the studio following the master's death and – ever curious – investigated what other schools had to offer. In the process, he came across examples of art displaying a distinct western influence that had originally filtered through via the Dutch trading post in Nagasaki.

To appreciate the impact of such influence, it is necessary to remember that Japan underwent a policy of National Seclusion from 1639 to 1854. Foreign trade was strictly limited and the Japanese themselves forbidden to travel abroad. The pictures derived from European engravings inspired Hokusai finally to become a landscapist at the age of thirty-eight. He began work afresh, experimenting with western perspective, making endless observations; the ensuing work went into twelve volumes of the Hokusai Manga (sketchbooks) published in 1814.

But it was the *ukiyo-e* – 'pictures of the floating world' – that made the reverse journey in the late nineteenth century to complete a circle of influences and reveal to a delighted Europe the glories of the Japanese print.

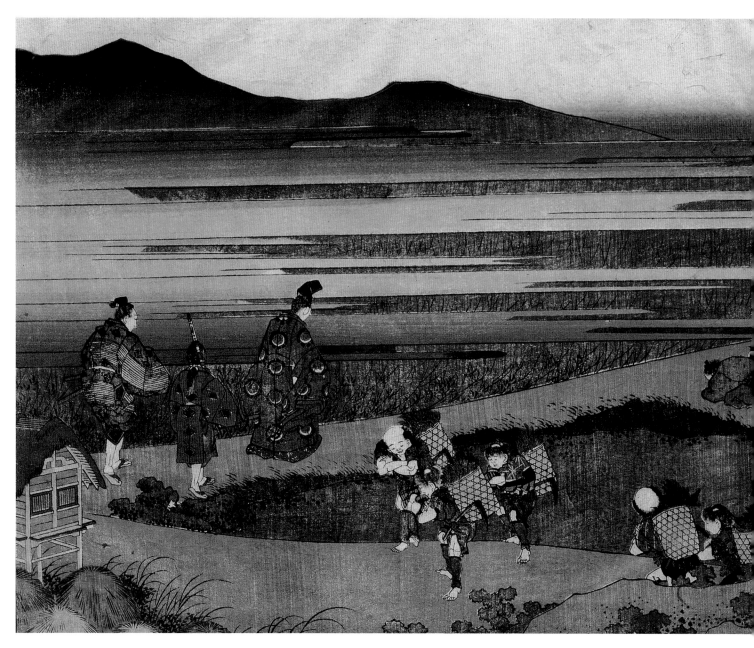

A Daimyo Musing on a Lost Love *(1835–6)*
One of a series entitled One Hundred Poems Explained By the Nurse, *this
masterpiece of colour printing illustrates a poem by Sanji Hitoshi. Hokusai's
innate sense of proportion marries well with his development of western-style
perspective; and figures of all kinds, at work and leisure, fed his insatiable
enthusiasm for depicting life in all its aspects*

HANS HOLBEIN THE YOUNGER

Sir Richard Southwell *(1536)*
When this portrait was painted, Southwell had been sheriff of Suffolk and Norfolk for two years, despite the fact that he was a convicted murderer. Holbein conveys a certain unpleasantness about the man but, as always, in his dispassionate style. The unshaven jaw below his sneering mouth draws the viewer's attention to the scars on his neck

Hans Holbein was one of two gifted sons trained by their artist father Hans Holbein the Elder. Both started out as book designers and illustrators for the leading German printer Froben of Basel, but the older boy died in 1518. In those days, printers were publishers too and their workshops were meeting places for the intellectual community. Froben's office attracted many scholars and so the young Holbein met the Dutch humanist Erasmus.

Holbein painted his first official portraits in Basel – of a burgomaster and his wife – but, despite their success, he didn't restrict himself to portraiture. He created a popular series of woodblocks called *Dance of Death*, designed stained glass, made models for goldsmiths, and painted some religious subjects. However, in 1525, as the Reformation spread throughout northern Europe, religious images came under attack in Basel and disorder even threatened the town's food supply. Artists everywhere were seeking alternative work and Holbein decided to go to England.

He sailed in 1526, having persuaded Erasmus to write a letter of introduction to Henry VIII's Treasurer, Sir Thomas More. Holbein's admission to the English Court was the key moment of his career and before long they had accepted him as their leading artist.

Together with his responsibilities for ceremonial and festive occasions at Court, Holbein provided an accompaniment to Henry's serial marriages with his portraits of the king's actual and prospective brides. But these were a mere handful among the one hundred or so, including miniatures, that he painted in total.

Anne of Cleves *(1539)*

The Tudor period was one of intrigue and deception. In this portrait of Henry VIII's fourth wife, perhaps Holbein did smooth over with his meticulous, blended brushstrokes those features that caused the king to call her the 'Mare of Flanders' once he had met her. Her elaborate dress certainly outshines her facial expression. Should that have been a clue? However, by the time he and Anne were wed, Henry was more or less ready to commission Holbein's portrait of his fifth wife

WINSLOW HOMER

Home, Sweet Home (*1863*)
As a war artist, Homer lived among the soldiers and in this picture he captures a scene with two federal infantry privates at suppertime. The band in the distance is supposedly playing 'Home, Sweet Home'. The men's 'brogan' boots are brown, which is how they were issued. Soldiers were supposed to apply boot black to them, but often had more important duties

'In the future I will live by my watercolours.' Although Winslow Homer first used the medium when he was already a mature artist, he significantly raised the profile of watercolour in America and through several hundred works became its acknowledged master.

Homer's art training consisted of apprenticeship to a lithographer. Once he had become an illustrator for *Harper's Weekly* in New York, he seemed destined to remain so. However, a year's assignment as a Civil War artist meant expeditions to the Virginia front where he assembled a portfolio, which formed the basis for his first important oils. Unlike **Whistler** and Sargent, Homer – a reserved and unostentatious man – worked mostly in America and left avant-garde European movements like Impressionism to proceed without him.

His early watercolours evoked a pre-Civil-War rural idyll and stand in contrast to his war reportage. Then Homer went still further – to the north of England for two years, in fact – and produced a series based in the fishing village of

Shark Fishing *(1885)*
Homer was not America's first sporting artist but he did become master of the genre, just when the nineteenth-century 'church' of the sublime landscape was transformed into the great outdoors and the 'theater of manly enjoyment'

Cullercoats. Steam trawlers had already begun to replace smaller fishing craft, but Homer persisted in recording the old ways and traditional skills, as in *Mending the Nets*.

He moved to Prout Neck, Maine, after his return to New York. It became his home for the rest of his life, apart from working holidays on the New England coast, in the Adirondacks and Quebec, and the winters that he spent in warmer climes. Homer painted the sea and its people repeatedly until, finally, he omitted people in favour of the vastness of the ocean alone.

PIETER DE HOOCH

A Musical Party (1677)
A sophisticated interior, painted darkly during the artist's Amsterdam period, and hinting at the decline of the affluent classes into tasteless extravagance. There is possibly some innuendo attached to the oyster being offered to the woman in red

Seventeenth-century customers of Dutch artists came from the merchant classes, unlike other European countries where church and aristocracy were still the major patrons. This meant Dutch painters were free to choose any genre – such as portraiture or still life – for themselves.

Pieter de Hooch's best genre work was accomplished early in his career, in Delft where he met Fabritius (a pupil of **Rembrandt**) and **Vermeer**. Given that Delft was the manufacturing centre of high quality lenses, it is likely that all three made use of a technology so conveniently to hand. Themes associated with the Dutch school – town views and domestic interiors – gave scope for experiments in perspective and reproducing various surfaces. Apart from the well-tried *camera obscura* (see page 198), there were magnifying and reducing lenses, and mirrors, any of which could be employed in rendering mellow brickwork, tiled courtyards, and reflections in glass or metal.

Besides technical proficiency, de Hooch's gift lay in his sensitivity to human relationships and especially, 'those silent moments when…emotions are triggered by… a gesture, a

a set of trifling circumstances'. Sadly, de Hooch's later years saw a decline in his powers. He was devastated at his wife's death in 1667. But already his move to Amsterdam in pursuit of wealthy clients had led to coarser work on a larger scale, executed with a darker palette, reinforcing the feeling that de Hooch's gentle light no longer shone.

The Courtyard of a House in Delft *(1658)*
Typical of de Hooch's handling of space and perspective, with the long vista through the arch and various doors left intriguingly ajar. The stone inscription reads: 'This is St Jerome's vale if you wish to repair to patience and meekness. For we must first descend if we wish to be raised.' Does it invite us to compare the contented mother and child in the cluttered back yard with the woman under the new brick archway, poised to step out in her best clothes?

EDWARD HOPPER

The Absinthe Drinker (1876) by Edgar Degas
Degas' imagination accidentally transformed the reputations of two of his friends with this picture. The woman is actress Ellen Andree, the man a painter called Desboutin. Degas portrays them sitting deep in thought, but claimed he did not mean to portray them as dissipated and degraded, which was how the critics perceived them

The paintings of Edward Hopper are landmarks of American Realism, a style he never abandoned but did not follow merely in order to reproduce the visible. As he said, 'No amount of skilful intervention can replace the essential element of imagination.'

Fifty years separate *The Absinthe Drinker* from *Automat* but **Degas** stirred Hopper's awareness of what the American artist called 'decaying from your original idea', with the statement: 'It's much better to draw from…memory. It's a transformation in which imagination collaborates…One reproduces only…the necessary.'

Although educated in the European tradition and a visitor to Paris in the early 1900s, Hopper remained unaffected by movements like Cubism, just as he avoided Abstraction later on in America.

'America seemed awfully crude and raw when I got back ,' he admitted, yet it was those qualities that rooted Hopper's disquieting vision, through which he conveys the sense of alienation that pervades any big city.

Initially trained as an illustrator, Hopper was not a good painter technically. But the severity and harsh illumination of his compositions, populated by solemn figures who at times appear scarcely more alive than the furniture, draw viewers in with a collective atmosphere. Like all significant artists, Hopper can, without a trace of

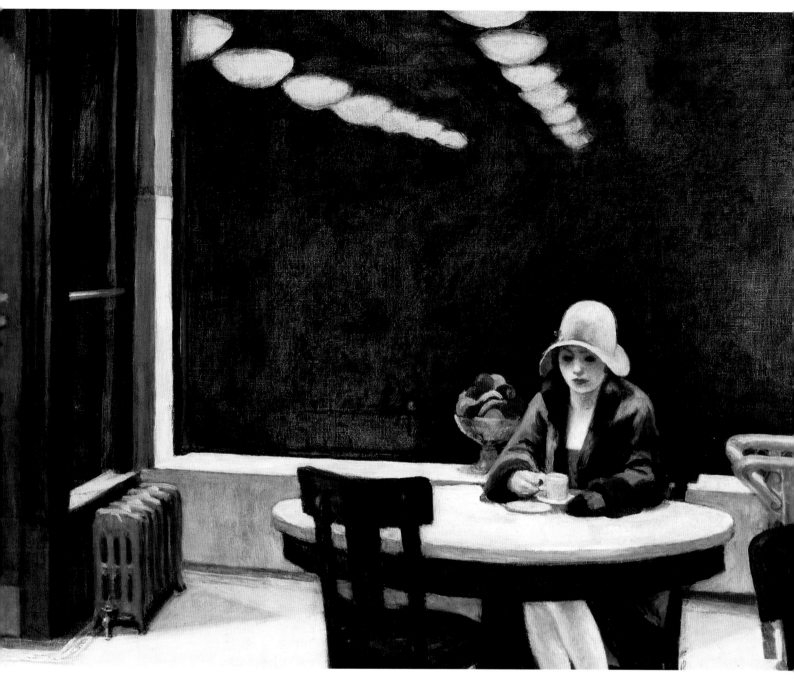

Automat *(1927)* by Edward Hopper
A woman sits alone with a cup of coffee. We can only guess if the empty chair opposite means that she's expecting someone or indeed would welcome the arrival of anyone at all. Placing her in an alienating environment where people connect only with vending machines, Hopper makes use of distance and detachment – painted and imaginary – to create a situation where the viewer supposes the consequences

sentimentality, make people look at some commonplace image and perceive their own susceptibilities in the face of daily existence.

For over forty years, Hopper was married to Jo Nivison, his inspiration, model and intellectual match. Jo was an artist herself, whose development was thwarted by Hopper's demands on her time. They had a studio apartment in New York and another home at Cape Cod, where Hopper represented the sunshine as the sole antidote to melancholy.

JEAN-AUGUSTE-DOMINIQUE INGRES

Louis-François Bertin *(detail) (1832)*
Seated in a simple chair against a sober backdrop, Bertin the founder and director of the Journal des Débats, *epitomizes the liberal bourgeoisie and establishment. This superbly delineated portrait is considered one of the finest of the nineteenth century and certainly a crowning achievement by Ingres*

Jean-Auguste-Dominique Ingres made his reputation in portraiture, although he believed that history painting would bring him lasting recognition. Having won the Prix de Rome, he lived in Italy for seventeen years, returning to Paris in 1824. There he found little in common with his French contemporaries, who had meanwhile 'breathed the atmosphere of Romanticism'. Ingres called his younger rival, **Delacroix**, 'the apostle of ugliness'. In retaliation, Delacroix declared Ingres had 'no imagination at all'. Indeed, Ingres had no instinct for narrative and his set pieces suffer for it. Up close, there is a mass of information but no connecting energy.

He had a bourgeois mentality, and yet his works reveal, as Baudelaire admitted, 'a deeply sensuous nature'. This is why Ingres is so admired. His pictures are painted with amazing physicality; and he relishes every detail of his wealthy sitters' clothes and jewellery. A supreme example is *Madame Moitessier* in her floral gown, which took twelve years to paint. Her little daughter was to have been included in the portrait, but she had grown up by the time Ingres finished.

Ingres returned to Rome as Director of the French Academy in 1834. Away from the constant criticism in Paris, he unwrapped his talent for teaching. Like his own tutor, **David**, he advocated drawing above all: 'If I had to put a sign over my door, I would write "School of Drawing" and I'm certain that I would create painters.'

Thetis Imploring Jupiter *(1811)*
In this illustration from Homer's Iliad, *Thetis begs Jupiter to repair the
Greeks' injustice to her son Achilles. Ingres casts Thetis in the familiar mould
of an elongated odalisque, her body curved around the solid architectural figure
that is Jupiter. Meanwhile, Jupiter's imperious pose both echoes Ingres'
Neoclassical treatment of* Napoleon I *(1806) and foreshadows the* Apotheosis
of Homer *(1827)*

WASSILY KANDINSKY

1866	*Born in Moscow, son of a tea merchant*
1886–92	*Studies law and economics at Moscow University*
1895	*Visits Impressionist exhibition, decides to be a painter*
1901–04	*Founds Phalanx. Travels to Italy, Netherlands and North Africa*
1910	*Paints first abstract in watercolour*
1911	*Co-founds* Der Blaue Reiter *with Marc*
1917–20	*Marries Nina Nicolayevna Andreyevskaya, birth of son Vsevolod. Works in Moscow at People's Commissariat of Education*
1921	*Death of son Vsevolod. Teaches at Berlin Bauhaus*
1924	*Co-founds* Blaue Vier *with Feininger, Jawlensky and Klee*
1925	*Moves with Bauhaus to Dessau*
1933	*Moves to France when Nazis close Bauhaus*
1944	*Dies in Neuilly-sur-Seine*

The Dream *(1911)* by Franz Marc
Marc nearly always included animals in his vivid pictures. For him, animals represented the innocence and harmony with nature that human beings had lost, and he firmly believed that art could bridge the natural and the spiritual worlds. Marc died in battle at Verdun in 1916. One of his last works, Fighting Forms, *moves towards abstraction under the influence of Kandinsky. The two artists collaborated on* Der Blaue Reiter *almanac and exhibitions in 1911 and 1912. The professed desire of the group was to go 'behind the veil of appearances'*

Wassily Kandinsky could hear colours. This condition – known as synaesthesia – was key to his art, and he even named some of his paintings 'improvisations', 'lyrical' and 'compositions' as though they were pieces of music. Kandinsky's pioneering development of abstract painting paralleled his need to express colours and forms as if they were plucked from the same air through which sound waves travel. He aspired to 'pure painting' that would bring the viewer to the same emotional threshold as listening to a symphony: 'Colour is the key. The eye is the hammer. The soul is the piano with its many chords. The artist is the hand that, by touching this or that key, sets the soul vibrating automatically.'

Kandinsky was thirty before he began to paint and yet became one of the most original and influential artists of the twentieth century. In 1901 he led an avant-garde movement in Munich called Phalanx. Both a school and a society, it aimed for freedom from an academy-dominated art world.

Kandinsky had a long-term relationship with one of the Phalanx students, Gabriele Munter, whose vision and experimentation influenced his style dramatically. Up to the outbreak of war in 1914, when Kandinsky had to leave Germany, Munter was present at crucial moments in his career: his first abstract painting, and the founding of the Expressionist *Der Blaue Reiter* (Blue Rider) group with Franz Marc (1880–1916). She led him to an appreciation of child art, which Kandinsky believed offered a deep spiritual understanding through which all humankind might grow.

Impression 5 *(1911)* by Wassily Kandinsky
Kandinsky's style was based on the non-representational properties of form and colour, used to express the full range of his memories, emotions and imagination

ANGELICA KAUFFMANN

1741 — *Born in Chur, daughter of a mural painter*

1757 — *Family move to Schwarzberg (now Austria)*

1763–65 — *Travels to Rome, Milan, Venice, Naples and Florence, finally joins St Lucas Academy, Rome*

1766–81 — *Moves to England, marries Antonio Zucchi, a Venetian painter working with the Adam brothers*

1768 — *Founder member of London's Royal Academy with Reynolds*

1781 — *Returns to run successful studio in Rome*

1807 — *Dies in Rome*

Family of Ferdinand IV *(1783)*
An extraordinarily large painting in which the royal family of Sicily and Naples appear lifesize, posed against a landscape rather than the rich interior of a palace. Bringing children up in the freedom and beauty of rural surroundings is a reflection of the philosophy of Jean-Jacques Rousseau

Angelica Kauffmann was a professional woman in the age of the amateur and the first to challenge seriously the male domination of history painting. Despite being barred from drawing the male nude – on which the conventions of history painting rested – she underwent several years of preparation in Italy before arriving in London at the age of twenty-five.

As a child prodigy, Kauffmann spoke four languages, played music and above all she could paint, completing her first commissioned work at the age of twelve. She travelled widely with her father, filling in the backgrounds to his murals. She continued to receive commissions and established a reputation in her own right, following the Neoclassical example of the German painter Mengs.

Invited to London by the wife of the English Ambassador in Venice, she painted numerous portraits in her first year – one sitter was the famous actor and theatre manager, David Garrick – until she had sufficient funds to buy her own house and could turn to history painting. Promoted by Joshua Reynolds, Kauffman became a founder member of London's Royal Academy of Art, contributing no fewer than four classical compositions.

Zoffany painted *The Academicians of the Royal Academy* in 1772 to commemorate the occasion. Ironically, it was decided that the members were to be arranged around a nude male model, so in order to include the two women academicians – Mary Moser and Kauffman – Zoffany represented them as portraits on the wall.

Elizabeth Hartley as Hermione in *A Winter's Tale* (c.1770)
Elizabeth Hartley was one of the most celebrated actresses on the London stage, and specialized in tragic Shakespearian heroines. Kauffmann makes the most of her striking red hair, but without a hint of the complexion that Hartley herself described graphically as 'freckled as a toad's belly'

GUSTAV KLIMT

1862	*Born in Baumgarten, son of a gold engraver*
1876	*Enrols at School of Arts and Crafts, Vienna*
1886–91	*Paints various commissions for ceilings and murals*
1892	*Death of father and brother*
1897	*Becomes first Chairman of Vienna Secession*
1900	*Wins gold medal at World's Fair, Paris*
1903	*Visits Ravenna twice for Byzantine mosaics*
1905–11	*Resigns from Secession, becomes member of Viennese Workshop, creates the* Stoclet frieze *in Brussels*
1907–8	*Paints* The Kiss
1911	*First prize at International Art Exhibition, Rome*
1918	*Dies of pneumonia after a stroke in Vienna*

Judith II (*detail*) (*1909*)
*The 'Kunstschau' marked Klimt's leadership of a new movement, after a dispute with the Secessionists. *Judith II* is in the Jugendstil (German art nouveau) mode but shows some influence from Schiele's drawings, which Klimt greatly admired*

A leading exponent of art nouveau among anti-conservative Vienna Secessionists, Gustav Klimt frequently provoked antagonism. The Emperor Franz Joseph II even forbade his drivers to go past any place showing Secessionist art. The objections were not to Klimt's sumptuous use of gold and Byzantine ornamentation, but to the barely concealed eroticism in his paintings.

Klimt's effect on other artists was more positive. He himself had been influenced by the Swiss **Hodler**, who returned the compliment saying: 'I love his frescoes...the freedom with which he treats everything.' And although **Schiele** later resolved his own colour handling by different means, he too was impressed when he first saw Klimt's work at the 1908 'Kunstschau'. Klimt helped the younger man considerably over the next two years.

Far from Paris, Klimt spent every summer at the Attersee – Austria's biggest lake. He found the landscape inspiring, and some of his best-known works were painted there, including *The Kiss*. Klimt's works on canvas were comparatively few, he regarded himself more as a muralist, which had been his prime route to success.

Three Ages of Woman (*1905*)
The three ages representing the cycle of life are set in a sea of silver bubbles. The figures themselves are more closely surrounded by shapes reflecting Klimt's interest in the science of microbiology. A little research reveals the shapes floating above the younger woman resemble colonies of bacteria, while the older one stands amid the elongated protozoa associated with death and decomposition

LEONARDO DA VINCI

La Scapigliata (1508)
A delicate oil study, perhaps a Madonna, known as
The Lady with Dishevelled Hair

Leonardo da Vinci trained as an artist and craftsman but soon proved himself a scientist as well. It is not known where he learned engineering; he might even have taught himself the laws of mechanics. His notebooks reveal the scope of his originality and are full of exquisite detail. Everything is in Italian because Leonardo lacked Latin, which was probably an advantage since his work was rooted in his own observation rather than the teachings of others.

Not all Leonardo's ideas were successful. His characteristic device of *sfumato* ('in the manner of smoke') depended on slow, careful modulation of light and shade – to Leonardo strong colour contrasts confused the eye – whereas traditional methods of fresco painting required rapid work on wet plaster. So Leonardo developed a new compound to prime the wall for *The Last Supper*. Unfortunately, it neither held the paint nor protected it from moisture.

However, what remains of the fresco demonstrates Leonardo's approach to composition. Rather than placing Christ and the apostles in a strict row, he grouped them naturally, each gesturing in reaction to Christ's statement that one of them would soon betray him. The way that the space appears to recede behind Christ's head is a classic example of one-point perspective.

Leonardo is one of the greatest painters and most versatile geniuses in history; the embodiment of the European Renaissance. His participation in a debate at court, between representatives of the arts and sciences, is reported admiringly by Vasari: '[he] silenced the learned and confounded the liveliest intellect.'

The Virgin and Child with St Anne *(c. 1510)*
The stream of life flows from the head of St Anne down through three generations in an intricate twisting manner known as contrapposto

AMBROGIO LORENZETTI

1290(?)	*Born in Siena, younger brother of the artist Pietro*
1319	*Recorded as living in Siena*
1325(?)	*Paints frescoes for chapter house of S. Francesco, Siena*
1327	*Enters the Guild at Florence*
1331–32	*Revisits Florence*
1337–39	*Paints frescoes in the Palazzo Publico at Siena*
1348	*Dies of the plague in Siena*

The Life of Saint Nicholas of Bari
(detail) (c.1332)
As bishop of Myra, St Nicholas is shown saving the town from famine by miraculously drying and multiplying the sacks of wheat that had fallen into the sea

There are few hard facts available about Ambrogio Lorenzetti. It is most likely that he was a pupil of **Duccio**, together with his older brother Pietro; and he is known to have paid at least two extended visits to Florence from his home in Siena. He was clearly familiar not only with the work of **Giotto** but also that of Giotto's Florentine successors; and he is probably responsible for certain Sienese influences on the art of Florence, particularly in the area of small devotional pictures.

Both Ambrogio and Pietro tend towards narrative rather than decorative work; and Ambrogio – the more inventive of the two – is best-known for his frescoes in the grand council chamber of Siena, dealing with themes of good and bad government and their effects on both urban and rural life. His delightful scenes are crammed with incident and architectural detail. They are the first panoramic views of town and country since classical times, and demonstrate the remarkable control of structure, space and distance achieved in Italian painting at this time, with Ambrogio as an advanced master.

The Lorenzetti brothers both died in the great plague of 1348, which killed two-thirds of the population of Siena, including a great many of the controlling aristocracy.

The Effects of Good Government in the City *(detail) (1337–39)*
This detail affords a glimpse of everyday life in a well-governed city. Men and women ride about on horseback, a shop stands open for business and an interesting portion of the town architecture is revealed, full of battlements and balconies. Although Siena rivalled Florence in prosperity at the time of painting, it is probably an idealized representation to contrast with the 'bad government' fresco in the same chamber, showing a city devastated by famine and monsters falling from the sky

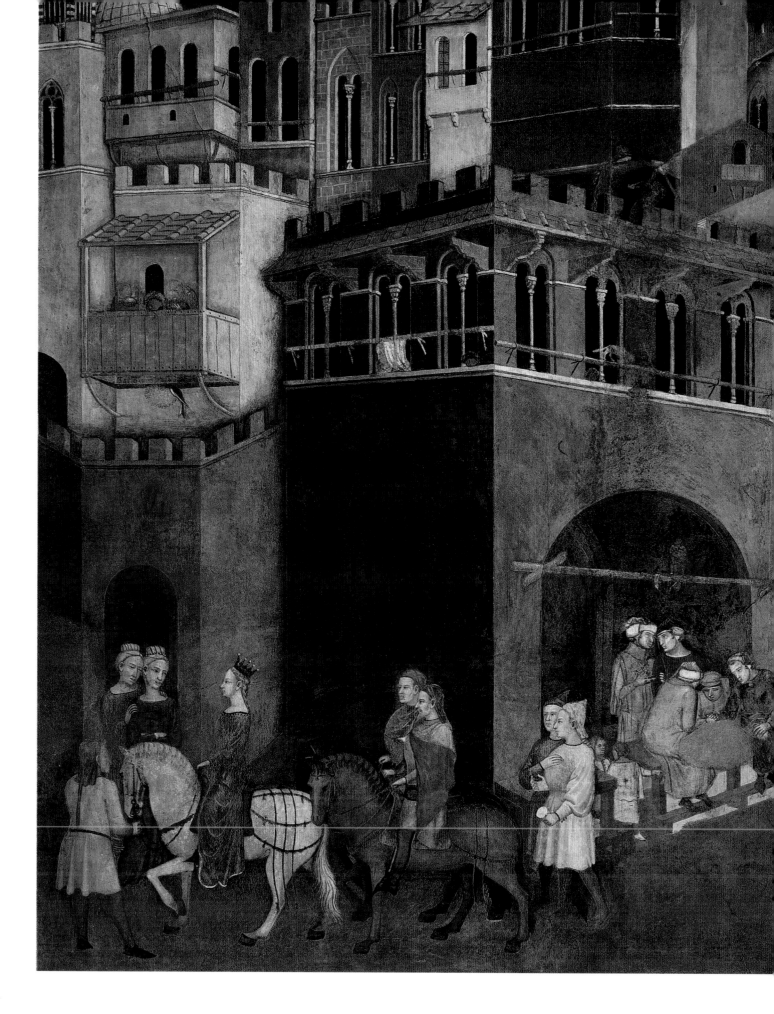

AUGUSTE MACKE

1887	*Born in Meschede, son of a civil engineer*
1904–06	*Studies art at Düsseldorf Akademie*
1905	*Visits Italy. Attends Böcklin exhibition in Heidelberg*
1906	*Visits Belgium, Netherlands and London.*
1907	*Visits Paris, influenced by Impressionists. Moves to Berlin, studies under Corinth*
1908	*Visits Italy and Paris*
1909	*Marries Elisabeth Gerhardt*
1910	*Birth of son Walter. Meets Marc, Jawlensky and Kandinsky in Munich. Joins Der Blaue Reiter*
1911	*Meets Ernst and Klee in Bonn*
1912	*Visits Delaunay in Paris with Marc*
1913	*Birth of son Wolfgang in Bonn. Visit from Delaunay and Apollinaire*
1914	*Visits Tunisia with Klee. Dies in battle at Perthes-les-Hurlus*

Pierrot *(1913)*
Although generally Fauvist in his colouring and Cubist in form, Macke had not yet had time to assimilate all the influences he had encountered during his mere six years as a painter

Auguste Macke was lucky enough to enjoy financial security, and was always free to study and travel. He also gained the patronage of his wife's uncle, Bernhard Koehler, in return for advising him on his art collection.

Macke first saw Impressionist paintings in Paris in 1907. Then, in Munich in 1909, he met **Kandinsky** and Marc, co-founders of the Expressionist group *Der Blaue Reiter* (Blue Rider) and worked with them to prepare the almanac for their first exhibition. Within a few years, through frequent travel and personal contacts, Macke had encountered every major modern art movement: the French Fauves (including **Matisse**), the Cubism of **Picasso** and Braque, and the Italian Futurists. He was particularly sympathetic to the colour harmonies of the Orphic Cubist Delaunay.

Macke took an independent line with the art of his time. His interests were figurative never mystical, using bright colour in broad outlined areas, and sometimes against a multicoloured mosaic in the style of Delaunay.

On Easter Monday, 1914, Klee and Macke arrived in the Tunisian village of Sidi Bou Said. Macke sketched the outside of a cafe before they hurried on elsewhere. Six months later he was killed in action. His friend Marc – who would meet the same fate two years on – wrote this epitaph: 'We painters know…he gave a brighter and purer sound to colour than any of us; he gave it the clarity and brightness of his whole being.'

Woman in a Green Jacket *(1913)*
*Painted at Lake Thun in Switzerland, this famous picture shows a particularly
sensitive and harmonious arrangement of form and colour. It is certain that
Macke would have become a greater artist if he had survived. As Marc said:
'We, his friends, we knew what promise this man of genius secretly bore in him.'*

RENÉ MAGRITTE

Fantomas poster (1925)
The Fantomas Appreciation Society was founded by the avant-garde poet Apollinaire in 1912. René Magritte and his brother Paul shared a passion for the Fantomas films, shown in 1913 and 1914 and based on the novels by Souvestre and Allain. The fictional criminal became a source of inspiration for Magritte and often suggested his choice of titles

Unlike most of his fellow Surrealists, René Magritte adopted an unassuming, rather dull lifestyle. The low profile was his way of ensuring that he met with as little interference as possible whilst concentrating on the Surrealist task of 'barring from your mind all remembrance of what you have seen, and being always on the lookout for what has never been'.

The tricks and puns presented in Magritte's paintings communicate on a level that contemporary viewers understand very well. We know that things are not always what they seem because we are subjected daily to thousands of media-generated images. What does the evidence of our own eyes mean anymore?

But Magritte will not let us dodge this onslaught, nor allow any situation to remain blindly accepted. He manipulates time, scale and viewpoint repeatedly. He turns night into day. He offers mirror images that show the reverse of what we expect to see. He creates vistas through window frames juxtaposed with canvases, suggesting the possibility of finding three-dimensional reality through the flat surface of a picture; yet the viewer must see that it's all merely painted. 'Everything we see hides another thing, we always want to see what is hidden by what we see.'

The Happy Donor *(1966)*
Magritte was always conscious that things have a flip side even more curious than their facade. In order to render the 'dark' side visible, several of Magritte's recurring motifs are assembled here: bowler-hatted Mr Average, the melodious cowbell (with associated cheese) and the evocative house at twilight. Being fooled allows us to 'shift our gaze', as the philosopher Lacan wrote, to eventually see things for what they really are by seeing what they really aren't

KASIMIR MALEVICH

Three Little Girls (1928–32)
Although painted in the period of Socialist Realism imposed by Stalin, these three figures echo the old Suprematist formalities and may also refer directly back to one of Malevich's earliest works, the Flower Girl *of 1905*

Kasimir Malevich did not attribute any use or purpose to art and it was his belief that artists should be spiritually independent in order to create it. Starting with simple drawings, his geometric square, cross and rectangle were intended to show the 'supremacy of forms'. Malevich initiated Suprematism in 1913 with his sets and costumes for the Futurist opera *Victory over the Sun*, for which one of the backcloths was a black and white square. He finally exhibited the iconic *Black Square* at the '0.10' show in Petrograd in 1915. Three years later, he produced his famous *White on White*, adding a mystic announcement: 'I have emerged into white. Beside me, comrade pilots...swim! The free white sea, infinity, lies before you.' This statement anticipated Minimalism by fifty years.

Post-revolution, the young Soviet Union seemed fertile ground for artists, and Suprematism became the style for everything from film posters to ceramics and textiles. Malevich, a man of great charm and a brilliant

Suprematist Composition *(1915)*
*An example of the straightforward combination of geometrical elements
that Malevich painted between the unveiling of Suprematism in 1913
and the 'White on White' series of 1917–18. He has introduced colour, a
red triangle appears, rectangles become trapeziums and there is strong
emphasis on the diagonal*

speaker, held teaching posts in various institutions and was made a curator at the Kremlin.

But beyond the early 1920s, the State tightened its grip and decreed that the arts should glorify political and social ideals. Oppressed and marginalized – even arrested once – Malevich watched while Stalin imposed Socialist Realism in 1932 and banished independent art movements from what had been the world's most progressive country for modern abstract art.

EDOUARD MANET

1832	*Born in Paris, son of a judge*
1850–56	*Studies in Paris under Couture. Travels widely*
1852	*Birth of father's illegitimate son Léon*
1855	*Meets Delacroix*
1858	*Meets Baudelaire. First painting* The Absinthe Drinker
1861	*Meets Degas*
1862	*Death of father*
1863	*Marries Suzanne Leenhoff, Léon's mother. Exhibits* Déjeuner sur L'Herbe
1865	*Exhibits* Olympia
1866	*Meets Cézanne and Monet*
1868	*Meets Berthe Morisot*
1870	*Serves in National Guard*
1875	*Exhibits* The Seine at Argenteuil
1881	*Awarded Legion of Honour*
1882	*Exhibits* Bar at the Folies-Bergères *at Salon*
1883	*Leg amputated. Dies of syphilis in Paris*

Lola de Valence *(1862)*
Lola de Valence was the lead dancer in a troupe from Madrid who performed at the Porte Dauphine during the summer season of 1862

Edouard Manet was a paradoxical combination of the revolutionary artist who craved official gold medals; the debonair man-about-town who used street slang; and the republican liberal who wanted to go home to the comfortable conservative lifestyle to which he was accustomed. He was handsome, witty and generous to friends, who included Baudelaire and Zola. And he loathed the hypocrisy of people like his own father, a pillar of the legal establishment with an illegitimate son, whose mother Manet married himself, once his father was dead.

He was one of the generation regularly excluded from the Paris Salon. Rejected for both style and content, the famously controversial *Olympia* and *Déjeuner sur L'Herbe* ended up in the Salon des Refusés, although Manet really had not anticipated the power of public opinion against him. Yet, as far as his peers were concerned, *Déjeuner* marked the dawn of Impressionism. Manet's composition follows a sixteenth-century engraving of a lost drawing by Raphael, called *The Judgement of Paris*. By reinterpreting the work of a Renaissance master, Manet was questioning the possibility of belief in anything one once trusted. This painting was completed the year after the death of Manet's father, who was both a judge and an adulterer.

By 1874 Manet's reputation as experimental artist and leader of the Impressionists was firmly established. The Café Guerbois, near his Batignolles studio, became the meeting place

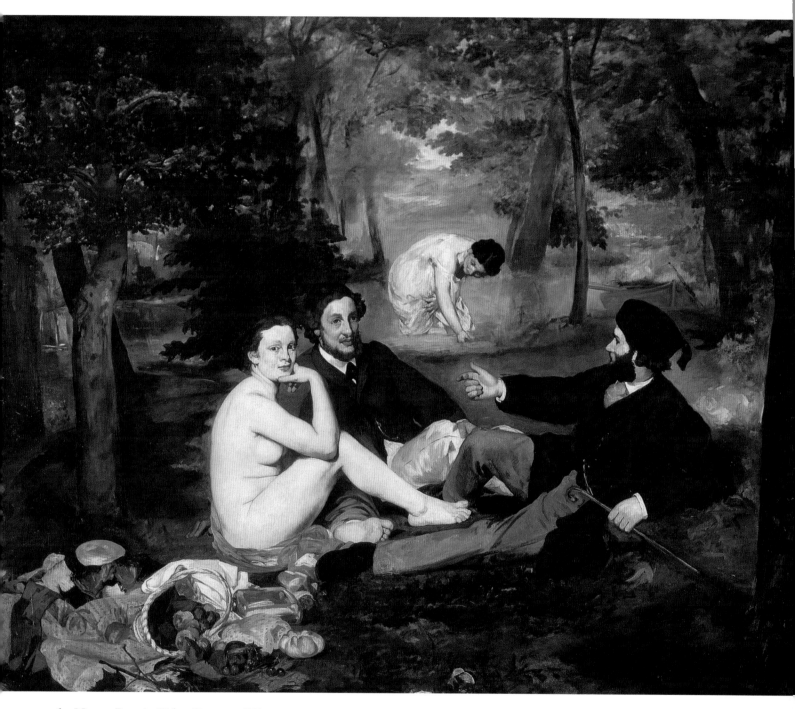

for **Monet**, **Renoir**, **Sisley**, **Degas** and **Pissaro** and although Manet presided over them regularly, he would not participate in their exhibitions. He chose instead to remain focused on the Salon, which he called 'the true field of battle'. His main influences had always been the Spanish painters **Velazquez** and **Goya**, but it was during this time – when he actually went painting *en plein air* from Monet's boat studio – that he came closest to the Impressionist style.

Déjeuner sur L'Herbe *(1863)*
The woman's bold stare challenges the law concerning her naked presence and that of the other woman (mixed bathing and nudity were illegal). It has been suggested that the face is that of Manet's model Victorine Meurent, but that the body belongs to Suzanne Leenhoff, mother of his half-brother and shortly to be his wife. The accompanying men are Suzanne's brother Ferdinand, a sculptor, and Manet's brother Gustave, in an 'artistic' fez. The bullfinch – hovering overhead – was a popular caged songbird in Paris at that time, perhaps the sight of one at liberty adds extra significance to the scene

ANDREA MANTEGNA

Ludovico Greeting His Son Cardinal Francesco Gonzaga
(detail) (1471–74)
The frescos in the Camera degli Sposi *(bridal chamber) of the ducal palace in Mantua are striking examples of fifteenth-century illusionism*

When Andrea Mantegna was a young man, there was huge interest around the north Italian city of Padua in the collection and study of Roman antiquities. Mantegna knew many of the university scholars and antiquarians involved in this work, and what he learned from them he frequently reproduced through his art.

In turn, his paintings fed a growing interest in the revival of classical forms. Throughout his career he made frequent reference to Roman-style bas-relief, as shown with Caesar himself in the epic suite, the *Triumph of Caesar*. Mantegna's sculptural effects reflect the influence of Donatello, for whom he once worked as an apprentice.

Mantegna's major skill lay in his use of illusionist perspective both for foreground action and background scenery. The prime example is his fresco painting in the *Camera degli Sposi*, Mantua, which inspired **Raphael** and Correggio and the work of the baroque masters. The St Zeno altarpiece in Verona is another fine example. The spatial construction of the painted hall in which the Madonna is displayed fits the actual frame, which itself simulates the front of a temple.

Together with his brother-in-law Giovanni **Bellini**, Mantegna was largely responsible for spreading the ideas of the early Renaissance in northern Italy. Not only were his paintings highly regarded, his engravings also won the admiration of **Dürer**.

When he died in Mantua in 1506, Mantegna received the rare honour of having a funeral chapel dedicated to him in the church of Sant'Andrea.

Lamentation over the Dead Christ (*c.1490*)
Mantegna has framed this confined space in a way that architecturally defines it as the cell of a morgue; and, trained as he was in the study of classical models, he conveys an impressive austerity with his Christ figure. His mastery of foreshortening also ensures that whatever the angle of approach, the viewer encounters the pierced feet. The draperies are sharply defined, painted – it is said – from Mantegna's models of folded paper and gummed fabric

SIMONE MARTINI

1284(?)	*Born in Siena, son of a plasterer*
1314	*Visits Avignon*
1315	*Paints* Maestà *in Palazzo Pubblico, Siena*
1317	*Visits Naples*
1319	*Paints polyptych for church in Pisa*
1324	*Marries Giovanna di Filippuccio*
1321–32	*Paints many church and government commissions, some lost later*
1333	*Paints* Annunciation *for Siena Cathedral with Lippo Memmi*
1339	*Settles in Avignon, becomes friend of Petrarch*
1344	*Dies in Avignon*

Angel Gabriel, Annunciation *(detail) (1333)*
The gilder's art is evident here, scribing the angel's words into the matt gold leaf background. With no currency laws, professional goldbeaters could get over one hundred leaves (8.5cm square) out of a single ducat, the gold coin of medieval Italy

Simone Martini died at the papal court in Avignon, after a successful and well-rewarded life spent in the service of influential patrons. His illness was such that he had already drawn up a will, and his generosity and love for his extended family are clear from the document. He was much loved in return, especially by his wife Giovanna who remained in full mourning for him.

This type of evidence is scarce from the fourteenth century and, in contrast, nothing definite is known of Martini's life before 1315, when he painted and signed his *Maestà* in Siena. Judging from the importance of this commission, he was already a distinguished painter, and probably regarded as equal in rank and skill with **Duccio** and Ambrogio **Lorenzetti**.

It is presumed that Duccio was Martini's teacher. He developed Duccio's treatment of space and volume, and mastered the Gothic style so brilliantly that his reputation spread across Europe. Martini did not, however, have Duccio's instinct for dramatic narrative. His skill was as a colourist, and in conveying the elegance of richly-clad figures in grand settings. He was the perfect Court painter. Martini also directed a workshop in Siena, undertaking ornamental work, such as gilding and heraldic devices. He was a consummate handler of detail, who could as readily paint a realistic townscape on a wall as he could illuminate a single page of manuscript for his friend, the poet Petrarch.

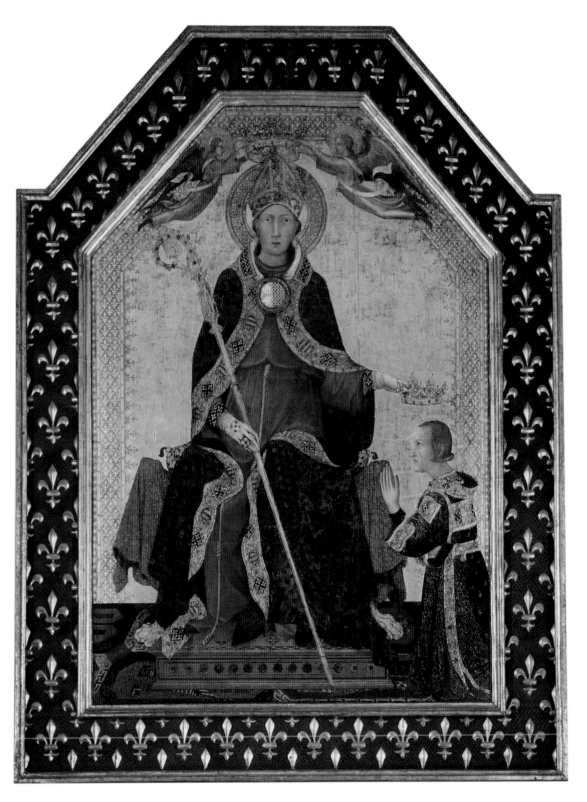

Saint Louis of Toulouse Crowning Robert of Anjou *(1317)*
*A double coronation takes place, while Louis IX of France offers his
earthly crown to his brother, he receives the crown of sainthood. Martini's
greatest skills are on display with lavish costumes, a coat-of-arms, large
quantities of gold leaf, and some clever perspective*

TOMMASO MASACCIO

Madonna and Child with Saint Anne *(1424)*
This group was a collaboration between Masaccio and Masolino. The composition of the major figures shows that they were Masaccio's contribution. The Madonna's right knee presses forward through the fabric of her dress and the hand of St Anne seems to explore the depth of the picture-space. By contrast, Masolino's angels remain rather flat and pale, with scarcely enough strength in their slender hands to hold the curtain up at the back

Tommaso Masaccio lived a hand-to-mouth existence with his widowed mother in Florence. His best clothes resided with the pawnbroker, and he couldn't afford to pay his assistant, who eventually took him to law. A search for fresh patronage may have been why Masaccio suddenly left for Rome in 1428, never to return. One report speaks of death by poisoning, while others say he fell victim to the plague.

Masaccio could have been just one of the crowd who struggled to survive and then vanished anonymously through conflict or disease. Instead, he left behind a body of work that, like **Giotto**'s before him, gave new life to western art. Along with two Florentine contemporaries, the architect Brunelleschi – who taught him perspective – and the sculptor Donatello, Masaccio embraced the principles of humanism wholeheartedly. He placed the fallible individual and the real world at the centre of his vision, drawing subjects from life around him rather than from gilded medieval models.

In 1426, when his former collaborator, Masolino, left the Brancacci Chapel unfinished

and went to Hungary on other business, Masaccio took the project over. The frescoes that he painted there were not only greatly superior to Masolino's but may be said to have started the Italian Renaissance with his mastery of perspective and observation of light. During a regrettably brief career, Masaccio gave Florentine art the direction it required. As a legacy, his Brancacci frescoes became the acknowledged training school of generations of Florentine painters.

The Rendering of the Tribute Money *(detail) (1426–27)*
An episode from Matthew's gospel. The tax collector at Capernaum demands payment of the temple tax. Jesus' answer is to order Peter to catch a fish, and in its mouth they will find a miraculous silver coin. Historians believe this picture alludes to a controversial tax reform in Florence. Masaccio may have included himself among the group of apostles, possibly as St Thomas, on the right. The apostles stand in a distinct semi-circle, solidly modelled in their Greek-style tunics and cloaks. The landscape in the background is painted in perfect perspective with successive planes of distance and the light very clearly coming from one source

HENRI MATISSE

The Apparition (1874–76) by Gustave Moreau
Gustave Moreau, the son of a Paris architect, became leader of the Symbolists. Inspired by the fifteenth-century Italians, he was a creator of hallucinatory worlds based on myths and dreams. Matisse spoke of his teacher as an invigorating influence, although the art establishment disapproved of his methods. 'He did not set us on the right roads, but off them. He disturbed our complacency.' Moreau's lavish use of paint gave rise to textures that inspired Matisse's later decorative work

Henri Matisse and Pablo **Picasso** shared artistic pre-eminence and popularity for much of the twentieth century, but there was a huge difference between them. Against Picasso's unrelenting showmanship, Matisse developed slowly and methodically, and never set out to be controversial. He once famously said he wished his art to be like a comfortable armchair to relax in at the end of a busy day. Behind the nude dancers and riot of colour, Matisse was an unashamed bourgeois.

Matisse took early training from Gustave Moreau (1826–98), who positively encouraged his students to question everything and to advance their own opinions. Matisse studied the works of **Manet**, **Gauguin**, **Van Gogh** and **Cezanne**. Then he explored **Seurat**'s pointillism through Signac. But it was from 1904–07 that he got together with Derain,

Still Life of Fruit and a Bronze Statue *(1910)* by Henri Matisse
Matisse allowed the colours of these objects to dictate the final composition.
Warm, glowing fruits and bright ceramics leap out from the cool background,
at the same time remaining integral to the arrangement. Matisse rejoiced in the
use of newly invented pigments and the restoration of colour's emotive power

Vlaminck, Braque and other former students, to experiment in the vivid colours and exaggerated style that was called Fauvism. Matisse travelled south one summer with Derain to Collioure; and that was where he first had the idea for his painting *The Dance*, while watching fishermen dancing in a circle on the beach.

After the Fauves, Matisse began to work with bolder shapes and strong patterns. Once he had moved permanently to the Cote d'Azur, his pleasure in floating bright colours onto canvas culminated in some of his most successful works.

As an old man, Matisse underwent abdominal surgery, which left him quite disabled. Undaunted, he entered yet another phase of creativity with simple coloured paper cut-outs; and so, often bedridden, he carried on making art to the last.

MICHELANGELO BUONARROTI

The Holy Family with Infant St John the Baptist *(Doni tondo) (c.1506)*
Painted for the birth of Agnolo Doni and Maddelena Strozzi's daughter, this is a fine example of Michelangelo's sculptural eye for intertwining bodies and the play of light on muscles and drapery. His female figures are unfailingly muscular because Michelangelo used male models, claiming that females charged more

Michelangelo Buonarroti – like his Florentine contemporary, **Leonardo da Vinci** – is one of art's most versatile geniuses. Possibly the greatest marble sculptor in the western tradition, he was also a master painter and architect. Had he only sculpted his first *Pietà*, painted the Sistine Chapel or designed St Peter's in Rome, any one of those achievements would have ensured his place in history.

Michelangelo's ability to judge a block of marble was legendary; some even said that he could see the potential figure inside. However, for his *David*, Michelangelo was obliged to rework a forty-year-old block, previously abandoned by another sculptor

Leading up to the commission for the Sistine ceiling, Michelangelo was in constant demand and always well rewarded. Throughout his life, he invested wisely in property for his four brothers and possessed a fortune himself at the time of his death.

His response to the Sistine Chapel assignment was to protest: 'painting is not my art'. The rest – as we know – is history. For four highly uncomfortable years, Michelangelo struggled to transform an odd-shaped, leaky vault with some of the most sublime and memorable images in the world.

As an old man, he devoted the final eighteen years of his life to St Peter's Basilica. The dome that he designed was not finished in his lifetime, but he would be satisfied that it is now a world-famous architectural landmark.

Christ, the Last Judgement, Sistine Chapel *(detail) (1541)*
This fresco gave rise to controversy from the start. Christ standing, rather than sitting as the Bible states, was the chief problem. Although standing certainly seems a more authoritative position, in response to later laws against nudity, another painter added spurious draperies. Level with Christ's left foot sits the martyred St Bartholomew, holding his own flayed skin. The skin contains Michelangelo's self-portrait

JOHN EVERETT MILLAIS

1829	*Born in Southampton, son of member of Jersey Militia*
1840	*Enters Royal Academy Schools*
1848	*Co-founds Pre-Raphaelite Brotherhood with Hunt and Rossetti*
1849	*Exhibits* Lorenzo and Isabella *at Royal Academy, London*
1850	*Exhibits* Christ in the House of His Parents *at Royal Academy, London*
1852	*Paints Siddall as* Ophelia, *exhibits at Academy*
1853	*Visits Scotland with Ruskins*
1854	*PRB breaks up*
1855	*Marries Effie Ruskin after her annulment*
1862	*Family settles in South Kensington*
1865	*Tours Italy*
1878	*Wins medal at Paris Universal Exhibition, awarded Legion of Honour*
1885	*First artist to become Baronet*
1896	*Elected President of Royal Academy. Dies of throat cancer in London*

Pears' Soap Advertisement Featuring Bubbles (1886)
Millais' grandson, William James, was the model for this picture, originally titled A Child's World. *When bought by Pears, Millais' permission had still to be obtained for the addition of a bar of soap, for use as an advertisement.* Bubbles *remains one of the most iconic advertising symbols ever devised, and many of the colour prints that Pears later published hung in homes around the world*

In 1840, aged only eleven, John Everett Millais became the youngest pupil ever admitted to London's Royal Academy Schools. Whilst there, he met Holman Hunt, who became a lifelong friend, and also Dante Gabriel Rossetti. All three agreed that the Academy had stifled British art too long with its 'murky chiaroscuro'. So in 1848, out of their radical discussions, the Pre-Raphaelite Brotherhood emerged to challenge orthodoxy with a colourful return to pre-Renaissance values.

The life of the Brotherhood was fairly short – six years – but spent under attack from both press and public. Millais' *Christ in the Home of His Parents* drew a venomous review from Dickens. The fuss reached the ears of Ruskin who wrote to *The Times* in defence of the Pre-Raphaelite Brotherhood. This proved a fateful connection for Millais, who fell in love with and later married Effie, Ruskin's ex-wife. They went on to have eight children.

The passion for medievalism wore off when

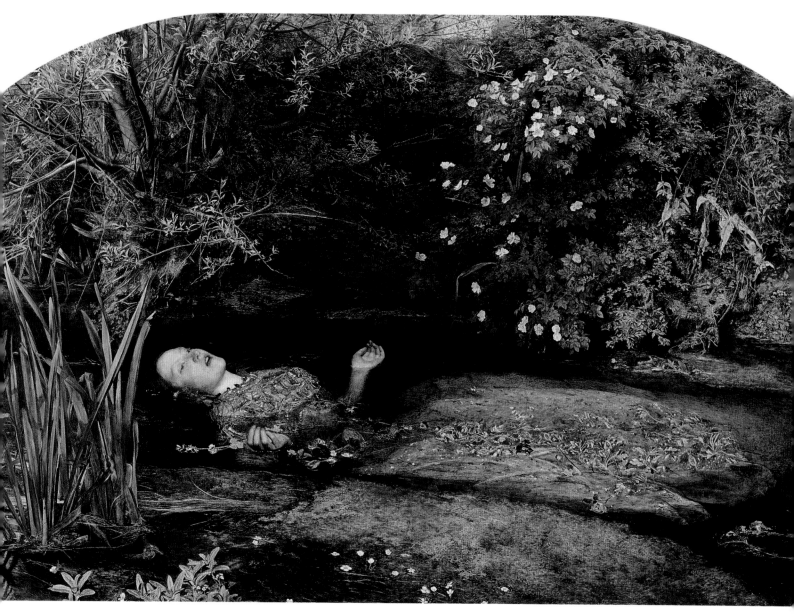

Millais tired of spending all day painting an area 'no larger than a five shilling piece'. He decided to loosen up his brushwork and settle down to being a first-class academic painter. Millais was a brilliant technician but he was no intellectual. He painted politicians and sentimental narratives without a trace of cynicism. He enjoyed the wealth and awards that his talent justly brought him; doted on his family; and kept the loyalty and affection of his friends, especially that of his fellow artists.

Ophelia (1851–2)

The Pre-Raphaelites experimented with every new pigment available, glazing them for maximum luminosity, onto canvas primed with zinc white. Ophelia 'reads' like a colour merchant's catalogue, with its cobalt blue, madder lake, chrome yellow, chromium oxide and zinc yellow. Millais began painting the background out of doors, near Kingston-upon-Thames. The painting was completed in London the following winter. Lizzie Siddal, the Pre-Raphaelite muse, wearing an antique brocade gown, had to lie in a bath of water, heated by oil lamps from below. The cold she caught as a result brought the threat of damages against the artist from her father

AMEDEO MODIGLIANI

1884	*Born in Livorno*
1902–03	*Studies in Florence and Venice*
1906	*Moves to Paris*
1909	*Returns to Livorno and to Paris again. Meets Brancusi, decides to be a sculptor*
1912	*Exhibits sculptures at Salon*
1914	*Health begins to fail, turns from sculpture to painting*
1917	*Moves to South of France, meets Jeanne Hebuterne.*
1918	*Birth of daughter Jeanne*
1919	*Returns to Paris*
1920	*Dies of tubercular meningitis in Paris*

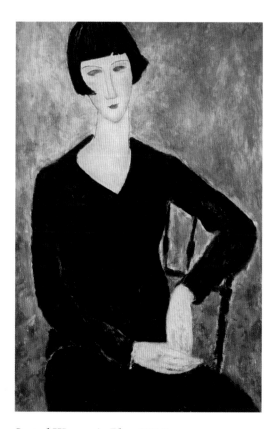

Seated Woman in Blue *(1919)*
A beautifully understated portrait in a limited palette that conveys a meditative mood. The subtle broken tones used in the background seem to reflect the inner space of a calm mind, and also complement the comparative flatness of the flesh tones on the sitter's face, neck and hands

Amedeo Modigliani produced such distinctive work that people wonder how – in Paris at the start of the twentieth century – he remained untouched by either Cubism or Fauvism. Instead of fracturing his image or painting in heightened colour, he took a decidedly representational approach.

Modigliani never had any interest in the abstract and found no affinity with Picasso or Matisse. After befriending the Romanian sculptor Brancusi, he moved from Montmartre to Montparnasse, where Brancusi had a studio. Modigliani, as an Italian, favoured the stone-carving tradition, and the rebuilding of Montparnasse meant he could beg plenty of limestone from building sites. He established his elongated style with a series of elegant heads that he exhibited in the 1912 Salon d'Automne.

Two years later, Modigliani abandoned sculpture on health grounds. His paintings consist almost entirely of portraits and nudes. The portraits of his friends are stylized but quite recognizable. The nudes were models, paid for by his dealer Zborowski, who often supplied paint and canvas too. The slender, mannered figures became Modigliani's trademark; the oval

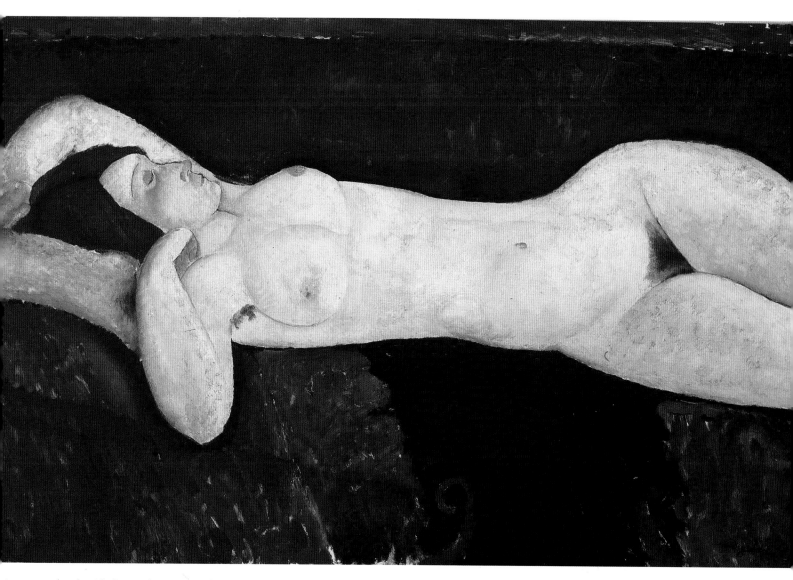

head with linear features, inclined on a long neck, with the body quickly brushed in ochre.

Modigliani was destroying himself with drugs and alcohol, but still attractive, as one female sitter described: '...with black tousled hair and the most beautiful hot, dark eyes... his red silk scarf carelessly knotted around his neck.' He was married with a small daughter, but shockingly, two days after his untimely death, his pregnant widow Jeanne committed suicide by leaping from a fifth-floor window.

Reclining Nude *(1918-19)*
Early in 1917, in Zborowski's apartment, Modigliani painted a series of nudes that ensured his fame. Gallery owner, Berthe Weill gave him a one-man show in December, describing the nudes as 'sumptuous'. The police commissioner rapidly closed the gallery, outraged that the figures had 'hair'. Modigliani's nudes are voluptuous in their sculptural curves but never indecent. He painted intensively in the last years of his life, refining the female form in unique compositions that achieve a harmonious balance between the erotic and the aesthetic

PIET MONDRIAN

1872	*Born in Amersvoort, son of a headmaster*
1892–94	*Studies fine art at Rijksacademie, Amsterdam*
1903	*Wins travelling prize from Arti et Amicitae Society*
1908	*Learns pointillist and fauvist techniques at Toorop's Domberg art colony*
1909	*Joins Theosophists, breaks with Calvinism*
1911	*Encounters Cubism at exhibition in Amsterdam*
1912	*Moves to Paris. International fame after shows in Paris and Berlin*
1917	*Founds* De Stijl *group with Van Doesburg*
1919	*Returns to Paris. Publishes* Le Neo-Plasticisme
1934	*On Hitler's list of 'degenerate art'*
1938	*Moves to London, meets Hepworth and Nicolson*
1940	*Settles in New York*
1944	*Dies of pneumonia in New York*

Interior *(1919)* by Theo van Doesburg
An architectural model in De Stijl style, showing marked similarities with Mondrian's principles of design

Piet Mondrian came from a devout Calvinist family of keen painters and musicians. But their repressive discipline led to his rejection of a steady art teaching career in favour of the artist's life itself, and later still, to his embrace of Theosophy.

This mystical belief system – in humanity's evolution towards spiritual unity – was popular in the West at the time, not least amongst the pioneers of abstract art, **Kandinsky** and **Malevich**. Mondrian's encounter with Cubism in 1911 was the critical point of his artistic development, when he removed natural forms from his pictorial vocabulary. Together with Theosophy, it propelled him into the ranks of the avant-garde. The obscure Dutchman left for Paris, the first step towards an international life that would have a lasting impact on western art.

Stranded in Holland by World War I, Mondrian and Theo Van Doesburg (1883–1931) formed a group and published a magazine called *De Stijl* (The Style). The writer Schoenmaeker's ideas of 'positive mysticism' were directly incorporated and Mondrian's aesthetic became their guiding force, committed to purifying modern art and bringing it to everyone via architecture, product design and typography.

The very term, Neo-Plasticism, that Mondrian adopted for his geometric abstractions in 1921, was borrowed from Schoenmaeker. With his typical asymmetrical arrangements of squares and rectangles painted in primary colours divided by black bands on a white ground, Mondrian strove for transcendental experience and pure harmony.

Composition with Red, Black, Blue and Yellow, 1928 by Piet Mondrian 1872-1944
*Mondrian kept strictly to vertical and horizontal lines of composition and broke with
Van Doesburg for introducing diagonals into his work in 1924. When Mondrian moved to
New York, in response to his energetic new surroundings, his lines formed the all-colour grids
he called 'boogie-woogie'*

CLAUDE MONET

Late Summer Haystacks *(detail) (1891)*
After the Gare Saint-Lazare, *Monet subsequently embarked on other series – haystacks, Rouen Cathedral and the waterlilies at Giverny – each a painstaking demonstration that atmospheric colour, caused by changes in the light, can modulate a subject through the entire spectrum*

Claude Monet is the central figure of Impressionism. The pioneering movement had its seed in an encounter between a teenaged caricaturist and a local painter, at the shop of the only picture framer in Le Havre. There, young Monet was introduced to Eugene Boudin; Academy-trained, but one who liked to paint his beach scenes in the open air, in dabs of pure colour with loose, delicate brushstrokes. That summer, Boudin taught Monet to draw and paint directly from nature, 'in the light, within the atmosphere, just as things are'. To honour Boudin, the Impressionists included him in their first Paris exhibition.

In April 1874, a group of artists – all Salon rejects – mounted their show in a former photographic studio. Some of the names read now like a role of honour: **Cézanne**, **Degas**, **Monet**, **Morisot**, Pissarro, **Renoir** and Sisley. Most critics were scathing and the term 'Impressionists' was unwittingly coined by one, Louis Leroy, who reserved particular scorn for Monet's *Impression Sunrise*. Turning the joke back on Leroy, the artists adopted the name permanently.

Steam Train, La Gare Saint-Lazare *(detail) (1877)*
One of a series of twelve railway station pictures, created at different times of the day. For his most ambitious study of the urban landscape, Monet chose Saint-Lazare, gateway to his beloved Normandy. He concentrated on the full-spectrum effects of light, smoke and steam, building cloud shapes with curly brushstrokes. Monet was a master at adapting strokes to show how light affects texture and form

BERTHE MORISOT

Young Woman Powdering Her Face *(detail) (1877)*
One reason Morisot joined the Impressionists may have been their revival of the genre scene. Impressionist men had abandoned set-piece history works, which required complex studio arrangements, and now painted en plein air or within a bourgeois domestic setting. Scenes from everyday life were the territory of artists of both sexes

Berthe Morisot produced over 300 paintings. Their principal subjects are women and children; and a large proportion of them feature her sisters and their families, or her own daughter, Julie, whom she regularly recorded, from the baby in *Wet Nurse* to the adolescent in *Julie Daydreaming*.

Morisot's own mother was responsible for fostering the talents of her artistic daughters, Berthe and Edme. Their tutor was the landscapist **Corot**, who encouraged them to work *en plein air* and make painting trips away from Paris. Summer 1862 found the whole family riding mules through the Pyrenees because Berthe and Edme could not go unchaperoned. Their father – a highly paid government official – even built a studio in the garden for them, and he and his wife frequently entertained painters and musicians at their home.

Morisot became greatly attracted to Edouard **Manet**. He included her in his 1869 Salon picture *The Balcony*, became her mentor and, eventually, her brother-in-law. Once married to Eugene Manet, Morisot constructed

The Butterfly Hunt *(1874)*
Morisot's sister Edme and her young children. Edme's marriage in 1869 marked the end of the sisters' painting partnership. She wrote rather wistfully to Berthe: 'Your life must be charming…to talk to M. Degas while watching him draw, to laugh with Manet, to philosophize with Puvis.' Maybe the butterfly in this painting is not the only elusive object in Edme's view

artistic circles of her own. At their new house in Bourgival they hosted regular soirees for artists and writers, among them **Degas**, Caillebotte, **Monet**, Pissarro, **Whistler**, **Puvis de Chavannes**, **Renoir** and Mallarmé.

No doubt her wealthy background gave Morisot opportunities beyond those of less privileged women. However, she needed no prompting or protection to ally herself boldly with the Impressionists in 1874 and, despite the misogynistic attitudes of a few fellow artists, she managed to pursue and sustain a professional role.

EDVARD MUNCH

Rêverie *(1870)* by Odilon Redon
Odilon Redon was a graphic artist and writer as well as a great Symbolist painter. Influenced by Courbet and Corot, he eventually escaped from the effects of an unhappy childhood, due to his epilepsy

Edvard Munch's visits to Paris between 1889 and 1892 were vital to his development, particularly as a stimulus for German Expressionism. He studied **Van Gogh** and the Symbolists, **Gauguin**, Moreau and Odilon Redon (1840–1916). The first version of *The Scream* followed in 1893. The swirling lines of colour are reminiscent of Van Gogh's landscapes; the agony of the soundless scream comes directly from Munch.

'From the moment of my birth, the angels of anxiety, worry, and death stood at my side...' Death was a recurring topic for the artist; both his parents and two siblings died early. Munch survived into his eighties but suffered from chronic anxiety, psychosomatic diseases and alcoholism. His depression once led to hospitalization. Munch's themes foreshadowed many of the preoccupations of the twentieth century: loneliness, alienation, neurosis and sexuality. A note from his diary announces: 'No longer shall I paint interiors with men reading and women knitting. I will paint living people who breathe and feel and suffer and love.' He found no lasting happiness in either of his own love affairs, although he commemorated both women in *The Frieze of Life*.

Munch's art was exhibited worldwide, won awards and attracted collectors within his lifetime. In 1937, Hitler's response was to strip his paintings from gallery walls, along with those of other 'degenerate' modern masters.

The Scream *(1893)* by Edvard Munch

'I was walking along the road with two friends,' wrote Munch, 'The sun set. The sky became a bloody red. And I felt a touch of melancholy. I stood still, leaned on the railing, dead tired. Over the blue-black fjord and city hung blood and tongues of fire. My friends walked on and I stayed behind, trembling with fright. And I felt a great unending scream passing through nature'

CLARA PEETERS

1594	*Born in Antwerp*
1607	*Paints first recorded picture*
1610(?)	*Paints self-portrait* Vanitas
1657(?)	*Dies in Antwerp*

Table With a Pie, Game and Olives *(c.1611)*
Peeters' work developed noticeably from her earliest, cautiously traditional compositions, executed from a high vantage point, to elaborate arrangements like this one. The vantage point is lower and a selection of luxurious items are placed on a minutely detailed brocade tablecloth, all set against a dark background for maximum effect

The term 'still life' had not been invented when Clara Peeters' career began. Her type of picture was generally called a 'breakfast piece' (*ontbijtje*) because it depicted bread and fruit. More elaborate arrangements of food and drink qualified as a *banketje* (banquet).

Peeters' paintings are highly skilled, beautifully finished and of a size that demands prominent display. All evidence points to her as a professional artist with wealthy clients, and the only Flemish woman to have specialized so early in this genre. She left over thirty works, signed and dated between 1607 and 1621, including a self-portrait, *Vanitas*, painted around 1610.

Yet, we know almost nothing about Peeters

personally. Her birth is recorded in Antwerp in 1594 but the time and place of her death remain a mystery. She is said to have left a picture dated 1657, which would be the latest date for her, but it is lost. Nor does her name appear on any guild rolls, although women had been listed since 1602.

It may seem improbable that a girl of thirteen could have painted so expertly, but Angelica **Kauffmann** accomplished her first commission at the age of twelve. The 1607 picture is a wedding piece: the green berkemeyer and Venetian wine glass represent husband and wife; a gold ring lies near a lit candle; sprigs of rosemary signify fidelity. It would have provided Peeters with a charming debut and the ideal platform for her amazing skill.

Table with Vase of Flowers and Dried Fruit *(1611)*
*This decorative genre gave artists the opportunity to show off their virtuoso
talents. Peeters amply demonstrates her ability to render ceramics and metals
as well as spring flowers. Her oil technique was versatile, ranging from
glazes to impasto. Her sound training suggests she may have been the pupil of
Beert or Van Hulsdonck*

PABLO PICASSO

1881	*Born in Malaga, son of a drawing professor*
1901–06	*Travels between Barcelona and Paris, finally settles in Paris. 'Blue' and 'Rose' periods*
1906–14	*Paints* Les Demoiselles d'Avignon *(1906). Meets Braque. They invent Cubism and pioneer collage*
1914–18	*Works with Cocteau, Satie and Diaghilev*
1930s	*Works as sculptor, writes in surrealist style. Paints* Guernica *for Paris International Exhibition, 1937*
1939–45	*In France for WWII with Sabartes, Dora Maar, later Françoise Gilot*
1947–49	*Birth of son Claude and daughter Paloma, both by Gilot. Works as ceramicist*
1954	*Meets Jacqueline Roque*
1961	*Marries Roque. Moves to Mougins*
1971	*Louvre solo exhibition*
1973	*Dies at Mougins*

Female Figure at a Table *(1912)* by Umberto Boccioni
Umberto Boccioni (1882–1916), a founder of the Futurist movement, first met Picasso through Severini in Paris, in 1911. The dialogue between Milanese Futurism and Parisian Cubism was fruitful. Boccioni absorbed Picasso's technique of fusing figure and background, dissolving traditional perspective and making use of tonal modelling. Picasso's portrait Daniel-Henry Kahnweiler *was a major influence*

'Each time I had something to say, I said it in the way I felt was right. Different motifs demand different techniques. This does not imply either evolution or progress but an accord between the idea that one desires to express and the means of expressing it.' Pablo Picasso's words express what many – both critics and admirers – find so elusive and capricious about him. He never 'developed' in a satisfying linear progression or stayed within a style once it had evolved. Instead, as one art historian wrote, he was like a spider 'who sits watching in the centre of a web…from time to time he pounces and the direction of his pounce is usually unpredictable'. Picasso's ventures into ceramics, sculpture and printmaking were all unfailingly inventive; in fact, from the painting of *Les Demoiselles d'Avignon* onward, virtually no artist could escape his influence.

Later on, Picasso referred to art history, creating variations on earlier masters' works through a variety of media: prints, drawings and paintings. A prime example is the series *Las Meninas*. Picasso often turned to a specific work because he identified with it personally and, as a Spanish artist, he had always felt profound ties with **El Greco**, **Velazquez** and **Goya**.

Weeping Woman *(1937)* by Pablo Picasso
*The model for this intensely moving picture was surrealist photographer Dora
Maar (Theodora Markevich), Picasso's mistress and muse for seven years before
a stormy separation that left her broken and reclusive. Like other left-wing
sympathizers in 1937, the couple's eyes were on the civil war in Spain. Maar
photographed Picasso's creation of* Guernica *– the anti-war icon – which was
painted in a studio she hired in rue des Grands-Augustins*

PIERO DELLA FRANCESCA

1410/20	*Born in Borgo Sansepolcro, son of a tanner*
1435(?)–39	*Working in Florence under Veneziano*
1442	*Town councillor in Borgo Sansepolcro*
1445–62	*Paints* Madonna della Misericordia *in Borgo Sansepolcro*
1452–65	*Paints frescos for church of St Francis, Arezzo*
1455(?)	*Working for Court of Rimini*
1459	*Paid for work (now lost) in Vatican*
1465(?)	*Working for Duke of Urbino*
1492	*Dies in Borgo Sansepolcro*

Battista Sforza, wife of Federico da Montefeltro
(c.1472)
Battista Sforza was a member of the ruling Milanese family. She bore Federico seven daughters and a son after whose birth she died. Most historians believe this portrait – one of a diptych – was painted posthumously. The background shows Urbino and the surrounding countryside

Piero della Francesca appears to have led a quiet provincial life. Although Veneziano was his master, he is not recorded as belonging to any workshop, and spent most of his time either in Arezzo or Borgo Sansepolcro. He seems to have freelanced only for short periods in Rome, Ferrara, Urbino and Florence, perhaps juggling a number of assignments at any one time.

Della Francesca's work in the field of architectural invention would have made him much sought-after, for he was also a master geometrician and the author of a learned treatise on the rules of perspective. Such expertise with scale and proportion makes his paintings visually powerful. What makes them pleasing as well is his genius for organizing colour masses, carefully balanced against large pale areas to achieve unity between space and lighting.

Della Francesca worked slowly. For a fresco painter, this normally poses problems but he hung wet sheets over the plaster at night so he could return to it the next day. Oil painting on wood – such as he had probably seen in Urbino – gave him no such trouble. Della Francesca's style reflected the popularity of Flemish oil painting among the patrons of the period, which may account for the loss of esteem after his death, when tastes inevitably changed.

Pala Montefeltro *(1472–74)*
The Brera altarpiece: Madonna and child with angels, saints and Federico da
Montefeltro, Duke of Urbino *The Duke lost his right eye and part of his nose in a
tournament and was always shown facing left. This was probably della Francesca's last
work before his eyesight failed but his mastery of proportions is still remarkable. The
ostrich egg hanging from the shell in the apse symbolizes the virgin birth and is echoed by
the oval of the Madonna's head, placed in the precise centre of the composition*

JACKSON POLLOCK

Navajo Sand Picture
Pollock developed his compositions by allowing the imagery to evolve spontaneously, without preconceptions. He called this technique 'direct' painting and compared it to Native American Indian sand painting, made by trickling thin lines of coloured sand onto a horizontal surface. Pollock claimed, however, that for him it was 'a means of arriving at a statement'

Jackson Pollock's groundbreaking method helped New York to supplant Paris as the avant-garde capital of modern art. By the end of World War II, it was time for a cultural challenge from the New World. Pollock declared, 'I don't see why the problems of modern painting can't be solved as well here as elsewhere', and began blazing a trail for other Abstract Expressionists. Even De Kooning admitted, 'He broke the ice.' De Kooning and Pollock were friendly rivals; it was the critics who liked to champion one against the other. But De Kooning never captured the public imagination as Pollock did when he broke with tradition.

Pollock's Action painting was influenced by the Surrealists' 'psychic automatism'. Rejecting easel and palette, and without any preliminary sketches, he spread unprimed canvas over the floor and poured paint straight from a can, or he dripped and flicked it, using brushes and sticks. Sometimes he incorporated broken glass or wire for added texture.

Pollock is famous for the wild drunken behaviour that ultimately killed him. Yet he was a solitary individual, not one for the groups or ideologies that bonded artists in those days.

Pollock was free of the 'art-historical' approach; unsophisticated and intellectually uncomplicated, his chief contribution to art was to express emotion and sensation through abstraction.

Undulating Paths *(1947)*
*His large scale 'drip paintings' are Pollock's most impressive works,
which he produced between 1947 and 1952 (Pollock abstained from
alcohol from 1948 through most of 1950). Moving rhythmically, he
would cover the whole canvas, quickly interweaving pattern and
colour; the procedure was always controlled and far from random*

LIUBOV POPOVA

1889	*Born Liubov Sergeyevna Eding in Moscow, daughter of a draper*
1907–08	*Studies under Zhukovsky and Yuon*
1909–11	*Travels around Russia and to Italy*
1912–14	*Studies in Paris, travels in France and Italy*
1915	*Exhibits with Tatlin and Malevich in 'Tramway V' and '0.10' in Petrograd*
1916	*Joins Malevich's Suprematists*
1921–23	*Teaching, exhibiting and theatre design*
1924	*Dies of scarlet fever in Moscow*

Architectonic Composition *(1918)*
A later abstract style, painted in brilliant colours on rough board; geometric shapes are superimposed on one another to create depth. With Malevich and Tatlin, Popova was the most outstanding painter of the post-1914 Russian abstractionists

Daughter of a wealthy draper in Moscow, Liubov Popova initially studied art with private tutors. She also had the opportunity to travel a great deal around Europe and was introduced to a broad range of influences, from Russian icons and the Italian Renaissance to the Cubists and Futurism.

When Popova was forced to return home at the outbreak of World War I, she was not alone. Unlike artists in other parts of Europe, who were dispersed, the Russians found themselves reunited, thereby forming the most formidable avant-garde. At first, Popova was occupied with working through the Cubist and Futurist inspirations that she had received while studying in Paris. However, by late 1916, she had joined the Suprematists and was painting dynamic geometric compositions.

In the early 1920s, Popova's fascination with Constructivism resulted in her giving up pure painting in favour of industrial design. Before her untimely death at the age of thirty-five, she had worked in theatre and costume design and was also leading the design studio that served the First State Textile Factory in Moscow.

Across Europe, in the early twentieth century, women artists were more active in the visual and performing arts than they had ever been before. Not only had they gained wider admission to training but they were in the forefront of all the new art movements. In post-revolutionary Russia, women artists had equality with men and their contribution was vital to the advancing scene of art and design.

Seated Figure *(1915)*
Popova's Cubist-inspired composition illustrates the Russian approach to Cubism,
which tended towards abstraction and reconstruction. The figure remains definable
through Popova's use of advancing and receding planes of graduated colour

NICOLAS POUSSIN

The Shepherds of Arcadia (detail) (1638)
In the mid-1630s, Poussin explored the work of Raphael, Roman architecture, and Latin books on moral conduct. From these he adopted the pure, classical idiom that he used for the rest of his life. The inscription 'Et in Arcadia ego' is a quotation from the Latin poet Virgil. Poussin reminds us that there is no escape from death, even in the perfect world of Arcadia

Nicolas Poussin formulated the precepts of French classical and academic art, in the belief that a painting should arouse a rational and intellectual response in the viewer, not mere pleasure. His rather austere, authoritative approach to ancient history and classical mythology influenced painting as far as the nineteenth century, and most French artists from **David** to **Cézanne**.

Poussin wasn't particularly interested in the events or personalities of his time and the only portrait he ever did was of himself. Nor was he sympathetic to the artistic factions that he found in Rome. In his opinion, the Mannerists were too affected and the Naturalists weren't refined enough. Poussin's great passion was history, and through his art he told epic, noble and stirring tales. He undertook historical research responsibly, training himself in archaeology and the study of coins, and carefully checked the authenticity of everything. He once wrote in a letter: 'I am forced by my nature towards the orderly.'

As a painter, Poussin worked prodigiously hard, and reached a highly creative and inspired phase in his mid-forties. He constructed models of wood and wax from which he made preliminary sketches, and only then did he start painting. He observed the compositional styles of **Mantegna** and **Raphael**, and turned to **Titian** for the study of nudes. His later studies of sunsets and morning in the Roman Campagna are some of his purest achievements.

Echo and Narcissus *(1627–28)*
*For a period of five years, Poussin worked on themes from classical mythology
and the Renaissance poets. At the same time, he came under the painterly
influence of the Venetian Titian. Pictures like this one and* Rinaldo and
Armida *use sensuous colours and show true feeling for their poetic sources*

PIERRE-CÉCILE PUVIS DE CHAVANNES

1824	*Born in Lyon, son of a civil engineer*
1844–52	*Studies in Paris under Scheffer and Couture, influenced by Chasseriau*
1852	*Exhibits* Pietà *at Salon, submissions rejected for next 7 years*
1861	*State purchases* Peace *from Salon,* War *donated to make pair*
1865–69	*History painting commissioned for Marseilles Museum*
1872–75	*Decorates Poitiers town hall*
1873	*Exhibits* Summer *at Salon, purchased by State*
1876	*Commissioned to paint* Life of St Geneviève *in Paris Panthéon*
1888–89	*Decorates Paris Sorbonne*
1889–93	*Decorates Paris City Hall*
1893–95	*Paints murals for Public Library, Boston, USA*
1897	*Marries Princess Cantacuzene*
1898	*Dies in Paris*

The Poor Fisherman *(1879)*
Submitted to the Salon of 1881, this easel painting caused controversy. For some judges, the flatness of tone made it closer to decorative, rather than 'fine', art. Since then, this composition – evocative of the Holy Family – has become one of Puvis' most enduring images

Pierre-Cécile Puvis de Chavannes was the leading mural painter of his time. He was even admired by the younger generation, which included **Van Gogh**, **Gauguin** and **Seurat**, as well as the poet Gautier. Although a contemporary of the Impressionists, Puvis' practice remained rooted in the Italian frescoes he had encountered on his travels as a young man. **Piero della Francesca**'s work in Arezzo had inspired Puvis to become an artist himself.

Yet his flat, shadowless, decorative style aroused establishment hostility for many years. The establishment seemed not to appreciate his reference to fresco painting – Puvis used oil on canvas for his murals, rather than applying pigment directly to plaster – and accused him of not knowing how to paint or draw. His work incorporated a strong linear element; his palette, however, always remained pale and subdued. Unpopular though it was in academic circles, his technique exerted a strong influence upon Gauguin and impacted on the development of the Nabis, a symbolist group led by Denis, Bonnard and Vuillard.

Puvis' fortunes switched dramatically in the last twenty years of his life, when a far-sighted Director of Fine Arts decided to commission the monumental *St Geneviève* series in the Paris Pantheon. In 1895 Puvis found himself the guest of honour at a grand banquet presided over by Rodin; and the year after his death, the Salon mounted a successful retrospective of his work.

Young Girls by the Sea *(1879)*
Puvis conjures up an atmosphere of remote antiquity in which the girls seem cocooned in eternal peace, beauty and fair weather

RAPHAEL SANTI

1483	*Born Raffael Santi in Urbino, son of Giovanni Santi, Court painter to Federico da Montefeltro, Duke of Urbino*
1491	*Death of mother*
1494	*Death of father*
1500	*Apprenticed to Perugino in Perugia*
1504	*Moves to Florence, studies Leonardo, Michelangelo, Bartolomeo and Masaccio*
1505–07	*Paints a series of Madonnas*
1507	*Paints the* Deposition
1509–20	*Called to Rome by Pope Julius II to paint the* Stanza, *including* School of Athens
1513	*Death of Pope Julius II. Paints* Sistine Madonna
1514	*Made architect of St Peter's, Rome*
1517	*Paints the* Transfiguration *(unfinished)*
1520	*Dies in Rome*

Saint Barbara, Sistine Madonna *(detail) (1512)*
Saint Barbara looks out of the picture frame towards the imaginary congregation at the foot of the Sistine Madonna. *She is as exquisite as any of his Madonnas, for whom Raphael drew on a wide range of beauties he had known. Both the colouring and composition of this painting typify Raphael's Roman period*

The youngest of the three giants of the Italian High Renaissance, Raphael is best known for his Vatican frescos, numerous Madonnas and fascinating portraits, including the beautiful *La Fornarina* (now revealed as Raphael's secret wife) and the haunting *Pope Julius II*. Son of a Court painter, Raphael was born into the right surroundings for an artistic career and, despite being orphaned at eleven, his precocious talents ensured his survival.

Having completed his apprenticeship with Perugino, Raphael moved to Florence. There he honed his art to the Renaissance ideals of beauty and harmony, although his genius was tied by the demands of patrons.

Raphael's strength lay in his draftsmanship and, at that time, drawing was considered the foundation of all visual arts. For the last seven years of his life, he employed Marcantonio Raimondi in his Rome studio, engraving the backlog of drawings that he lacked time to convert into paintings. It was Raimondi's

rendering of Raphael's *The Judgement of Paris* that suggested the pose of **Manet**'s figures in *Déjeuner Sur L'Herbe*, over three centuries later.

When assigned to the Papal Court, Raphael was given charge of all major projects; not only paintings but architecture and the preservation of antiquities. Raphael wasn't a great innovator or discoverer, yet when he died at thirty-seven, his art showed an emotional depth that might well have matured to equal that of **Leonardo** and **Michelangelo**.

The Deposition of Christ (1507)
Raphael pays homage to Michelangelo's Doni Tondo – *painted only the year before – with the kneeling woman twisting back, like Michelangelo's Virgin. His deposition group has reverently distanced itself from the scene of death on the hill and the body they carry is barely marked. It is a picture with all the qualities that Delacroix once listed as Raphael's most admirable: 'his marvellous sobriety; his constant measure; no extravagance, no vulgarity, no triviality'*

REMBRANDT VAN RIJN

1606	*Born in Leiden, son of a miller*
1624	*Studies in Amsterdam under Lastman*
1625	*Sets up studio in Leiden, pupils include Dou*
1631	*Moves to Amsterdam, becomes successful portraitist. Starts etching and first uses canvas*
1634	*Marries Saskia von Uylenburgh*
1635–41	*Saskia gives birth to four children, one son, Titus, survives*
1642	*Death of Saskia. Paints* The Nightwatch
1647	*Engages Hendrickje Stoffels as housekeeper, later model and partner*
1654	*Birth of daughter Cornelia by Hendrickje. Paints* Hendrickje Bathing
1656	*Declared bankrupt. Paints* Titus Reading
1663	*Death of Hendrickje*
1668	*Death of Titus*
1669	*Dies in Amsterdam*

Portrait of the young Saskia (1633)
Saskia may never have worn this curious hat in public, since Rembrandt often painted himself and his family dressed in exotic costumes. The Dutch term tronie *refers to a special type of picture intended as a character study rather than a straight portrait*

Rembrandt van Rijn's clear empathy with the human condition makes it surprising to learn that he never travelled outside Holland. However Lastman, his most influential teacher, had been to Italy and observed the work of **Caravaggio**. Lastman taught his pupil the technique of *chiaroscuro* (the rendering of extreme light and shade) and Rembrandt quickly learned to handle it with a skill few have ever matched.

The artist's personal life was a catalogue of misfortune. His first wife, Saskia, and three of their children died very early. Rembrandt, although successful, had no head for business and disastrously expensive tastes. At his bankruptcy, an inventory of his art and antiquities showed a collection that included **Leonardo**, **Michelangelo**, **Raphael**, **Holbein**, **Titian** and **Rubens**; and he had stores of exotic clothes, ornaments and armour, which he used as props in his paintings.

During Rembrandt's long career, he engaged in drawing, etching and painting. Over 2000 of his works still exist and although he is probably best known for portraiture, particularly his own, his subjects range through biblical themes, everyday life, landscape and nudes. In each genre he conveys a mixture of moods – he would study his own expressions in the mirror – and such depth of feeling, that he endures as one of the most sympathetic and appreciated of all the great artists.

Archangel Raphael Leaving the Family of Tobias *(1637)*
*The Archangel Raphael helps Tobias to restore his father's sight and then flies
off in a Baroque flurry of foreshortened limbs, wings and drapery. But most
impressive of all is Rembrandt's masterful chiaroscuro*

PIERRE AUGUSTE RENOIR

1841	*Born in Limoges, son of a tailor*
1854	*Apprenticed to paint porcelain and decorative items*
1862	*Joins Atelier Gleyre, meets Bazille, Monet, Sisley, Cézanne and Pissarro*
1864	*Exhibits at Salon*
1868–69	*Shares studio with Bazille. En plein air studies with Monet*
1870–79	*Works and exhibits as Impressionist*
1880	*Meets Aline Charigot*
1881	*Travels to Algeria, Spain and Italy, influenced by Raphael, Rubens and Velazquez*
1885	*Birth of son Pierre*
1886	*Exhibits in New York*
1890	*Marries Aline*
1893	*Birth of son Jean*
1898	*Seriously disabled by arthritis*
1901	*Birth of son Claude*
1912	*Legion of Honour*
1915	*Death of Aline*
1919	*Dies of heart attack in Cagnes-sur-Mer*

Uphill Path Through Long Grass *(1876)*
A landscape with figures, from Renoir's purest Impressionist period. Reminiscent of Monet's Wild Poppies, *it was probably painted during one of the summers that the two artists spent together at Argenteuil*

With the arrival of the railway, the banks of the Seine beyond Paris became a popular resort for city workers. La Grenouillère at Croissy-sur-Seine was a restaurant built from several boats roped together, providing a dance floor in the evenings. This was the destination of Pierre Auguste Renoir and Claude Monet one day in 1869, when the two young friends set up their easels together *en plein air* and initiated the breakthrough to Impressionism.

By 1881, the year he turned forty and began travelling round Europe and North Africa, Renoir knew it was time for a reassessment.

He decided that colour was to be the servant not the master, and that he would attempt to express form more carefully by tonal relationships. Not that he altered his palette; Renoir kept to the bright colours he had always favoured. In his later works, Renoir's experimentation brought an outpouring of monumental nudes and sensual young women with luminescent skin. Uncompromisingly, Renoir had always painted what pleased him and, since his days of decorating fans in the style of **Watteau**, Fragonard and **Boucher**, his immense skill and the ability to convey charm remained entirely undiminished.

Woman Combing Her Hair *(1907–08)*
Gabrielle Renard was a distant cousin who came as his son Jean's nurse, and
stayed on as housekeeper and model for Renoir. When arthritis reduced his
hands to claws, Gabrielle wrapped them in powdered gauze to prevent the skin
adhering. Disabled as his father was, Claude Renoir recalled slipping
paintbrushes between his father's fingers to enable him to paint

HENRI 'DOUANIER' ROUSSEAU

1844	*Born in Laval, son of a plumber*
1864–68	*Army service as clarinettist in regimental band*
1869	*Settles in Paris. Marries Clémence Biotard, they later have three children*
1871–93	*Works in toll-station for excise corps. Nicknamed 'Douanier' (customs officer)*
1886	*First exhibits at Salon des Indépendants,* Walk in the Forest
1888	*Death of Clémence*
1897	*Paints* The Sleeping Gypsy
1898	*Marries Rosalie-Josephine Noury*
1903	*Death of Rosalie-Josephine*
1905	*First exhibits at Salon d'Automne,* The Hungry Lion
1908	*Picasso holds a banquet in his honour*
1909	*Acquitted of involvement in bank fraud*
1910	*Dies of gangrene in Paris*

The Football Players *(detail) (1908)*
In contrast to his exotic subjects, Rousseau enjoyed featuring the everyday life of people around him, sharing their love of parties and recreation of all kinds. The striped footballers look more as if they are performing a surreal ballet

An encounter with Henri 'Douanier' Rousseau revealed a strange mixture of unworldly shyness and a cast-iron belief in his own artistic talent. He had undergone the usual elementary schooling but at some point he became convinced that painting was his true vocation and claimed that his parents' poverty had precluded art school.

Later, Rousseau went ahead and obtained a copyist's card for the Louvre, where he spent a lot of time studying the early Italians. He met the poets Jarry and de Gourment, who commissioned a lithograph from him for their review, *L'Imagier*, and before long Rousseau found himself admitted to the world of writers and artists. Encouraged by the company of the avant-garde – in the end he listed such names as **Picasso**, **Gauguin**, Delaunay and Apollinaire among his acquaintances – Rousseau began submitting to the Salon des Indépendants, to which he remained loyal for the rest of his life.

Rousseau's paintings are termed 'naïve' but this doesn't imply that they are instinctual. On the contrary, he planned his work with extreme care, using numerous sketches and picture references. Some mocked him for going as far as taking his sitters' measurements for portraits, as if he were a tailor, but he was mastering anatomy and proportion the best way he knew. Once past the preparatory stages Rousseau's imagination took off, and the unremarkable one-time toll collector became the exotic storyteller whose unique images are now recognized and admired everywhere.

The Snake Charmer *(1907)*
*This lone musician stands like a dark Eve, calling out all the serpents from her
moonlit paradise. Rousseau would often take his sketchbook to the Jardin des
Plantes and – thanks to a secret arrangement with one of the gardeners – draw
for hours among the jungle greenery of the hot-houses. It was the nearest he
would ever come to experiencing a tropical landscape*

PETER PAUL RUBENS

1577	Born in Siegen, son of a lawyer
1591–95	Apprenticed in Antwerp
1600	Visits Venice, sees work of Titian and Veronese. Visits Florence
1601	Visits Rome, sees work of Caravaggio
1603	Diplomatic visit to Spain
1605–06	Returns to Rome
1609–14	Marries Isabella Brant, settles in Antwerp, has three children. Paints commissions for Antwerp Cathedral
1610–20	Studio receives many Catholic commissions
1621	Diplomatic service for Hapsburgs
1622–25	Commissions in Paris and Antwerp
1626	Death of Isabella
1628–30	Negotiates peace between Madrid and London. Knighted by Charles I. Marries Helena Fourment, has five children
1631	Knighted by Philip IV. Retires from diplomatic service
1640	Dies of heart failure in Antwerp

The Straw Hat (c.1625)
A portrait of Susanna Fourment, sister of Rubens' second wife, Helena. Rubens' easel pictures were painted with a relaxed pleasure in the subjects to be found close to home

Peter Paul Rubens was the possessor of phenomenal gifts, together with the physical energy and organizational ability to exercise them. As well as being an exponent of the lush Baroque style that he had acquired in Italy (**Caravaggio** was a key influence, whose work Rubens continued to champion across northern Europe), he was Roman Catholic, multilingual, and appointed ambassador for the Hapsburg rulers of the Spanish Netherlands. His status as Court painter exempted Rubens from paying taxes and it also freed him from guild rules; he could deploy, without restrictions, the huge studio staff needed to carry out all his commissions, many of whom had their own specialities.

These commissions chiefly consisted of dynamic imagery designed to tempt people away from the sombre Protestantism of the Reformation. It was what the Catholic Church and European royalty required for their propaganda purposes. Drawing upon his Latin

**Marie de Medici Disembarking at Marseilles After Marriage
to Henry IV of France** *(1622–25)*

*One of the cycle of 21 paintings for the Palais de Luxembourg, commissioned by
the French dowager queen Marie de Medici to depict her life. Rubens prepared
hundreds of master sketches for his studio to work from. It was no easy task
diplomatically either, since the queen was quarrelsome, far from attractive, and
had wasted huge amounts of money without achieving anything remarkable in
her life. To Rubens' credit, he left a satisfied customer on completion*

school education, Rubens produced scores of elaborate altarpieces and allegorical ceilings. He was adept at painting supposedly Christian virtue but giving it a subversive sinuosity; the voluptuous features of his nudes are deliberately exaggerated to emphasize fecundity and freedom from want.

Rubens' stylistic influence endured over three centuries, from **Van Dyck** and Murillo, through **Watteau** and **Gainsborough** to **Delacroix** and **Renoir**.

ALEXEI SAVRASOV

1830	*Born in Moscow, son of a merchant*
1844–54	*Studies at Moscow School of Painting, Sculpture and Architecture*
1855–57	*Travels across Europe*
1857–82	*Teaches landscape painting at Moscow School of Painting*
1863	*Founder member of Wanderers group*
1871	*Founded Association of Travelling Art Exhibitions.* Exhibited The Rooks Have Returned
1897	*Dies in Moscow*

By the Whirlpool (Deep Waters) *(1892)* by Isaak Levitan
'I want to discover and locate in my own country the most simple, the most intimate, the most commonplace and the most emotionally moving; that which often causes a sense of melancholia.'

Alexei Savrasov was the most lyrical – and named 'father' – of the Russian landscapists. He was a founding member of the radical Wanderers group in 1863, together with Klodt and Shishkin. The group formed in revolt against the stifling international neo-classicism that prevailed against any Russian genre. Acting as a co-operative, the Wanderers organized travelling exhibitions of their work. Their patrons were to be found among Moscow's merchant class, many of whom were discerning art collectors.

Isaak Levitan (1860–1900) attended the landscape classes of Savrasov at the Moscow School of Painting. Levitan entered the School at thirteen and studied there for ten years before travelling to Paris where he came under the creative influence of Monet.

Levitan was also a lifelong friend of the playwright Chekov. Both men felt emotionally bound to the Russian landscape and conscious that the country's history was written upon it. A key example of Levitan's 'mood' landscape work is *The Vladmirka Road*, the highway to Siberia, along which so many prisoners walked to their deaths.

The Rooks Have Returned *(1871)* by Alexei Savrasov
The return of the rooks to a recently frozen land signals the transition from winter to spring as the birds rebuild the rookery. The artist had travelled widely in the northern provinces of Russia and he frequently painted winter landscapes and the ensuing thaw

EGON SCHIELE

	
1890	*Born in Tulin, son of a railway-station master*
1904	*Family moves to Vienna. Death of father*
1906–09	*Studies at Academy of Fine Arts, Vienna*
1908	*Encounters Klimt and his work at Vienna Kunstschau*
1908–10	*Influenced by Klimt. Works at Secessionists' Wiener Werkstatte*
1911	*Meets Valerie (Wally) Neuzil. They move to Neulengbach*
1912	*Convicted of public immorality. Exhibits at Cologne. Meets Munich dealer Hans Goltz*
1914	*Meets Edith Harms*
1915	*First one-man exhibition in Vienna. Marries Edith. Joins army*
1917	*Represents Austria in government sponsored exhibition in Stockholm and Copenhagen*
1918	*Major exhibitor in 49th Secession. Dies of influenza in Vienna*

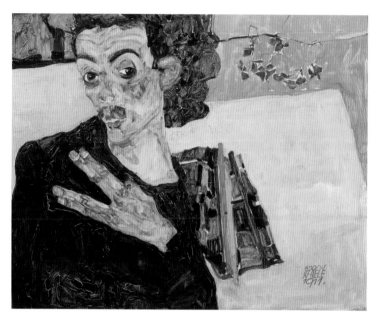

Self-Portrait *(1911)*
Schiele's preening self-satisfaction is – like so many of his poses – most probably an act. The images he made of himself at this time veered between melodramatic and sincere, as he tested a multiplicity of identities and inner feelings

Egon Schiele, like his idol Gustav **Klimt**, took eroticism as a major theme of his work. It led to accusations of his being 'sex-obsessed' and he once found himself in prison briefly for 'exhibiting an erotic drawing in a place accessible to children'. But, again like Klimt, the unquestionable quality of Schiele's work eventually found an appreciative audience, and even government sponsorship when the authorities wished to boost Austria's international image.

Schiele's uncompromising candour in his treatment of the nude figure – female and male – offers an unsettling mixture of adolescent sexuality and superb technical skills. His mother claimed that he could draw before his second birthday, and his drawing ability was something that Schiele honed tirelessly throughout his life until he achieved a near-faultless line. Painting he found less easy, especially in oils, but he had a facility for approaching a medium and taking it swiftly beyond a technical challenge to stylistic mastery, which he did to marvellous effect with gouache and watercolour. That mastery over a medium was vital to Schiele – nothing should impede his progress towards the purity of vision and essential truth that he felt were the purpose of his art.

Woman Undressing *(1914)*
At this time, Schiele's nudes became yet more voluptuous. He used gouache to wash the figure, brushing bright accents of colour on top of ochre. The multiple folds of fabric accentuate the movement of the woman as she wriggles free of the dress

GEORGES SEURAT

The Sideshow *(1887–88)*
A wonderfully atmospheric, skillfully composed picture of a travelling fair, with the oil and gas lamps relieving the gloom of a winter's evening and tempting the audience to some escapist entertainment

Georges Seurat's name is practically synonymous with the word 'pointillism', a divisionist painting method that he himself called 'optical painting'. Seurat was a Neo-Impressionist. With Signac and, early on, Pissarro, he engaged in an analysis of the techniques used by the Impressionists to reproduce light and colour.

Seurat's goal was a formula for the creation of luminous colour on canvas by painting dots of contrasting colours next to one another. The effect was to be one of pure colour, blended literally on the retina of the beholder and not on the painter's palette. It is reasonable to ask why an artist should seek the constraint of a formula; the answer could be lack of confidence in handling paint, or too-rigid training that rejects anything irregular or impulsive. Or perhaps, like other highly disciplined painters – **Della Francesca**, **Poussin** and **Mondrian**, for example – Seurat relished the intellectual challenge, loved to work 'scientifically' and enjoyed the laborious process of proving his theory. Unfortunately, it didn't actually work; at least, not as predicted.

Apart from an incomplete grasp of existing colour theories, Seurat and Signac didn't question the purity or relative colour values of the pigments that they used. The result was not the luminosity they had hoped for. As Signac admitted: '…red dots and green dots make an aggregate which is grey and colourless.'

Of course, Seurat's works are not colourless, but nor are they rainbow bright. Instead, all those painstakingly applied dots produce the pleasant visual sensation of a light pearly haze, or grain, which has become Seurat's distinguishing mark after all.

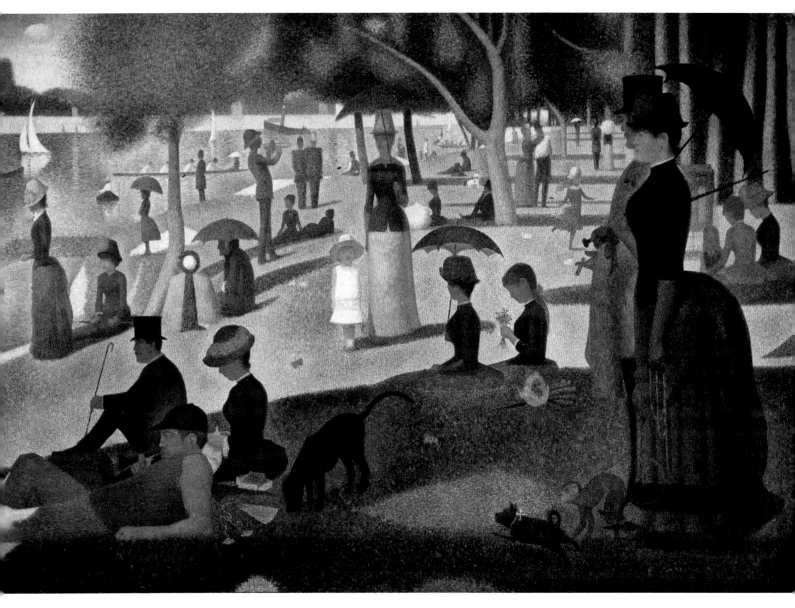

A Sunday Afternoon on La Grande Jatte *(1884–86)*
*Seurat's most famous painting, the product of many preparatory drawings
and painted 'rehearsals', and the centrepiece of the 8th Impressionist
exhibition where it first appeared. His pointillist technique has successfully
created the dreamlike suspension of time and motion on a warm, sunny
afternoon beside the river*

GEORGE STUBBS

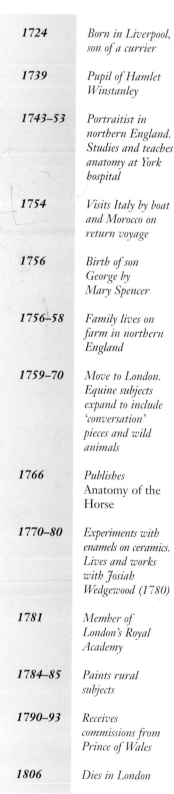

1724	*Born in Liverpool, son of a currier*
1739	*Pupil of Hamlet Winstanley*
1743–53	*Portraitist in northern England. Studies and teaches anatomy at York hospital*
1754	*Visits Italy by boat and Morocco on return voyage*
1756	*Birth of son George by Mary Spencer*
1756–58	*Family lives on farm in northern England*
1759–70	*Move to London. Equine subjects expand to include 'conversation' pieces and wild animals*
1766	*Publishes Anatomy of the Horse*
1770–80	*Experiments with enamels on ceramics. Lives and works with Josiah Wedgewood (1780)*
1781	*Member of London's Royal Academy*
1784–85	*Paints rural subjects*
1790–93	*Receives commissions from Prince of Wales*
1806	*Dies in London*

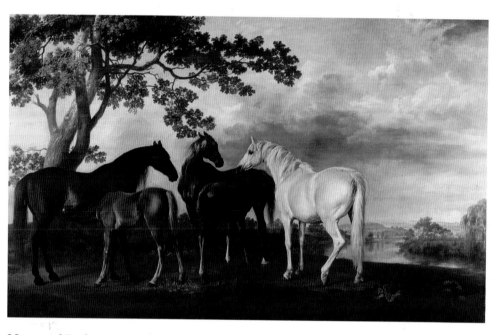

Mares and Foals in a River Landscape *(detail) (1763–68)*
Stubbs made a series of studies of brood mares and foals set against a variety of backgrounds, from woods to mountains. His expert anatomical knowledge enabled him to pose the horses convincingly in a pleasing design. He usually painted the animals first and then filled in the surrounding landscape from his imagination

George Stubbs had a passion for anatomy, both human and animal. He received little formal training but knew enough of the subject to teach it to medical students while in York; and in 1751, he illustrated Dr John Burton's *Essay Towards a Complete New System of Midwifery*. Burton was a notorious Jacobite, which, by association, could explain Stubbs' dislike of the Hanoverians and his prolonged refusal of commissions from George II.

Stubbs' exquisite anatomical drawings formed the basis of his expertise as a horse painter. For eighteen months he rented a remote Lincolnshire farmhouse where he could work undisturbed, dissecting specimens to discover the function of every bone and muscle. This led to his publication of *The Anatomy of the Horse*, which became a major reference for artists and naturalists.

In those days, horse paintings were ranked lower than landscapes. Yet, with a circle of wealthy patrons, Stubbs kept busy enough, painting top racehorses for aristocratic owners and breeders who wanted a pictorial record to accompany their stud book listings. And other commissions followed for families posing in their horse-drawn carriages.

Stubbs also enjoyed painting a variety of wild animals, including lions, tigers, giraffes, monkeys and rhinoceros, which he observed in fashionable private menageries. He once travelled to Morocco, where he witnessed at first hand a lion stalking a horse.

Many of Stubbs' pictures were executed in thin oils and exist now in a rather fragile condition. However, most are still privately owned by the families for whom they were originally painted.

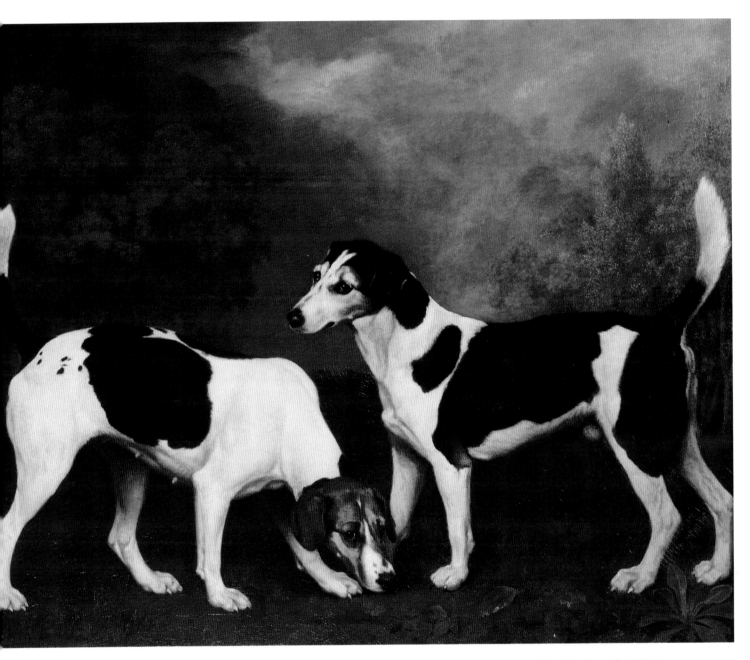

Two Foxhounds (1792)
A commission from the Reverend Thomas Vyner of Lincolnshire, who was an avid sportsman and expert breeder of foxhounds. This dog and bitch in an imaginary landscape were probably from the Earl of Yarborough's renowned Brocklesby pack

JACOPO TINTORETTO

Theft of the Body of St Mark *(1562–66)*
Three paintings of the miracles of St Mark were made for the Scuola di San Marco. Here, the Christians of Alexandria rescue the saint's body, under cover of a storm. The scene bears all the hallmarks of Tintoretto: dramatic composition and perspective, high contrast lighting and foreshortening

Tintoretto is a nickname meaning 'little dyer'. As a child, the story goes that he made charcoal drawings on the walls of his father's shop in Venice and coloured them in with dyes. Hopefully, the dyer apprenticed his son to **Titian**. But Titian and Tintoretto quarrelled to such a degree that the boy walked out. Some believe the master wanted to be rid of a rival talent; however, Tintoretto does seem to have gone through life with a reputation for being awkward.

Typically enough, he decided to work on alone, consolidating what he had learned from Titian with his observations of **Michelangelo**. He wrote: 'Michelangelo's drawing and Titian's colour' on the wall of his studio.

Tintoretto enjoyed experimenting with special lighting effects. He owned scale models of statues from the Medici tombs, made by one of Michelangelo's assistants. These were the focus of his lantern-lit experiments. He even hung them up so that he could observe figures in motion.

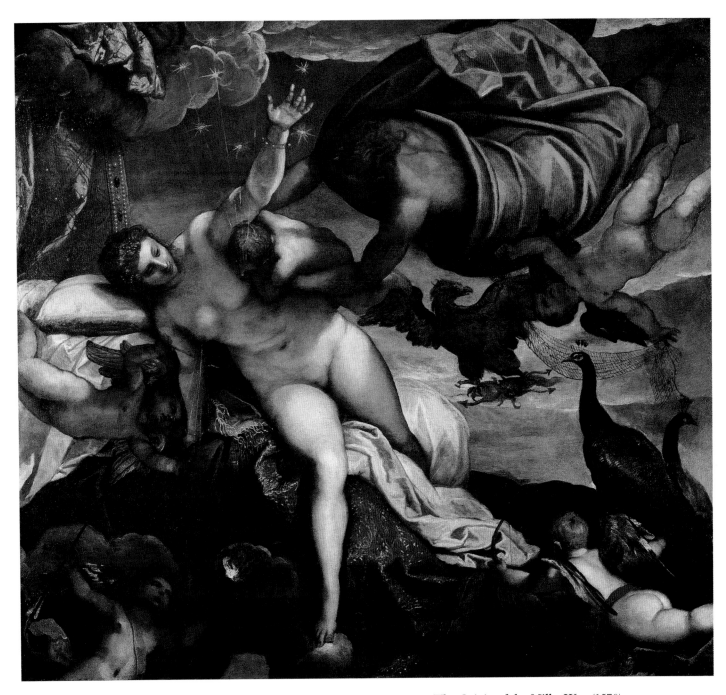

Tintoretto lived and worked exclusively in Venice. Everything he did was ordered by the Venetian state or various churches and confraternities. With ever-increasing commissions, he called on a large band of assistants, including his daughter Marietta and son Domenico, whose style closely followed their father's. As a Mannerist with remarkable skill in depicting form and light, Tintoretto's influence had some impact on both **El Greco** and **Rubens**.

The Origin of the Milky Way *(1570)*
Wishing to immortalize his infant son Hercules, Jupiter holds him to the breasts of the goddess Juno. The milk that sprays upwards forms the stars of the Milky Way, the drops that fall to earth become lilies. Tintoretto painted lilies along the base of the painting but at some point the original canvas was trimmed. This work is one that owes most to the influence of Titian

TITIAN

1488	*Born Tiziano Vecelli in Pieve di Cadore, son of a lawyer*
1498	*Apprenticed to the Bellinis' studios*
1507–10	*Assistant to Giorgione*
1513	*Starts own work-shop*
1516–18	*Paints* Assumption of the Virgin
1520-1545	*Period of major portraits*
1523	*Meets Gonzaga, Duke of Mantua, introduction to Charles V*
1525	*Marries Cecilia, they have four children before her death in 1530*
1530	*Commissioned by Vatican*
1533	*Appointed Court painter to Charles V*
1538	*Paints* Venus of Urbino
1545–46	*Commissioned by the Farnese in Rome*
1548–51	*Commissioned by Charles V in Augsburg*
1555-62	*Paints series of erotic mythologies for Philip II*
1576	*Dies of the plague in Venice*

Pope Paul III, Alexander Farnese *(1543)*
Alexander Farnese, the last of the Renaissance popes and a veteran politician. He was seventy-five at the time Titian painted this portrait, a patron of the arts and also a reformer who later summoned the Council of Trent. This was the pope responsible for excommunicating Henry VIII of England from the Roman Catholic church

Titian became the most celebrated painter in Venice, following the premature death of Giorgione from the plague. Both were trained by the **Bellini** brothers, but Titian found them uninspiring and had joined Giorgione's studio once his apprenticeship was over. The pair were so compatible that sometimes people could not tell their work apart.

Titian evolved rapidly as a pure painter, with no 'Renaissance man' distractions such as science, poetry or architecture. The *Assumption of the Virgin*, painted for the Franciscans, attracted Alfonso d'Este, Duke of Ferrara, who ordered three mythological studies from Titian's workshop for his personal gallery. The Duke's *studiolo* had alabaster walls and a gold ceiling. It was a commission marred only by Este himself, whose manner alternated between flattery and bullying.

Later in his career, when his work had matured throughout the demands and adulation of so many kings, princes and popes, Titian came to value the exploration of colour above

any other aspects of art. All his life he had known how to extract the best from his materials and he advanced to a tonal painting style, using not only brushstrokes but also his fingers and pieces of rag (he claimed he did this to avoid looking like **Raphael**). *The Death of Actaeon* and *Tarquin and Lucretia* are two outstanding confirmations of Titian's later supremacy, which point forward to the heirs of his influence, among them most notably **Delacroix**, **Goya**, **Rembrandt**, **Renoir**, **Rubens**, **Van Dyck** and **Velazquez**.

Bacchus and Ariadne *(1522)*
One of three mythological subjects painted for the Duke of Ferrara's studiolo *between 1518 and 1525. For this picture, Titian first painted the background in full. Each foreground figure was then filled in over a silhouette of white ground, for the richest colour effect. His palette included most of the pigments known to the workshops of the day. The composition of the painting is complex but so skilfully accomplished that every detail of the story unfolds smoothly as the eye travels round*

JOSEPH MALLORD WILLIAM TURNER

1775	*Born in London, son of a barber*
1785	*Lives with uncle in Brentford on Thames*
1790	*Enters Royal Academy Schools*
1791–94	*Lives in Bristol, sketching tours in Britain*
1796	*First oil shown at Academy,* Fishermen at Sea, *influenced by Wilson and Poussin*
1798– 1818(?)	*Lives with mistress Sarah Danby, they have two daughters*
1802	*Member of Academy. First of many visits to Europe (Paris and Alps), influenced by Claude*
1804	*Death of mother. Opens London gallery*
1805–25	*Lives near Thames at Isleworth and Twickenham*
1819	*First visit to Italy*
1829	*Death of father. Suffers depression*
1838	*Paints* The Fighting Temeraire
1844	*Paints* Rain, Steam and Speed
1851	*Dies in London*

Crossing the Brook *(1815)*
This Devonshire scene has been given the 'Claude' treatment so expertly that rural England could easily be mistaken for Italy. Turner had learned to draw and colour topographical views in the mid-1790s when he and Girtin were employed together by Thomas Monro

The name of J.M.W. Turner is closely associated with London's Royal Academy. He became a full member when only twenty-seven, never missed showing at the annual exhibition and served as a member both of the Council and the hanging committee. He even lectured in landscape painting for seventeen years. Altogether, Turner sounds like a thoroughly respectable Academician who could be relied upon to produce the sort of 'brown gravy' paintings that the Impressionists rejected half a century later.

However, Turner's fellow Academicians on Varnishing Days could tell a very different story. Varnishing Days allowed exhibitors to retouch their work before the varnish went on. Turner would arrive, complete with top hat, to attend to several pallid canvases that looked 'like chaos before the creation', and set to work 'with all the brightest pigments he could lay his hands on...until they literally blazed with colour.' Many Academicians looked askance at Turner's apparent lack of social grace, but to hang next to him and risk being eclipsed by his works was a fate they all dreaded. Even Constable, no stranger to criticism of his own bright 'nasty green', was heard

to exclaim, 'He's just been here and fired a gun.'

Turner had indeed fired a gun – or at any rate a starting pistol – for the run up to Impressionism. Around fifty years later, in Rouen, Monet set up his easel at the second-floor window of a shop opposite the cathedral. He had decided to follow the example of Turner, whose gouache sketch of Rouen Cathedral he had once seen in London and never forgotten.

Fire at Sea (1835)

Turner adored the sea and painted it in all its moods. The ship at the centre of this catastrophe is the Indiaman Orontes. *It was not the sea that destroyed her but a bundle of straw set alight by a candle in the purser's store. Turner whirls the smoke and flames into one huge vortex with the sea and sky. The mass of white and gold in the foreground contains crowds of figures that look like some kind of heavenly host, until the viewer realizes with a jolt that these are the luckless passengers, losing their struggle against the two major elements of fire and water*

PAOLO UCCELLO

Horsemen, Battle of San Romano *(detail) (1455)*
San Romano *was originally a three-panel piece commissioned by the Medici. This is part of the right-hand section showing the rout of the Sienese by the Florentines in 1432. Undeniably, foreshortening gave Uccello certain aesthetic problems, light and shade required better handling. But this subtle coloured pattern of lances, helmets and trappings, above a forest of horses' legs, makes a pleasing design on its own and reaffirms Uccello's unfailing eye for the smallest decorative detail*

Paolo Uccello qualifies as one of the most versatile founders of the Early Renaissance, having begun his career with the man who produced the Doors of Paradise for the Florence Baptistery, he progressed to the invention of new methods of rendering perspective.

The training that Uccello received from the Florentine sculptor Ghiberti roots him firmly in the decorative International Gothic style; one that was shared by Fabriano and Pisanello. It was probably Pisanello who taught Uccello to paint.

The painter **Masaccio** and the sculptor Donatello are both credited with inspiring Uccello to take up the study of perspective. However, no one – especially his long-suffering wife – could have predicted how engrossed he would become in the subject with the encouragement of a noted mathematician called Toscanelli. By all accounts, Uccello practised drawing foreshortened objects night and day, and scarcely looked up if anyone approached while he was wrestling with his latest problem.

Uccello's meticulous perspective drawings

underpinned all his paintings. In his fresco of *The Flood* and the three-panel *Battle of San Romano*, he gave full rein to the technical effects he had mastered. Unfortunately, once the novelty was past, his work fell from favour and he spent a reclusive old age. Nevertheless, in the long run, Uccello's achievements were significant, and his system was further tried and tested by a succession of Renaissance artists, **Piero della Francesca**, **Leonardo da Vinci** and **Dürer**.

St George and the Dragon *(c.1456)*
Uccello tells the story of St George in true Gothic style. The valiant knight's deadly lance lines up with a storm cloud behind him, which could signify divine intervention. At the same time, it projects forward into the picture plane helping to establish a three-dimensional space round which the elegant damsel – no longer distressed – prepares to lead the conquered dragon, like a pet dog

ROGIER VAN DER WEYDEN

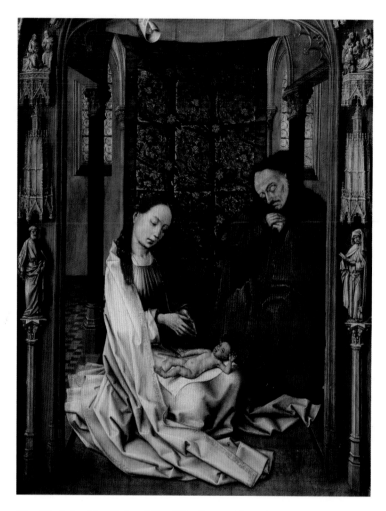

The Nativity (detail) from **The Miraflores Altarpiece** (c.1442)
By 1440, Van der Weyden's reputation reached as far as Spain, where King Juan II of Castile founded the monastery of Miraflores, near Burgos. As a final touch, he donated an altarpiece by 'Master Rogier, the great and famous Fleming'. This panel shows Mary wearing white to symbolize her purity, two others celebrate her virtues of endurance (in a red robe for pain) and faith (dressed in blue)

Rogier van der Weyden became the single most important Flemish painter following the death of **Van Eyck**. Since he signed none of his works, facts concerning their authenticity and chronology have to be gathered from comparison with others and the records of those who commissioned him. The start of Van der Weyden's career is easier to define. He enrolled in Campin's workshop in Tournai, emerging as a Master after five years and moving to Bruges, when he most probably came under the influence of Van Eyck.

After *The Descent* of 1435, Van der Weyden's rise to fame was rapid, taking him far and wide in pursuit of one prestigious commission after another. When the chancellor to the Duke of

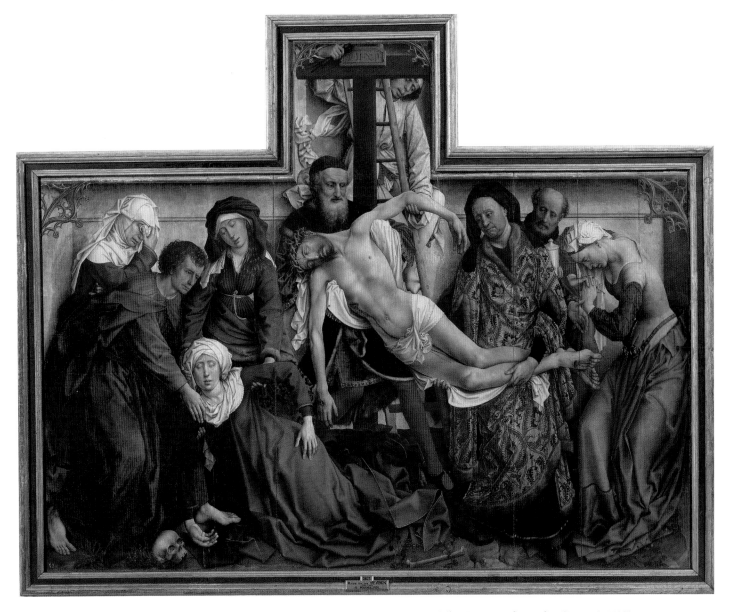

The Descent from the Cross (*c.1435*)
For one of the most emotionally charged pictures in the history of art, Van der Weyden has compressed the scene into a painted imitation of a gilded shrine, which concentrates the grief and despair of nine very realistic – almost life-sized – figures surrounding Christ's body. These are not statues, they are mourners, each grieving in their own way. Through Van der Weyden's use of rhythmic line, colour and pattern, they relate to one another in an elegaic chain of sorrow

Burgundy, Chancellor Rolin, founded his Hospice in Beaune, Van der Weyden was called upon to decorate the chapel. In Italy, he was kept busy by the Medicis in Florence and the Estes in Ferrara. Whilst there, he also taught the technique of painting in oils, something at which Flemish painters were particularly adept. Although he favoured Fabriano and **Fra Angelico**, whose styles were nearest his own, Van der Weyden's later work was certainly enriched by what he saw of other Italian masters.

The Flemish painters who succeeded him – Bouts, Memling and Van der Goes – were all indebted to Van der Weyden, but his influence persisted even more widely for the remainder of the century, in France, Germany, and Spain.

ANTHONY VAN DYCK

1599	*Born Antonio van Dijck in Antwerp, son of a silk merchant*
1609	*Apprenticed to Hendrik van Balen in Antwerp*
1613	*Paints first portrait*
1618	*Master of Antwerp Guild of Painters*
1620	*Reported in studio of Rubens*
1620–21	*First visit to England*
1621	*Returns to Antwerp*
1621–27	*Works on commissions in Italy*
1627–32	*Returns to work in Antwerp. Paints portraits and religious subjects*
1632–34	*Works in London. Appointed Court painter to Charles I*
1634	*Returns to Antwerp*
1635	*Returns to settle in London*
1639	*Marries Mary Ruthven, they have one daughter*
1640–41	*Travels between London, Antwerp and Paris*
1641	*Dies in London*

Henrietta of France, Queen of England
(1632–38)
Van Dyck had an eye for the texture of fine fabrics from a very early age. The queen's serene appearance in this magnificent yellow gown makes it difficult to believe misfortunes lay ahead of her; war and the execution of her husband

In 1632, Anthony van Dyck became Court painter by invitation of Charles I, who presented the celebrated Flemish artist with an allowance and a riverside house in Blackfriars. Van Dyck remained in London for most of the rest of his life.

He and the king understood each other perfectly. Charles wanted an image that was not just a likeness but symbolic of his right to rule, while Van Dyck – familiar with the nobles of Antwerp and Genoa – was ambitious for wealth and status. Just three months after his arrival in London, he received a knighthood and a valuable chain and medal. He later portrayed himself holding the gold chain and pointing jubilantly to an enormous sunflower.

Van Dyck painted dozens of portraits of Charles, Henrietta Maria and the royal children – with and without their dogs and horses. His success was confirmed by increased orders from the aristocracy. Having worked with Rubens, Van Dyck knew all about busy studios. He organized his own to keep apace with one portrait per week, making facial likenesses of the sitters himself, before instructing his helpers to paint the garments, which they modelled on dummy figures. Van Dyck then added the finishing touches

What emerged was a spectacular body of work that chronicles the elegant Cavalier style and profoundly influenced portraiture for over a century. Lely and Kneller owe much to Van Dyck; and his most ardent eighteenth-century follower was **Gainsborough**.

Lords John and Bernard Stuart *(1638)*
Van Dyck was expert at composing the double portrait. The resplendent Stuart brothers present three-quarter views of themselves to the onlooker, at the same time facing each other as if they were about to dance. The empty glove held by Lord Bernard is a common device to make the fingers of his left hand look longer. Pictured here shortly before a three-year tour of Europe, both brothers ultimately died for the royalist cause in the Civil War

JAN VAN EYCK

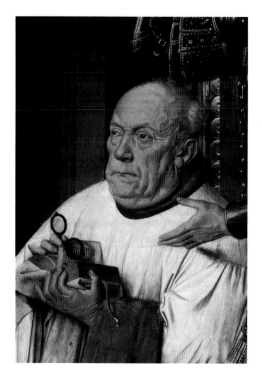

The Madonna with Canon Joris van der Paele *(detail) (1436)*
The inclusion of the Canon's spectacles is significant. Being wealthy and well-connected, Van Eyck almost certainly had access to optical aids – mirrors and lenses – to assist his image-making

The foremost Flemish painter of the fifteenth-century led a double life for the first half of his career. Jan van Eyck's appointment as Court painter and valet to Philip the Good of Burgundy was a useful cover for secret diplomatic missions to Spain and Portugal. However, after his move to Bruges, where they welcomed him as both an artist and a city councillor, he produced several signed and dated works without interruption. His patrons included Chancellor Rolin and Canon van der Paele, for whom Van Eyck painted two outstanding Madonnas.

Van Eyck and his brother Hubert – whose death left Jan to complete the Ghent Cathedral altarpiece – are usually credited with the invention of oil painting. The truth is rather more complex and comes from Van Eyck's desire to perfect a pigmented oil already employed to tint decorative metals.

Most importantly, Van Eyck realized that painters should use properly refined drying oils like poppy or linseed. Glazing layers gave stable colours, deeper than tempera, but this many-layered oil method needed patience. Tempera had the advantage of being quick-drying. Van Eyck's genius combined the two, applying layers of oil colour over a tempera ground. This yielded a full range of saturated hues; also new mixtures, because now the particles were coated in oil, adverse reactions between ingredients were avoided. Such care over the constituents ensured that Van Eyck's colours remain as fresh as the day he set down his brush.

The Arnolfini Portrait *(1434)*

This is probably not a marriage portrait; civil registers in Lille date Giovanni Arnolfini's marriage as 1447, thirteen years later. So who is the woman in green? One theory points to Arnolfini's sombre clothes and suggests it is a tribute to an earlier relationship that ended with her death in childbirth. St Margaret, the patron saint of childbearing is carved upon the bedpost, and a single votive candle burns in the candelabra for the repose of the mother's soul

VINCENT VAN GOGH

1853	*Born in Groot-Zundert, son of a Dutch Reform pastor*
1869	*Junior clerk at Goupil and Co in The Hague*
1873–76	*Works for Goupil in London and Paris*
1876	*Teaches in England*
1877–79	*Studies theology and preaches in Belgium*
1879–80	*Studies art in Brussels*
1881–83	*Sets up studio in The Hague, adopts model Sien Hoornik and family*
1883–85	*Returns to parents in Nuenen. Death of father*
1886–88	*Lives in Paris with brother Theo, meets contemporary artists*
1888	*Moves to Arles. Gauguin visits him, severed ear incident follows quarrel*
1889–90	*Voluntary patient in Saint-Rémy asylum*
1890	*Moves to Auvers-sur-Oise. Produces 76 pictures. Shoots himself, dies two days later*

The Chair and the Pipe *(1888–89)*
Van Gogh's own 'white deal chair', painted as a pendant (companion piece) to Gauguin's armchair. Both chairs were symbolic portraits of the two men, painted in a rare period of calm, shortly after Gauguin's arrival at the Yellow House in Arles

Sunflowers, starry nights, a severed ear and suicide: a compelling mixture to anyone looking for an example of tragic genius. And if Vincent Van Gogh's passions and difficulties are not clear enough from his canvases, we may also read the letters he wrote to his art dealer brother, Theo.

Van Gogh's first job was as an art dealer's assistant in The Hague. He taught himself to draw earlier but didn't paint until his late twenties, after failing every attempt to become a preacher, thanks to the erratic behaviour that blighted all his relationships.

For two years 'the Dutchman' lived in Paris with Theo, who was helpful in introducing him to many artists, including the Impressionists. Their combined influence transformed Van Gogh's previously sombre palette to something 'very much alive, very strong in colour...'

Painting at a fantastic rate, Van Gogh achieved his greatest works during the last two years of his life. From the blissful summer warmth of Provence in 1888, he declared: 'I am not conscious of myself any more...the picture comes to me as in a dream...'

But a violent outburst following Gauguin's arrival in Arles led to a year's stay for Van Gogh in Saint-Rémy asylum. Later, Theo moved his brother north again, to Dr Gachet's care in Auvers-sur-Oise. Van Gogh died there in July 1890, from a self-inflicted gun wound. Together with masses of yellow flowers around his deathbed in a tiny room at the inn, Theo lovingly arranged no fewer than seventy-six paintings. Van Gogh's creative energy had produced them all within his final seventy days.

Starry Night Over the Rhone *(1889)*
*Van Gogh's desire to paint a starry night sky was something he mentioned
repeatedly in his letters throughout 1888. The result was this study of Arles, as
he described it to Eugene Boch: 'The town lighted with gas reflected in a blue
river. Over it the starry sky with the Great Bear – a sparkling of pink and
green on the cobalt blue field of the night sky, whereas the lights of the town
and its ruthless reflections are red gold and bronzed green.'*

DIEGO DE SILVA Y VELAZQUEZ

1599	*Born in Seville*
1611	*Apprenticed to Pacheco*
1618	*Marries Juana Pacheco*
1623	*Appointed Court painter to Philip IV in Madrid. Influenced by Titian*
1627	*Appointed king's gentleman usher*
1628	*Meets Rubens on mission to Spanish court*
1629–31	*Sabbatical in Italy. Influenced by Tintoretto in Venice. Sees work of Michelangelo and Raphael in Rome. Returns to Madrid via Naples*
1631–48	*Paints portraits, religious and classical subjects, and hunting scenes*
1649–51	*To Italy, art collecting for king. Meets Poussin and Bernini. Paints* Innocent X *and* Rokeby Venus
1651	*Returns to Madrid. Appointed Chamberlain*
1652–59	*Paints portraits of new queen and children, including* Las Meninas
1660	*Dies in Madrid*

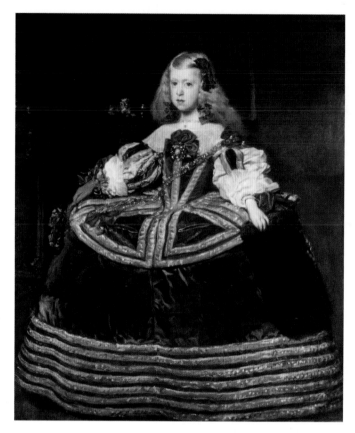

Margarita Teresa in a Blue Dress (*detail*) *(1659)*
The Infanta Margarita – the charming central figure from Las
Meninas *(1656) – here seems remote and imprisoned by her formal court
dress. Velazquez was instructed to paint regular portraits of the princess,
which were sent to the Austrian court to record her growing up. She had
been betrothed as a baby to Prince Leopold*

Diego de Silva y Velazquez went to
Madrid seeking royal patronage and,
with the help of the king's minister,
Count Oliveras, managed to secure a place at
the Spanish Court before his twenty-fifth
birthday. Court painters, however talented, had
to be aware of complex rituals. Velazquez
'…sailed into the current that had been running
deep through royal portraiture…the public
image of the Spanish Hapsburgs [had become]
codified through the interpretations of Titian
and Antonis Mor.'

It was an advantage that Velazquez and
Philip IV were both young. Their developing
friendship meant that the artist was not
overawed by Madrid etiquette and fortunately,
his portrayal of the king won acceptance
straightaway. Velazquez' career went from
strength to strength, using the 'keen eye and
prodigious facility with the brush' that his
teacher and biographer Pacheo noted from his
earliest days.

But he possessed more than a polished
technique; **Rubens** praised his 'modestia', a

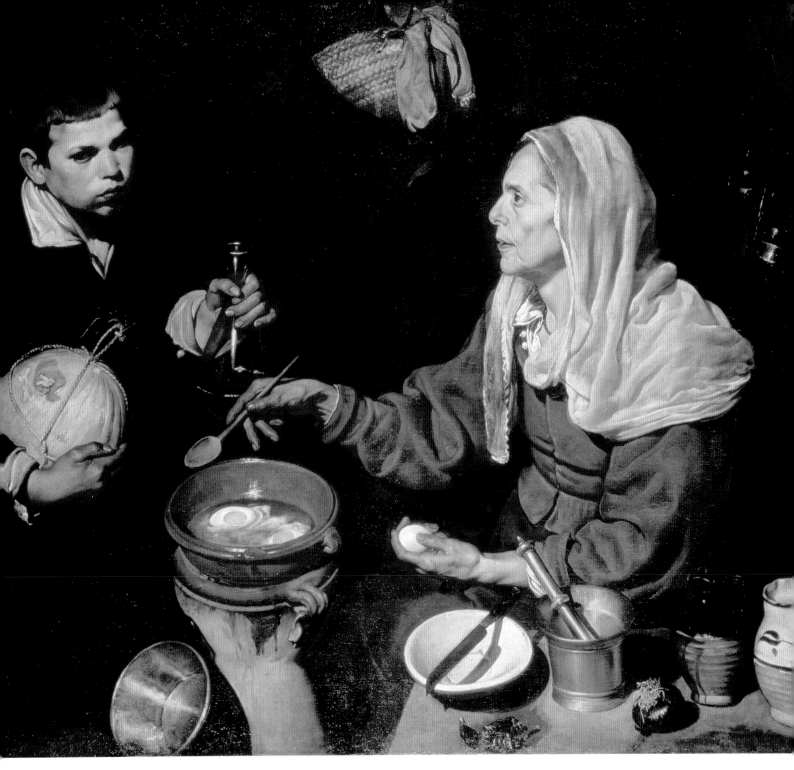

Old Woman Cooking Eggs *(1618)*

This type of picture is known as a bodegón, *literally Spanish for 'tavern' but generally meaning still-life based on a kitchen scene. All the objects are strongly lit from the front and demonstrate a variety of surfaces and textures. It is thought that Velazquez painted this as an advertisement for his skills, and took it with him when he went to Madrid looking for patronage*

kind of quiet authority. Velazquez had a gift for identifying, and communicating, truth of character through his works, as well as the obvious ability to record a likeness. He was as interested in the human condition of a band of Court dwarfs as he was in disclosing the ruthless edge of Pope Innocent X.

The twentieth-century artist Francis Bacon famously worked on his own interpretation of Velazquez' *Pope Innocent X*: 'I became obsessed...it haunts me, and opens up all sorts of feelings and areas of...imagination in me.'

JOHANNES VERMEER

1632	*Born in Delft, son of a silk weaver/art dealer*
1644(?)	*No records in Delft, trains in Utrecht or Antwerp*
1650s	*Paints historical and religious subjects*
1652	*Death of father, inherits family inn*
1653	*Member of St Luke's Guild. Marries Catharina Bolnes, they have eleven children*
1654	*Birth of first daughter Maria*
1660s	*Changes to painting genre subjects, influenced by Dou and Van Mieris*
1663	*Birth of first son Johannes*
1670s	*Business suffers on French invasion of Netherlands*
1675	*Physical and mental health deteriorates. Dies in Delft*

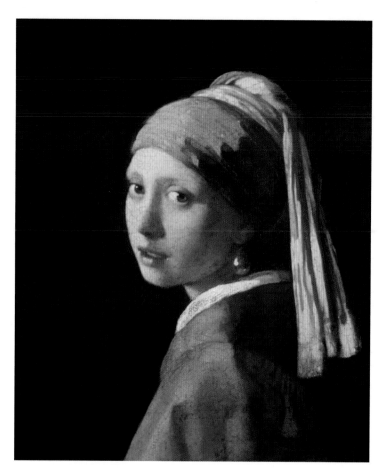

Girl With a Pearl Earring *(c.1665)*
The unknown girl is dressed oriental-style in a turban, which means that the picture is probably a tronie, *or character study. In its fresh simplicity and directness, it is one of Vermeer's most popular images*

The Dutch school of the seventeenth century produced, in effect, a documentary of every aspect of their daily lives. Each painter had his speciality, from tall ships to dead pheasants. Johannes Vermeer was chiefly concerned with interiors and with one room in particular. It features in so many of his carefully composed works, lit from the left by two windows, it has a tiled floor and one map-hung wall. People within this space always seem intent upon what they are doing but in a very detached way.

Vermeer's painted tranquil images did not tally with his real-life situation; he and his wife had eleven children. However, there is evidence that Vermeer built himself a space into which, in a sense, he could retreat – a *camera obscura*. It stood at one end of that familiar room, and Vermeer arranged his subjects at the other.

First advocated for artists in the 1550s, the *camera obscura* can be made to any size. A simple darkened box, it has a pinhole or – in Vermeer's case – a lens in the side. The image of an object outside passes through the aperture and appears upside down on a blank canvas fixed to the

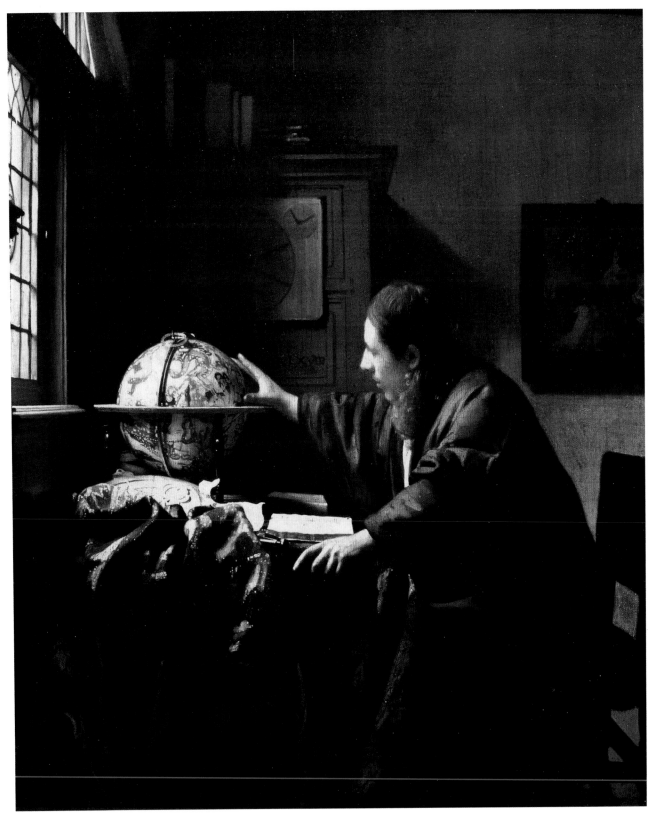

interior wall. Vermeer would oil-sketch the projected image in black and white; X-ray analysis reveals it beneath the colour layers. Then he would emerge from his 'camera' to paint slowly and meticulously the finished version in full daylight.

The Astronomer *(1668)*
This painting reminds us that Vermeer lived in an age of scientific discovery. He grew up in Delft with the inventor of the microscope, van Leeuwenhoek, who after Vermeer's death, became trustee for his estate. The astronomer's globe was made by Hondius in 1600. It sits on a table draped with an exotic cloth and the astronomer wears a flowing gown, as if the scholarly scientific future has still to contend with the superstitious past

PAOLO VERONESE

1528	*Born Paolo Cagliari in Verona, son of a sculptor*
1540(?)	*Studies under Antonio Badile in Verona*
1552	*Paints frescoes in Mantua Cathedral*
1553	*Settles in Venice. With Zelotti, paints ceilings in Doge's Palace*
1555–59	*Decorates church of San Sebastiano, Venice*
1561	*Paints frescoes in Villa Barbaro, Maser*
1562–63	*Paints* Marriage at Cana
1565(?)	*Marries Elena Badile, they have two sons*
1572	*Paints* Last Supper *for convent of SS. Giovanni e Paolo*
1573	*Tried for irreverence by Holy Office of the Inquisition*
1585	*Paints* Pietà
1588	*Dies of a fever in Venice*

Pharaoh's Daughter: The Finding of Moses *(detail) (1570–75)*
The Egyptian princess and her entourage, complete with dwarf jester, have come straight from a gathering at a Venetian palazzo; with calm assurance, Veronese transports the Bible story and the viewer to his own special world. As he told the Inquisition tribunal: 'Painters take the same liberties as poets and jesters.'

Together with **Titian** and **Tintoretto**, Paolo Veronese dominated the Venetian art scene during the sixteenth-century. Although a native of Verona, Veronese of the Most Serene Republic might have been a fitting title for him. His works exhibit all the opulence that Venice had gathered through centuries of commerce and conquest. He thought nothing of painting religious scenes in a Venetian setting with the saints in silks and jewels, and although some reproached him for it, others admired this flattering portrayal of their city state.

In 1563, Veronese completed the *Marriage at Cana*, signalling a talent for architectural set-pieces. Soon, more orders were placed for banquet pictures and in 1572, the Dominican convent of SS. Giovanni e Paolo requested a

The Marriage at Cana *(detail) (1562–63)*
The occasion of Jesus' first miracle, changing water to wine, takes place against a monumental backdrop of classical colonnades. The main players in this set-piece drama would have been readily recognizable, since Veronese included portraits of Francis I of France, Mary of England and Charles V of Spain. The musicians are none other than Titian, Veronese himself playing the viola, his brother Benedetto, Tintoretto, Jacopo Bassano and Palladio

replacement *Last Supper* for the Titian they had lost in a fire. Veronese produced a magnificent work of arches, pillars and staircases, bustling with fashionable people, servants and dogs. In the middle, dwarfed by their surroundings, sit Jesus and the apostles.

Before long, Veronese found himself before the Holy Office of the Inquisition, who objected to his *Last Supper* because it included irreverent elements not mentioned in the Bible, like a jester with a parrot and drunken German soldiers. Veronese stoutly defended an artist's right to use his imagination to fill up the space on his canvas and a compromise was reached by altering the title to *Feast in the House of Levi*, which the Bible says was attended by 'publicans and sinners'. Veronese was thankfully released to return to his palette.

ANDY WARHOL

Crime Scene of David 'The Beetle' Beadle *(1939)*
A scene-of-crime shot by 'Weegee', the photographer who inspired Warhol's silkscreen prints of violent news stories, such as riots and car crashes. Warhol openly incorporated the photographic image into his artwork at a time when people were not sure whether photography and art could be mentioned in the same breath

Pop artist Andy Warhol's early days as a commercial artist primed him for the world of advertising imagery and clichéd celebrity that he so coolly invaded in the 1960s. By the end of that decade he had marked out a new arena of activity, the essential element being that he should be the one to decide what happened there. At his New York studio called The Factory he and his assistants, quite literally, reproduced the American state of mind. They flattened it onto a mesh, squeezed ink through it and hung it out to dry – over and over again. Unique artwork was a thing of the past.

The Factory was more than a workplace, it became a fashionable drop-in centre for artists and musicians and home to the 'Warhol superstars' – including the rock band Velvet Underground – who formed his social set and featured in his films. Warhol's film-making totalled over sixty productions. His debut, *Sleep*, lasted six hours but actually repeated a single twenty-minute sequence – like the screenprinted dollar bills – until the mind switched from looking intently to passive acceptance.

Warhol's near-fatal shooting by Valerie Solanis, one of the Factory workers, left him in chronic pain from 1968 onwards. He did produce more silkscreens and videos, but his strategy had already worked, thereby demonstrating that second- and third-hand experiences are too often accepted for real ones. More than any other twentieth-century figure, he permanently altered the concept of art.

Mao 1973 *(1973)*
*Warhol returned to hand-painting in combination with silkscreen to produce
the Mao Tse-tung series. The Chinese communist leader and his 'Words' –
known and sold everywhere as the Little Red Book – had a cult following
among young westerners. Mao's unlikely acceptance into a capitalist society was
enough for Warhol to include him in his gallery of famous heads*

ANTOINE WATTEAU

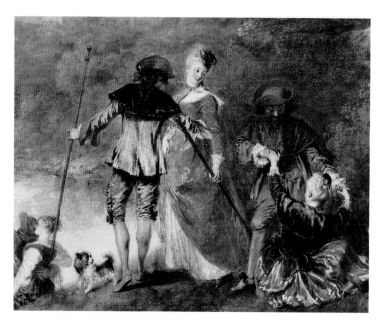

Two Pairs of Lovers, Embarkation for Cythera (*detail*) (*1717*)
Cythera is the fabled island of love for which pilgrims embark but never arrive. The pastoral setting suggests impossible dreams of casting formality aside in favour of spontaneity. The frisson *between these four lovers is subtle, bodily contact appears casual and yet the silks and velvets they are wearing are seductively tactile*

Nothing coarse or ugly is admitted to the parkland paradise of Antoine Watteau, major French painter and pioneer of Rococo. His genius for composition fills soft landscapes with elegant silk-clad courtiers, musicians and cherubs at play. At the same time, Watteau's idyllic world has an air of theatricality, explained by the fact that he once worked with a theatrical designer. Gillot designed décor and costumes for the Opera and was a painter of the fashionable Italian *commedia dell'arte* characters, which Watteau often used.

For some reason, their partnership ended after four years, although Watteau was notorious for his irritability and intransigence towards organization of any kind. However, a new offer led him to Audran, Curator at the Palais de Luxembourg. Not only did Audran initiate Watteau into the decorative painting style of *chinoiserie*, he also introduced him to the magnificent Medici cycle, produced by **Rubens** for the dowager queen Marie.

Rubens probably provided the spark for Watteau's creation of the *fête galante* (feast of courtship), a genre so new that the French Academy had to devise the term when they accepted *Embarkation for Cythera* as Watteau's diploma piece. Watteau's pupils Lancret and Pater perpetuated his style, but the *fête galante* did not last much beyond the Rococo period. However, Watteau as a colourist continued to inspire painters as late as the Neo-Impressionists.

Gilles *(1718–20)*
*Watteau may have painted this as a sign for the cafe owned by Belloni, an actor
who played the role of melancholic Pierrot from the commedia dell'arte.
Contrasting the gravity of Gilles with the boisterous group behind him,
Watteau sets him apart in a colourless world of his own. By this time, Watteau
was quite ill with tuberculosis and possibly very sensitive to the certainty that all
the world's pleasures are transient*

JAMES ABBOTT McNEILL WHISTLER

1834	*Born in Lowell, MA, son of a railway engineer*
1855	*Moves to Paris. Studies under Gleyre. Begins etching*
1859–1892	*Settles in London. Produces Thames etchings*
1861	*Paints mistress Joanna Hiffernan as* The Little White Girl
1866	*Travels to South America*
1872	*Begins Thames Nocturnes*
1876	*Decorates Peacock Room for Leyland, quarrels, loses patronage*
1877	*Exhibits* Falling Rocket
1878	*Sues Ruskin for libel and wins*
1879–80	*Bankrupt. Moves to Venice*
1884–86	*One-man shows in London*
1888	*Marries Beatrice 'Trixie' Godwin*
1891	*Sells to French and Scottish collections*
1892	*Moves to Paris with Beatrice*
1896	*Beatrice dies*
1903	*Dies in London*

Nocturne in Black and Gold: The Falling Rocket *(1874–77)*
Whistler's Thames Nocturnes, *painted during the 1870s, owe their inspiration to Japanese prints. This* Nocturne, *with its spangled sky, gave rise to the famous dispute between Whistler and the critic John Ruskin*

Arriving in Paris from the USA in 1855, James Abbott McNeill Whistler was surrounded by a sea of artistic talents, which included **Courbet**, **Degas**, Fantin-Latour, **Manet** and Pissarro. He studied under Gleyre, with English students who relished his flamboyance and sharp wit. Yet, behind the dandified exterior was a serious spirit who only wanted to make art.

Whistler moved to London and showed his first significant work, *The Little White Girl (Symphony in White, No. 1)*, at the Academy.

Speculation abounded. Was she in a trance? A nervous young bride? To everyone Whistler gave his longstanding reply: 'There is no story'. But an exercise in shades of white was incomprehensible to the Victorians, and so was 'his abhorrence of narrative, his refusal to moralize through art, his preference for the exquisitely designed moment over the slice of life: these were new.'

Despite French studio training, Whistler's truest inspiration was the Japanese print. It informed his later paintings, including the

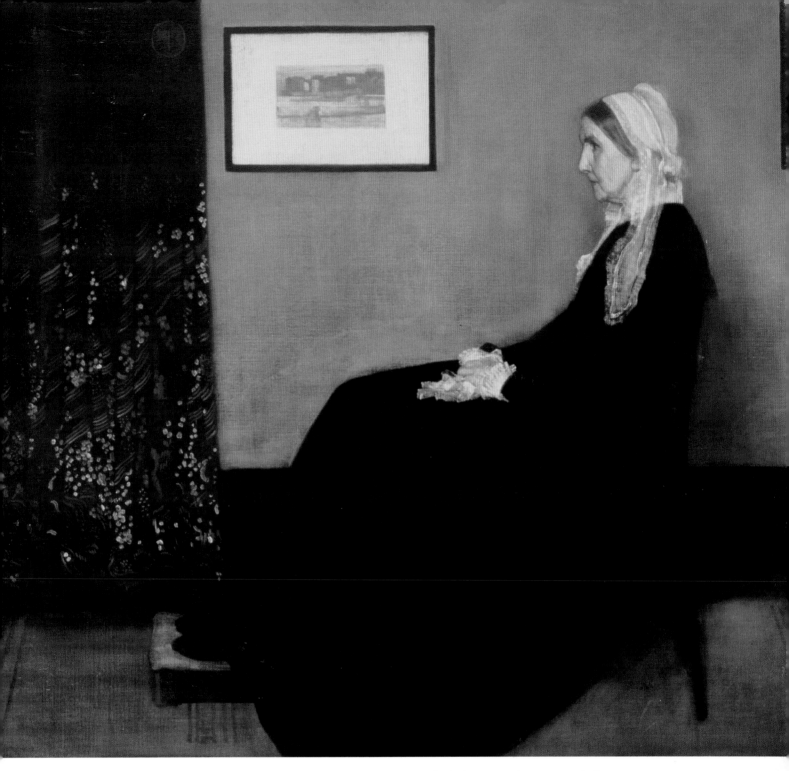

Nocturne that provoked Ruskin's libellous comment about the 'pot of paint thrown in the public face'. Whistler's *Times* obituary recounted wryly: 'The trial was painful to many, amusing to more; in the end Mr Whistler obtained one farthing damages'. But it also affirmed: 'He was set upon…painting and etching what he saw, with no ulterior thought of utility, or popularity, or what would advance him in position and esteem. "Art for Art"…the doctrine that Whistler professed and practised to the end.'

Arrangement in Grey and Black No. 1: The Artist's Mother *(1871)*
Whistler's enterprising, puritan mother arrived uninvited from the USA to live with her 'own dear butterfly' in his Chelsea home, and posed for him one day when he had no model. Standing was hard for her, so he seated his mother in profile – and an icon was born. With Japanese echoes, Whistler painted her as an austere arrangement of tones. He used black as the basis of his palette and much turpentine, which sank into the unprepared canvas to give a dulling effect that pleased him. It is Whistler's 'no narrative, no sentiment' approach, that has ensured her timeless appeal

ACKNOWLEDGEMENTS

Images reproduced with permission from the following:

Art Archive (Picture Desk):
6, 7, 8, 9, 10, 12, 14, 15, 16, 17, 19, 20, 21, 22, 23, 24, 25, 26, 27, 29, 30, 31, 32, 33, 34, 35, 36, 37, 38, 39, 42, 43, 44, 46, 48, 49, 50, 51, 53, 54, 55, 56, 57, 58, 59, 60, 61, 62, 66, 68, 70, 71, 74, 75, 76, 77, 79, 80, 81, 82, 83, 84, 85, 86, 88, 89, 91, 94, 95, 97, 100, 103, 104, 106, 107, 108, 109, 110, 111, 112, 113, 114, 115, 116, 117, 118, 119, 121, 123, 124, 125, 126, 127, 128, 129, 130, 131, 132, 134, 137, 138, 139, 140, 142, 143, 144, 145, 146, 148, 149, 151, 152, 153, 154, 155, 158, 159, 161, 162, 163, 164, 165, 166, 167, 169, 170, 171, 174, 176, 177, 178, 179, 180, 181, 182, 183, 184, 185, 186, 193, 194, 195, 199, 200, 201, 203, 204, 205

AKG Art Library:
63

Bridgeman Art Library:
11, 18, 40, 72, 73, 78, 122, 133, 135, 141, 156, 157, 160, 172, 173, 206

Corbis:
13, 28, 41, 45, 47, 52, 64, 65, 67, 69, 87, 90, 92, 93, 96, 98, 99, 101, 102, 120, 136, 147, 150, 168, 175, 187, 188, 189, 190, 191, 192, 196, 197, 198, 202, 207

Edward Hopper
P105: *Automat* Des Moines Art Center Permanent Collections; Purchased with funds from the Edmundson Art Foundation, Inc., 1958.2

David Hockney
p 91: *Mr and Mrs Clark and Percy* 1970-71. Acrylic on canvas. 84" x 120" © David Hockney

Salvador Dali
p 53 © Salvador Dali, Gala-Salvador Dali Foundation, DACS, London 2005

Vassily Kandinsky
p 109 © ADAGP, Paris and DACS, London 2005

René Magritte
p 121 © ADAGP, Paris and DACS, London 2005

Henri Matisse
p 133 © Succession H Matisse/DACS 2005

Piet Mondrian
p 141: *Composition with Red, Black, Blue and Yellow, 1928* Oil on canvas, 45 x 45 cm. © 2005 Mondrian/Holtzman Trust, c/o HCR International Warrenton Virginia

Edvard Munch
p 147: The Scream 1893. Tempera on board. 83.5 x 66 cm. Munch Museum, Oslo.
Artwork: © Munch Museum/Munch Ellingsen Group, BONO, Oslo/DACS, London 2005
Photo: © Munch Museum (Andersen/de Jong)

Pablo Picasso
p 151 © Succession Picasso / DACS 2005

Jackson Pollock
p 155 © ARS, NY and DACS, London 2005

Andy Warhol
p 203 © The Andy Warhol Foundation for the Visual Arts, Inc./ARS, NY and DACS, London 2005